Visual Communication

More than Meets the Eye

By Harry Jamieson

intellect
Bristol, UK
Chicago, USA

First Published in the UK in 2007 by
Intellect Books, PO Box 862, Bristol BS99 1DE, UK

First Published in the USA in 2007 by
The University of Chicago Press, 1427 E. 60th Street, Chicago,
IL 60637, USA

A catalogue record for this book is available from the British Library

Cover Design: Gabriel Solomons
Copy Editor: Holly Spradling
Typesetting: Mac Style, Nafferton, E. Yorkshire

ISBN 978-1-84150-141-7

Printed and bound in Great Britain by 4edge Ltd, Hockley. www.4edge.co.uk

CONTENTS

ACKNOWLEDGEMENTS

I would like to thank Audrey Hall for her valued assistance in selecting appropriate prints from the National Museums Liverpool collections held at the Walker Art Gallery and the Lady Lever Art Gallery. Thanks are also due to the Tate Gallery London for the provision of a print and to D.A.C.S. (Design and Artists Copyright Society) for providing me with the necessary licence. To Derrick Hawker I am indebted for a print from his collection. Thanks are also due to Hans Kaufmann for his diligence in reading the script. Finally, I wish to record my indebtedness to my wife, Doris, for her continuous help and encouragement throughout all the stages involved in the preparation of the manuscript.

LIST OF ILLUSTRATIONS

PREFACE

For all people, especially those concerned with the visual arts and those engaged in media which employ visual images, an awareness of the deep foundations of visual knowing is both necessary and vital for a full appreciation of visual communication. In contemporary society, where images abound in various media, particularly in television, there tends to be an uncritical acceptance of the power and influence of mediated images, similar in a way to that attributed to mythological symbolism. This state of affairs could be accounted for by their surface level innocence, an innocence where the eye is presumed to be both judge and master. Although such an appraisal has the appeal of simplicity, it may begin to crumble when it is subjected to careful scrutiny. For example, on closer analysis it can be revealed that, as in verbal language, an elaborate structure can be found, a structure which makes demands of an intellectual kind, different from the verbal, but nevertheless demanding. The ready acceptance of the power of visual images could be explained by the likeness or similarity between their appearance and their meaning; an earlier, more primeval attachment than that found in verbal language. However, the study of visual images in all their manifold guises brings forward a plurality of sub-structures. The most obvious, because the most observable, is the structure imposed by the media through which they are represented. Less obvious structures can be found to have their roots in fields as diverse as those of physiology, psychology, sociology and history. It is this richness that needs to be appreciated, a richness at work in most everyday situations and activities: in cities; in buildings; in images intended for pleasure or commerce; and in appreciation of the visual arts in general. It can be said that a book devoted to the study of visual communication and images lives on borrowed territory, that of the verbal, but the verbal itself frequently works in the opposite direction, as for example when the reader is called upon to imagine a situation and thus call upon the use of imagery, in other words to visualise. The common ground is to be found in the power of the verbal and visual to instigate thought ; so despite their differences, the final ground is the same, the ground of the human mind dealing with information, different in coding, but nevertheless a task of mental processing. The intention of this book is not to unfold the mysteries of visual communication and thereby lessen its potency, but to demonstrate its underlying complexities and thereby give 'voice' to the silence which is its nature.

INTRODUCTION

The world presents itself in manifold ways to the sense of vision. Broadly speaking, one could say that it communicates its existence, or, to use a visual term, it makes an appearance. But here at the outset we should be careful to make a distinction between appearance, that which appears in the eye of the beholder as an image, and information which is the effect produced by the image at the mental level. These factors of appearance and information are not necessarily synonymous, although they often seem to be so, particularly in the field of visual communication where the image appearing on the retina may also be its meaning. For example, an image of a tree bears a likeness to its meaning despite the difference in scale between its projected image and its reality in nature. In contrast, language in both its written and spoken forms is obviously distinct from its reference or meaning, with the exception of onomatopoeia.

The apparent affinity between medium and message in visual communication presents a surface-level innocence which can be beguiling on the one hand, and deceptive on the other, deceptive when it suggests an ease of comprehension which cloaks hidden intentions. It could be argued that this innocence owes its origins to the pre-verbal state of the infant whose world has an immediacy between cause and effect, a world where form and content are fused, where no distinction is perceived between message and meaning. Echoes of this primary innocence are still to be found in adulthood, exemplified whenever emotion is felt in the presence of an image as artefact, a good example is that found in audience reactions in the cinema where the sense of reality is further enhanced by the apparent movement of the projected image.

While at birth the attachment between form and meaning has important implications for survival, the developing individual soon enters a 'world' of fragmentations, of breaks and distinctions between form and content; it enters a world of symbolism. And yet, a world never entirely cut adrift from its sensory roots. It is here that we can begin to discern the essential power of visual communication, the power to operate along a continuum ranging from the near concrete to the abstract. However, it is the attachment to the sensory world and its immediacy that gives visual communication its special niche. Its life as analogue makes boundaries unclear, and yet, when it is employed as metaphor, for example in symbolic art, it operates within the realm of the digital, the place of concepts and boundaries. Thus, as a device for communication, it possesses a dual potential; the potential to operate within the sphere of the analogue (the continuous) or the digital (the discontinuous).

In studying the visual in communication we are constantly being drawn to and fro across the boundaries of sensory awareness and language awareness. But the starting point of our study is the eye, an eye contained in a body from which it reaches out to connect with things external to itself. Metaphorically speaking, it leaves the body and yet it is embedded therein, embedded in a physiological state which produces the first modification in the re-creation of external reality; perception is underway. Moreover, as a result of social and cultural conditioning, the 'space' between the retinal image and its interpretation is subjected to further modification. And thus appearance is transmuted into information through a parallel process of perception and cultural codes. This applies equally when viewing natural or mediated forms, but in the case of mediated forms or images the techniques of visual representation can cloak its arbitrariness and thus give an illusion of naturalness, of a 'message without a code' when in fact it may have been subjected to a significant amount of coding. Here we can note the contrast with print as a communicative device, whose material properties rarely influence the reader, except when type carries a particular connotation, for example the use of gothic type to suggest sinisterness.

The power of visual communication relies on its involvement with perception, and thus it has one foot in nature, while its other foot is in codes, in the invented world of society and culture. Thus in studying the visual in communication we are forced, of necessity, to operate on a broad front, one that pays attention to the producer's role in the creation of media and to the viewer's role as interpreter, with all that this means in terms of the physiological, psychological, and socio-cultural processes that together shape interpretation. It will be seen, then, that our journey is far from simplistic and that it opens avenues of apparently infinite dimensions.

In addition to specialised studies in the field of visual perception, concern with the visual has been a major source of enquiry within art history and theory, and for practical reasons, it is central to those concerned with graphics and pictorial representation in general. Furthermore, with the advent of computer-generated images and the notion of virtual reality, concern with the visual has taken on added significance. Despite the shift to computerised image generation, which, as Manovich (2001) pointed out, is evident across a range of 'new media', and the possibilities for inter-action between originator/sender and the viewer/receiver, the digital age has to contend with people. Thus, whatever the changes in technology of communication and image generation, the human factor is always present. Visual awareness and visual knowing is composed of a number of tributaries, at its source it is biological, to which psychological and socio-cultural forces join to produce, what we might term personal understanding or interpretation of that which is given to sight.

Visual media undergoes changes, it is made inter-active, but it is always only an artefact for connection. At the human level, there are deeper issues that are more resistant to change. This book focuses mainly upon these deeper issues. Each chapter follows a particular theme with sub-sections bringing out the salient points. At the end of each chapter is a summary which provides the reader with an overview of the main ideas which have been presented. The summaries could well be used as preparatory reading before each particular chapter. The reader follows a route whose first concern is with perception; from here we look at the implications of semiotics with particular reference to visual images; we then proceed to question the concept of meaning. Our enquiry is then directed towards other related concepts of particular concern to visual communication. These include the tacit or intuitive factor in knowing, the aesthetic factor, and the frames that guide interpretation. Finally, we face the question of the viability of the concept of a visual language.

1

THE PERCEPTUAL CONNECTION

Of the many facets that bear upon the study of visual communication, that of perception carries significant relevance. This is the inter-face where the individual makes contact with the world via the senses, and it is here that we can speak about connection or communication between events or things exterior to the person, and their interior representation in the form of mental images. In visual perception the exterior is made manifest through light, without which we would quite literally be blind. Light then is the first stage in the whole process of visual communication, spanning the distance between eye and object; an inaugural carrier system of information 'about' something rather than its 'physical being'. Light falling upon the eye activates the next stage in the process of visual knowing, its energy being transformed into neural energy, thus involving a change of state in an ongoing process which ultimately produces a mental image. But during this process other factors, psychological and cultural, help to shape the resulting image. Moreover, although our interest here is centred upon visual communication, we need to bear in mind that the act of interpretation may involve input from a combination of other sensory channels.

Here at the outset, it is necessary to be reminded that at this primary level of communication, modification and distortion can take place, leading to visual illusion. The issue of illusion is central to much of visual representation, it plays a part in, for example, perspective, photography, film, and computer-generated imagery. In fact, in describing the era of image-making 'from motion pictures to navigable interactive environments' as 'Architectures of Illusion' (Thomas & Penz, 2003), the whole enterprise is seen in terms of illusion. Through illusion a world of make-believe or of pseudo-reality is open to manipulation when the media is one that centres upon vision. Moreover, apart from engagement with visually manipulated images, vision, in its natural engagement with the world, carries the potential of illusion. The common notion of the 'innocent eye' representing the world in pristine faithfulness, can be seen more as a figment of imagination than of reality.

We need to challenge the concept of reality both in terms of direct perception, i.e. stimuli given to the senses without any form of human mediation, and indirect perception, i.e. through artificial modes, commonly known as media; and hence we will see that the question of reality becomes more one of definition. As it will become clear later, the symbolic transformations that occur in both direct and indirect perception always place reality at a distance, the things or objects being observed themselves becoming re-presentations. It

appears that we should focus more upon the process of visual perception rather than engaging in polemics about reality; and in following this route we place the individual at the centre of our enquiry, and thus allow for the idiosyncrasies that surround the act of interpretation. The process of visual communication is always one of transformation; at the retinal level an analogue input is transformed into a digital output for transmission by electrical impulses to the brain; and at the cultural level, symbolic images require to be transposed, via metaphor, in order for their meaning to be understood. Both processes bear the mark of coding, of change, where one thing is represented by something else. And thus we find ourselves in the field of symbolism.

We have set a broad scene for considering the place of the visual in communication, and now we must take upon ourselves a deeper and more thorough analysis. The essential starting point is that concerning man's engagement with the world through the senses, the world of phenomena, and it is here that students of the visual may obtain gratification in finding that visual words such as 'light' and 'showing' are central concepts in the study of phenomenology. For example, Heidegger traced the etymology of phenomenology to its Greek and Indo-European roots, showing that the word is connected with ideas of light and clarity, and that which shows itself. But, as reported by Macquarrie (1973), Heidegger was cautious to explain, as the subsidiary title of this book proclaims, that there is more to things than meets the eye. He went on to advocate that the 'truth' has to be 'wrested' from the shown phenomena, and that this wresting is made via a second level of 'showing'; by this he meant articulation by speech which allows structures and interconnections to be, as he would say, brought into the light. This second level was referred to by Derrida (1978) as the agency within us which always keeps watch over perception. Here we are in the territory of language, speech in Heidegger's case, and written in Derrida's.

This linguistic interaction with the world of the senses, with phenomena, has ramifications both psychological and cultural, and it draws attention to the fact that perception is multi-faceted. However, the starting point in our journey begins with things in themselves, or as the existentialist would say, with beings-in-themselves, things that show themselves in isolation from codes, existing here and now, in space and in time, the ultimate 'a priori' conditions set by Kant in his theory of knowledge. Thus presence can be seen to hold a privileged position along the two fundamental parameters of space and time. And it is in space and time that visual perception always has its being, a being that only knows itself as presence. In stressing the primacy of perception, Merleau-Ponty (1964) laid special emphasis upon the fact that it is contained in the present, but its roots, as he suggested, are primordial.

Space and time provide the foundations for the reality principle; the reality of one's existence in the world here and now. The reality 'out there' is, however, modified by the very system that is viewing it, and as we shall come to see in more detail later, this reality principle can be subjected to a variety of distortions when the source of the visual stimuli is that of artefactual images, for example, film or other images, static or moving. Gibson (1966) suggested that "a distinction is possible between what is commonly called experience at first-hand and experience at second-hand. In the former one becomes aware of something. In the latter one is made aware of something. The process by which an individual becomes aware of something is called perception ... The process by which an individual is made aware of something, however, is a stage higher in complexity ...

It involves the action of another individual besides the perceiver ... we speak of being informed, being told, being taught, being shown ... The principle vehicle for this kind of

indirect perception, is of course language. There is another vehicle for obtaining experience at second-hand, however, and this is by way of pictures or models. Although much has been written about language, there is no coherent theory of pictures." In these terms, indirect perception refers to any mediated form of communication, and it is our task to help shed some light on visual communication which of necessity is bound up with a theory of pictures.

The Primary Stage: the optics of viewing

Whatever the source of information, whether it is unmediated/natural, or mediated/cultural, the visual processes for dealing with the input of light are identical. This is the primary stage of visual perception in which a changing array of light energy impinges upon the receptor cells in the eye. The source of the light may be direct, as for example from the sun, or from other artefactual means such as an electric light, or it may be reflected, bouncing from the objects or scenes which it illuminates; this, of course, is the normal way we become visually aware of things in our surroundings. The light energy reaching the eye is converted into electrical discharges which are transmitted as impulses along the nervous pathways to the brain. The process is one of transduction and encoding; thus mediation is under way at this very early stage and reality is therefore placed at a distance. Something begins to stand for something else; so we can now, even at this primary stage of visual perception, consider awareness as being in part a symbolic activity; thus we can embrace within the term symbolism the neural processes which communicate information about exterior events, in addition to the cultural symbolism found in mediated communication, which we have defined as indirect perception.

Visual communication in all its manifestations incorporates a symbolic framework, a framework which is sufficiently flexible as to offer scope for varying degrees of realism. And it is in visual media that we find the greatest span of degrees of realism, from the ultra realism of trompe l'oeil to the near abstraction of schematic diagrams. It is this degree of flexibility, allied to the perceptual component, that gives visual communication its powerful place in the general scheme of human communication.

The eye is literally in the forefront of this process, filtering stimuli through rods and cones with varying degrees of specialisation before transmitting electrical impulses to the brain. However, although we have designated the term primary process to the retinal phase of visual perception, we may observe that psychological and cultural factors exert preliminary influences upon the direction and focus of attention. This is an inevitable fact of life, the eye is not multi-directional, which means that choice has to be made from a range of directional options which are available to the forward-looking eye. Thus bias, which is not intended here to be understood in a pejorative sense, will be seen to be a natural corollary to visual perception. Bias implies desire, and here we move to consideration of the viewer's personal motivation in the act of noticing, and hence we may observe that motivation is at work before vision is engaged, e.g., a tendency to focus on 'this' rather than 'that'. Such motivation may, for example, be the continuing influence of man's instinct for survival, noticing visual signs of danger; or it may stem from cultural influences which dispose individuals to orientate themselves in particular directions, noticing specific visual cues at the expense of others. When we talk about education of the visual sense, it means none other than this, making a conscious selection from the visual field, noticing particular relationships, and in the case of paintings and other visual images, sharing to some extent the bias imported by their creators.

So although we gave pride of place to the eye in our scheme of things in visual perception, we are forced to conclude that there exists a precursor. From the rear a guiding hand reaches forth directing attention in a selective fashion; the glove on the hand, still speaking metaphorically, being that of desire or motivation stemming from natural or cultural origins. Here of course we are in the territory of the brain, and it is to the brain that we need to direct our attention for further insights into the complexities of visual perception. Here we enter a world of symbolism where the initial presentation to the eye has been transformed; we are now in the realm of re-presentation which by further elision becomes representation. Reality is lost and the innocence that goes with it; realism takes over and with it arises the possibility of deception through natural or cultural causes, such is the path of the visual in communication.

The Secondary Stage: brain processing of visual information
Having discussed the primary stage where information in the form of light impinges upon the eye, and having introduced a detour to include reference to motivation, we follow the energy from the eye in its transformed state as neural energy. In this transformed, symbolic state, energy traverses neural pathways to the brain, the seat of processing and interpretation. It is here that neurological processes can be measured and psychological processes inferred. The physical characteristic that attracts our interest for the purpose of visual communication is that of brain lateralisation. And it is to this area of enquiry that we now turn before analysing the wider range of psychological issues which bear upon visual understanding and interpretation.

The brain, for descriptive purposes, can be classified into two distinct regions, a division commonly known as brain lateralisation. From this division we go on to speak about right and left cerebral hemispheres. These spatial terms are often used as nomenclature to describe types of people; for example, we may hear people being described as right or left thinkers. The right mode is employed to describe so-called visualisers, people strong on spatial, non-verbal modes of thought; the left mode is reserved as a category to describe verbalisers, people whose thought is considered to be mainly linear, sequential and analytical. Such definitions are of special interest for our concern with the visual, as it will be seen that the right mode is central to processing information which is presented holistically, for example, in pictures or illustrations where the eye is given a simultaneous display of information. This is in contrast to the verbal, whether in print or in sound, where words are received successively.

While such neat binary categories offer attractive definitions, we need to guard against making too simplistic assumptions about right and left thought processes. We know, for example, that total simultaneity in viewing is not always operative, that the eye makes linear movements in its search across pictorial presentations; and we know that succession is involved when viewing moving images, for example film and television. We also know that pictorial images may possess literary connotations which call upon verbal processing. Therefore, it is necessary to be reminded that while at the surface level we may emphasise right and left modes of cerebral processing, and that we may classify people into personality types bearing these labels, there are no absolute personality distinctions of these kinds. In fact it may be more appropriate to define people as having left or right preferences for thinking as a result of social or educational experiences. What is essential is to note that there exists a communication structure, technically known as the corpus callosum, between both

hemispheres, and that metaphorically speaking one side talks to the other. Thus, with this rejoinder, we go forward to a more detailed explanation of the right and left hemispheres.

Pioneering work in this field was first carried out in the second half of the nineteenth century by the French neurologist, Paul Broca, who was the first person to locate speech activity in a specific side of the brain. Subsequently his work led to interest in the contrasting specialisations carried out in both the right and left hemispheres. More specifically, it is to the work of Roger W. Sperry (1968) in the late 1950's and early 1960's, for which he was awarded the Nobel Prize for Medicine in 1982, that we may turn for further insights in our quest for understanding of the visual. Sperry's work on brain lateralisation highlights the idea of two contrasting modes of information processing; the left hemisphere being engaged with categories and analytical thought; and the right with perception and things non-verbal. So, in view of our concern with things visual and spatial, it is the right hemisphere that becomes the focus of our attention, but naivety should not prevent us from considering the contributions that both hemispheres make to the unity found in conscious awareness.

The later work by McCarthy and Warrington (1988) who carried out research into what they termed 'the modality-specific meaning systems in the brain', provides useful supportive evidence for differences in processing in the brain's two hemispheres. Although their work was oriented towards semantic knowledge, we can note, as they did, the contrast between semantic and visual knowledge. A summary of the paper which they presented at Cambridge University gives the full flavour of the distinction: "knowledge of letters, colours, objects or people may be lost as a consequence of damage to the left hemisphere of the brain. Recently there has been quantitative evidence for even more specific impairment and preservation of particular classes of knowledge. More recently the evidence of knowledge of living things as compared with inanimate objects is particularly striking. Such observations suggested that our semantic knowledge base is categorical in its organization. In this preliminary report, we describe a patient whose semantic knowledge deficit was not only category specific, but also modality specific. Although his knowledge of the visual world was almost entirely normal his knowledge of living things, but not objects, was gravely impaired when assessed in the verbal domain."

This supports the earlier work reported above, and it amplifies our understanding of the brain's two contrasting regions for thought processing. Particularly, for our concern with the visual, we may note the complete contrast with that of the verbal in the actual seat of mental processing, highlighting yet again visual processing as a right mode activity.

While we have discovered the actual region or place in the brain where visual information is processed, we need some understanding of the difference between the modes of information processing; and here the major distinction has been found to be that between serial and parallel processing. Serial processing, as the name implies, is sequential, the ground of language, and this is the style of processing that we find within the confines of the left hemisphere. In contrast, the right hemisphere operates a parallel system of processing, one that can deal simultaneously with concurrent inputs from the various senses, thus offering apparent immediacy of comprehension. It could be argued that the right mode, as the seat for processing sensory information, shows evidence of man's primordial origins, of an animal dealing with sensory inputs requiring speedy processing for reasons of survival. Thus we can offer this explanation to account for the greater speed in processing perceptual information within the right hemisphere. In contrast, the left hemisphere is slower because it works serially, dealing with categories and logic on a step-by-step basis. Armed with this knowledge,

we can put a convincing argument for the primacy of pictorial signs, such as road signs, where there is severely restricted time for processing the information on display. According to Gregory (1990), the parallel processing accorded to perception in the right hemisphere can be carried out in about a tenth of a second; this is in marked contrast to the slower serial processing of language in the left domain.

When we turn more specifically to the viewing of images, we find that in addition to speed of information processing there are a number of additional characteristics within the right domain towards which attention should be drawn. For example, its concern with relationships and form, the aesthetic ground of paintings. Its non-linearity offers scope for idiosyncracy, it offers ground for intuition where fusion can take place between separate inputs, and it seems as Edwards (1986) suggested, "… undaunted by ambiguity, complexity, or paradox." It is essentially the realm of the individual, where codes need not be paramount; indeed it is the place in which new codes can originate. However, while stress has been placed upon right mode 'thinking' in the construction and appreciation of things visual, serial style 'thinking' such as we associate with left mode thinking is also involved. Decisions have to be made among competing alternatives, seriality has to be considered, particularly in the construction of moving images; and the choice of style implies category differentiation. What we are talking about here is the cognitive or thinking element in the construction of visual images and in perception. And we may be reminded of the claim made by Arnheim (1970) that the world emerging from perceptual exploration is not immediately given, that some of its aspects build up quickly and some slowly. All are given to continued confirmation, reappraisal, change, completion, correction, and deepening of understanding; this he called visual 'thinking'.

At first sight, the concept of visual thinking may seem vague, particularly to those who believe that thought is a verbal activity, and yet there is substantial evidence that creative thinking, in science and in art, is essentially visual and therefore non-verbal. Penrose (1991) cited evidence to this effect when he quoted the views of eminent scientists, including those of Einstein.

From the eye to the brain we have been following a route founded in physical attributes, we have seen how the eye's engagement with the world is a reflection of things outside, that a symbolic world is made manifest, and that information fed to the brain from the eye is processed in two different areas. We were, however, guarded in accepting the concept of rigid distinctions between the two hemispheres, because we know that there is a certain amount of correspondence between them. Nevertheless, it appears that people may have dispositions towards or against processing visual information, such dispositions could be accounted for in terms of the emphasis placed upon visual learning in a person's life history. In terms of visual communication, the implications are quite powerful, namely that the visual utilises a particular part of the human processing system, that it has its own niche which differs from the verbal, and yet may enrich it.

The Third Arm: psychology and visual perception

At this point we turn away from the brain with its specialised areas for processing linguistic and perceptual information. We move to what may be considered the more open field of psychology for further insights into the many variables, such as anticipation and expectation, that intercede in the act of visual perception, and thus of visual communication. Our progression opens up many additional forces which exist at the level of the subconscious,

and , as such, they can be considered as undercurrents playing upon the surface of visual perception. To the uninitiated they are opacities in the seeming transparency of visual perception. Here we are talking about the role of the beholder or viewer in visual communication; a person whose role is always one of interpretation. And in addition to the visual, inputs from the memory belonging to other senses may be raised to mind, for example, we may speak of feeling the coldness of snow when viewing a painting or seeing a film. However, common to all aspects of visual perception is its dynamics, it is a continual process of structuring, of structures made in the first instance from the resources of the sensory systems, and secondly from the mental frameworks acquired from social/cultural conditioning. Here the observation should be made that both participants in the act of communication, the sender and receiver, or in terms more appropriate to our brief, the artist/image maker and beholder/viewer are engaged in construction, the distinction being that the artist's role is active while that of the viewer is passive. Although we have emphasised the psychological factors in perception, we should be reminded that socio-cultural issues to some extent intertwine with them. Hence an element of arbitrariness appears in divorcing the separate contributions which coalesce in the act of perception. Notwithstanding this observation, there is sufficient research evidence from the field of psychology to grant it separate emphasis.

The Primacy of Relations
We have spoken about the unity of conscious awareness which arises from the contributions made by both sides of the brain, and we may be reminded of Arnheim's claim, which he made when writing about art and visual perception, that the latter is a kind of thinking, which he termed visual thinking. We may also note his further claim that the artist uses categories of shape and colour to capture the universal in the particular. So, by introducing the concept of categorisation which we established earlier as lying in the province of the left hemisphere, we must now, if we accept the validity of Arnheim's proposition, consider that the unity given to consciousness in perception has an input from the left hemisphere, or else we must postulate that the right hemisphere can create categories of a non-verbal nature, such as shapes.

However, it is well established that categorisation arises from classifications which are made on the basis of relationships perceived or inferred between instances. This, of course, is none other than concept formation, familiar territory to those interested in language or psychology, but less familiar to those engaged in the visual arts. But it is the underlying concept of relationships that sparks our interest in this field, because one of the essential tasks in image construction is that of organising or creating relationships, which may be intended to produce harmony or its antithesis, disharmony. In either case, the objective is achieved only on the basis of the establishment of relationships. In a similar vein, the task of the viewer is one of perceiving relationships, which may produce feelings of harmony or otherwise. So whether we focus upon the artist as image-maker or the viewer, as image receiver, we find unity of purpose in this simple fact of relationships. Moreover, it is apparent that when art is employed to portray symbolic images, its prime duty is one of causing a relationship between an image and the idea or object to which it refers. This, of course, goes by the name of symbolic art, where the viewer is required, or indeed expected, to make the necessary mental connection between the image displayed and its reference which is absent.

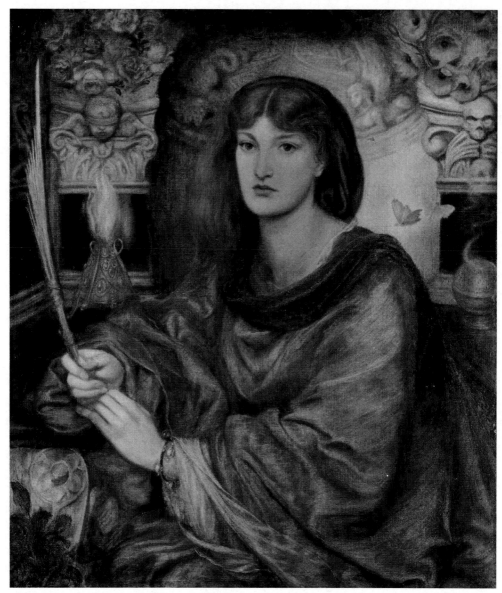

Fig. 1. Sibylla Palmifera, D.G. Rossetti, Lady Lever Art Gallery.

This painting by Rossetti is a good example of the use of symbolism in art. There is a range of symbols for the viewer to find and interpret. For example, the palm which she holds in her hands, is a medieval symbol of chastity; there are blind cupids with a flame of burning love in front; a skull indicative of death, a sphinx symbolic of mystery; and two butterflies, the Christian symbol of the resurrected soul.

From the foregoing it becomes apparent that we are concerned with relations, the relation between a symbol and its referent, and in the case of abstract art, the relationships among

the parts that make up the whole. Although admittedly the images themselves are spatially composed and bear spatial relationships, they nevertheless offer themselves for thought, to a consciousness at three levels of awareness; conscious, subconscious, and unconscious. In visual knowing there can be a shift between these levels, reflecting the viewer's motivations or concerns; the essential point is that relationships straddle the territorial boundaries; in the case of the unconscious in symbolic or disguised forms, to borrow Freudian terminology. And so, whether our interest focuses upon the making or perceiving of images, representational or non-representational, we are constantly engaged in aspects of relationships, from which emerge the higher order concepts of structure, order, and form.

Towards Structure
Having provided awareness of the adhesive, namely that of relationship, which is the bonding material for the creation of unity in consciousness, we need to take a step further. We need to focus upon the more inclusive aspect of perception, the building of structures, the creation of form. As is well known, the artist's task as image maker is essentially that of creating material form; it is less well known that the viewer is faced with a creative act of perceiving form. Form thus perceived is shaped not only from the image given to vision, but also from previous experiences which, as it were, act as frameworks for interpreting current perceptions. The geology of the human mind is composed of past events which, like strata, are ever present but are not always open for conscious inspection. The degree of conscious awareness in viewing paintings has been graphically explained (Gregory, 1990) as resembling the tip of an iceberg.

Thus, for visual communication, the lesson is clear, the viewer/receiver can only interpret visual images through his or her own mental schemata, and consequently the potential for differences in interpretation, even in the face of the same image, is ever present. On the other hand, the artist or designer of visual images has the task of externalising his or her interior vision, which correspondingly has its own history. The creative aspect is one of construction, of filling gaps, which is often tantamount to perceiving relations. This is an act of thought, and it was seen as such by Bartlett (1964) in his seminal work on thinking, when he suggested that artists are all the time endeavouring to fill up gaps. From this we could go on to say that viewers are also called upon to fill up gaps, gaps in their own mental frameworks, which when filled become insights, to use a visual metaphor to describe a mental event. Conversely, there are times when the gaps in the viewer's mental framework fail to be filled, in which case we may speak about incomprehension.

A Sense of Order
From the world outside to the mind inside we are led through a labyrinth of structures formed biologically and socially. And yet, despite the programmes to which they give rise and the apparent stereotyping of behaviour which they produce, there is still space for modification, for creative potential and individual growth. And moreover, from our concern with communication, we note that both originator and viewer have similar potential, the difference being between active and passive creation. It is now understood that the act of perception is itself creative. It is creative not only in its ability to see relationships and fill in the gaps, but it is also creative in the way in which it formulates plans for perceiving the world, in putting forward hypotheses from which judgements can follow. We can say that it imposes a particular kind of order, predetermined by the templates which it cares to utilise. The critical

word here is imposition, the imposition of a solution from a particular way of viewing a problem. It is to the work of Gregory (1990) that we are indebted for the idea of perception being guided by hypotheses, which he called object hypotheses. He drew a parallel with scientific thought when he suggested that "the brain generates predictive perceptual hypotheses of the world around us, very much as physics develops hypotheses from, let us say, signals from a radio telescope. It is a matter of sensed signals coming up for analysis, to be read 'top down' by knowledge and assumptions, for going beyond and generally enriching the limited available data." While the notion of prediction is central to an understanding of perception, we should be aware that it is also purposive and selective, given to expectation, to attending to certain facets at the expense of others. In total, this amounts not only to a mental ordering of the visual world, but striving towards a particular kind of ordering dictated by desire informed on the basis of the particular history of the individual, and thus we may account for differences in perception between people given the same event or image to scan.

The World Stabilised
In the earlier part of this chapter we followed the input of information from the eye to the brain, and conversely, we have seen how the mind itself reaches out to impose itself upon the world. This two-way flow could be visualised as possessing a point of neutrality where the outer and inner forces are stabilised, a kind of mid-point which we could refer to as the place of coalescence, the place where the dynamics of perception are quietened and stabilised into what we may call understanding. And if we follow Kant's (1982) teaching, we may locate this as an event structured within the pre-existent, non-learned framework of space/time which he promulgated as the 'a priori' condition for perceptual knowing. With a small leap of imagination we can connect the work of Gregory, which was mentioned earlier, with that of Kant, and by so doing create a more inclusive notion of perception. This would mean visualising space/time as a platform or base from which hypotheses or predictions are made about incoming sensory stimuli.

Gombrich (1984), whose work bears a close connection to the theme of this book, also highlighted the part that hypothesising plays in perception, he wrote, "without some initial system, without a first guess to which we can stick unless it is disproved, we could indeed make no sense of the milliards of ambiguous stimuli that reach us from the environment." Thus perception can be considered to share common ground with scientific enquiry in the sense that they both involve hypothesising, covert in the case of perception, and overt in the case of science. Of course, it is in the work of Karl Popper (1963) that we find the seeds of this idea.

It is an irrefutable fact that we live in an ever changing world of sensory stimulation, a world with no absolute constancy, and yet within this world we create a perceptual illusion of constancy, and thus create a feeling of stability, a steady state of 'being'.

For example, the actual physical height of people in the street stays the same even when the distance between them and ourselves becomes greater, but in fact the retinal image becomes progressively smaller as the distance increases. This compensatory activity of the brain works not only for what is called size constancy, but also for form and colour. The critical factor is the context within which relations are observed; visual perception is given to noticing change, but such change is always relative. The process can be likened to a screen with co-ordinates upon which relationships are plotted, the actual size being immaterial to the understanding. Throughout, it is the relationships, the connections, the associations that

provide the clues in the shaping of visual perception; scale is only important when it indicates difference between things within a context, when for example, we expect a telegraph pole to be taller than a person. The simple fact is that except in rare instances the retinal image is always smaller than that which it records; the adjustment from outer reality to inner understanding is a mental transformation that maps the real world, and as is the case with all maps it locates on the basis of co-ordinates. In addition to the co-ordinates in the retinal field and those of the visual environment, a third framework of spatial orientation is provided kinaesthetically by the muscular sensations in the body (Arnheim, 1974). And thus there is cross transfer of information between the senses, producing the condition known as synaesthesia, which can give rise to information generated by the visual sense triggering off sympathetic emotional responses in kinaesthesis. In this sense seeing is a visceral activity, which has been well documented in the work of Merleau-Ponty. To view a film, for example, one may feel totally involved, the ultimate expression of this state is to be immersed, a metaphor quite appropriate to describe a particular visual experience. It is to the visual sense and its unique characteristic of framing that we shall now focus our attention, and in a later chapter we shall see how this propensity 'to put things in the picture', to contextualise life in particular spatial ways, becomes a highly motivated activity with aesthetic, political and other potentials.

Framing and Context

The eye is naturally given to framing, to seeing things in relationships within frames which we call contexts; because it is uni-directional it provides, at any single moment, only one frame from a wider field. It may appear to have unlimited freedom, to be free-wheeling; but it is charged with intentions, conscious or unconscious. However, the things it surveys in natural life, uninfluenced by man's artefacts and inventions, are unmotivated, that is, they are given without conscious intent. It is a state of existence where reasons are neither expected nor given, it is fulsome. Speaking prosaically, we may say that in the face of nature things appear in the visual field just because they are there; more poetically and on another higher and more abstract plane of vision we may speak about being in the presence of the sublime, that which is beyond question (Fig 2, p. 24)

In nature there is no centre or periphery, such definitions stem from the nature of vision itself, from its focusing and framing. It is the seeming lack of intention, of presence within the frame being seen as a reflection of the natural order of things that gives us some significant clues about the way in which mediated images become proxy for reality. When artefactual visual images exclude the irrelevant, when the periphery is neglected, when concentration is placed upon the centre of the visual image, when there is little excess, it is then that we are fully conscious of being in the presence of an artefact. This is not how nature organises things. But when the opposite is the case when nature is mimicked in all its fulsomeness, the viewer is put more closely into relation with the natural order of things; as we might say, closer to reality. In the field of art history, Bryson (1985) gives useful examples of this way of ordering things; and, of course, cinéma-vérité is founded upon inclusion of the apparently irrelevant, of peripheral information, of fulsomeness in the attempt to portray real-life. It is within what we might call this innocent territory, the space which includes things for no necessarily apparent reason, unmotivated and thereby closer to the natural order of things, that we tend to ascribe the real. Moreover, there is the further paradox, the paradox that pictorial images being analogical in form, may bear a degree of likeness with the things they represent, giving

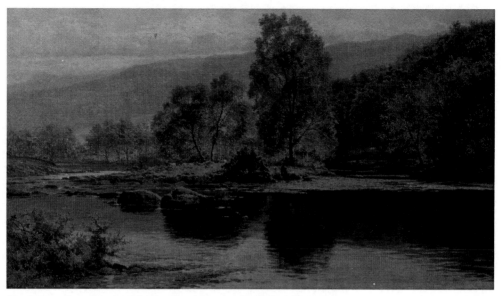

Fig. 2. Near Capel Curig, North Wales, B.W. Leader, Walker Art Gallery.

a surface impression of being uncoded, the natural state, and yet being coded through the very processes by which they are created. This, as Barthes (1977) was keen to emphasise, can catch the unwary into believing that pictorial images are value-free, i.e., not constrained by codes. Taken to extremes there are occasions when we can, metaphorically speaking, be 'taken out of ourselves' when viewing pictorial images. The best example is the cinema, but here the additional dimensions of time and movement play a significant part.

Time and Space and Movement
To perceive is to be in the world, a world known through the senses, given to experiencing sensations, a world located in space and experienced in time, a world through which we move and thus experience space and time in unity. Space is given to vision simultaneously, but time is perceived successively. They were portrayed by Kant as outer reality (space), and inner reality (time); fused in consciousness as a total experience, the outer being internalised.

However, when we turn from indirect perception to life mediated through artefactual images, particularly those of film and television, we enter a world of pseudo-space and pseudo-time which leads to the concept of pseudo-reality. The 'then and there' temporarily, if deceptively, become the 'here and now', the bases of presence and of reality. The paradox is that these pseudo conditions are experienced in real space and real time, the body is physically present in the cinema or in front of a television screen, able to transpose the artefactual visual images which it views into a felt experience, into coalescence with the other senses through synaesthesia, the technical term for this condition. This leads to an overall tone or emotional response. It is as though perception is hoodwinked into thinking that indirect perception is tantamount to direct perception; although a deeper analysis would point to the nature of consciousness itself, pointing to an inner reality which merely maps outer reality.

But the mapping about which we speak is not made upon a tabula rasa, a clean sheet, it is made upon a brain engraved with lines and connections set down in the past, representing the individual's personal history in the form of memory. And it is through memory that the past is framed and given to consciousness as presence. Moreover, it can provide the grounds for 'forward-looking', to anticipating future events or happenings. Thus we might say that anticipation is memory projected which enables time past and time future to be captured in the single instant of time present. This of course is the ground from which imagination springs, projecting to an absence from a presence. While this is an interesting thought, the fact is that, like nature, the mind lives in a world of continuity, where differences when they occur are seen against a backcloth of a greater whole or unity. Even static images, such as paintings, although given within boundaries are presented on one continuous plane, given to the viewer simultaneously but explored successively. In contrast, films are given in separate frames, they are discontinuous but the mind joins the sequential images into a total continuous representation which we might call the experience of viewing.

The propensity of filmic images to create the illusion of continuity from discontinuity has its origins in man's visual system, in his biology. It has been well documented in the literature on visual perception. But of particular interest to ourselves is the perceived continuity of action in the cinema, where we are generally presented with a series of still pictures at the rate of twenty-four per second, at which rate we perceive continuous action. This relies upon two distinct visual facts technically known as persistence of vision and apparent movement. To quote Gregory (1966), "Persistence of vision is simply the inability of the retina to follow and signal rapid fluctuations in brightness. If a light is switched on and off, at first slowly and then more frequently, one will see the light as flashing until at about thirty flashes per second it looks like a steady light." On the other hand, apparent movement refers to what is known as the phi phenomenon, which is best illustrated by reference to those electronic information displays that present verbal messages in the form of running headlines. What is seen is a single light moving across from the position of the first to the second and so on, giving the appearance of illuminated words moving linearly, when in fact there is no such movement. The movement is illusory, thus demonstrating a particular fallibility of the visual system, and the way in which it can be deceived. It could be thought of as a benign form of deception, that is, of course, when the intention behind the communication is motivated in this way.

We have spoken about continuity in broad terms, stressing the way in which discontinuous elements, in other words separate items, are fused into succession without any perceived breaks. What we have not mentioned is the difference in attention paid to particular points or episodes in any continuous presentation. It almost goes without saying that in viewing a moving image, film or otherwise, we rarely attend to every item or episode with the same degree of attention, in other words attention fluctuates. This can be accounted for in terms of the interest that we bring to the subject matter or the details of its presentation. Moreover, attention is rarely uniform throughout any serial presentation, in fact the unusual can gain ascendancy, it is as Gombrich (1984) wrote, "like the jolt we receive when passing from order to disorder or vice versa … The disturbance of regularity can act like a magnet to the eye." However, too much disorder or chaos can be self-defeating, it can cause the viewer to be in a state of overload, causing him or her to switch off mentally or to lose interest. On the other hand, a judicious use of discontinuity in a programme can sustain interest which might otherwise flag; and, moreover, it can be employed to direct attention to critical points or episodes, and thus act as a form of cueing.

From a theoretical perspective, this bears some relationship to human skilled performance where acuity in perception is paramount. Research in this field has established that only particular events within a series require concentrated attention. So we can see a clear connection between the concept of attention and its corollary arousal in all human activities which are time based, whether they are mediated or otherwise. At this point we shift our attention from things mainly psychological and psychophysical, fully aware that the technicalities of visual perception are far more extensive than they have been portrayed here.

The Fourth Arm: the socio-cultural dimension

So far, our attention has been focused mainly upon things internal to the individual viewer, upon natural entities that are common to people irrespective of social and cultural circumstances and conditioning. We have seen that at this level the world perceived is filtered through biological and psychological processes.

The world to which perception gives access is composed of natural forms and cultural forms. Through culture the world is always shaped or framed in particular ways; the undifferentiated is differentiated, boundaries are created and categories derived, concepts are formed thus creating 'food for thought'. This is the world of thinking, a term not usually applied to things visual, and yet it could be argued that visual perception is category bound, that it searches for structures, that it applies 'templates', and by doing so it orders the world in terms of categories. In fact, it could be argued that concept formation in language rests upon the earlier propensity to categorise, which is found in perception.

The categorisation of colour, for instance, rests in the perception of difference, and as we are aware, the difference between one colour and another can at times be difficult to define, particularly when they are in close proximity on the colour scale. However, words, being digital, make categorisation easy, they impose a kind of order. Likewise, symbolic images in all their guises categorise, and although presented to vision in the form of analogues, they assume the digital form in conception. The world in which we live surrounds us with categories, some are imposed through the process of perception itself, but the majority are learned, overtly or covertly, in particular cultural circumstances. They orientate thought in specific directions, and cause the beholder or viewer to make a particular interpretation. For example, colours can be loaded with social or cultural significance, red for socialism, and blue for conservatism. The colours in these examples represent categories, but they have feet in two camps, that of primary visual perception and that of culture. Significantly, cultural effects are a product of learning, including graphic and pictorial symbols, and conventions framed in non-verbal forms, e.g., ritual vestments and behaviour; but even more significantly, such learning may not be consciously understood. So while we have seen that much of perception is below conscious awareness, society and culture also affects the individual at the same level. The forces of nature and culture join together in the act of interpretation. For a fuller understanding of cultural forces we must leave nature and enter the world of signs, of representation, of media, of artefacts, of a world given as otherwise, and thus open to imaginative representation and deception.

Summary

In this chapter we have concentrated mainly upon the viewer's role in the act of visual communication, from the moment when light falls upon the retina, reflecting objects and events, given directly without human mediation and indirectly through media. In either case,

the interpretation that arises from a visual experience, mediated or otherwise, is a combination of factors; biological, psychological, and socio-cultural. These are the frameworks by which outside events are internalised, and having been internalised they add to the store of memories through which future percepts are anticipated, and through which imagination finds 'ingredients' for reconstructions. And it is here that we can introduce the creator of visual images, setting him or her within the constraints and possibilities that are contained within the preceding conditions. The creator and the receiver of images lie at opposite ends of the communication process, but they are both lodged within the same fundamental system of perception. The main difference is that the creator reproduces or invents cultural forms, provides 'ways of seeing the world', and thus affects the ways in which viewers themselves can 'see the world'. The ground for this is founded upon man's sign-making potential, to which we now turn.

2

THE SEMIOTIC CONNECTION

In the previous chapter it was established that visual perception has a social dimension, that 'ways of seeing' are influenced by social forces. It was also suggested that at the neurological level the world perceived is encoded, and that this applies equally to direct perception of natural forms and indirect perception through mediated cultural forms. Therefore, it will be seen that coding bears upon communication at two distinct levels: neurological and cultural. However, at the cultural level the act of translating a percept into a form of representation is an act of invention. In this act, the artist/image-maker goes forward from perception to an invented and coded form of representation.

Fig. 3. Ville d'Avray, G. Seurat, Walker Art Gallery.

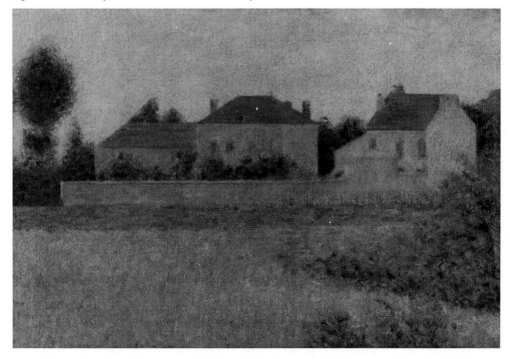

In a wider sense this shift from perception to representation can be seen to lead to the emergence of conventions, which later come to be spoken about in terms of 'isms', such as cubism, and impressionism for which the painting by Seurat, as shown in Figure 3, (p. 29) is an example.

While the artist, as has been mentioned, proceeds from perception to representation, the viewer/beholder is required to travel in the reverse direction, that is from the observance of an invented and coded representation to a re-constitution of the artist's original percept. But this can be problematic as Eco (1977) pointed out, "the process is not an easy one: sometimes addressees refuse to collaborate, and consequently the convention fails to establish itself." On the other hand, when it is successful, when invention translates raw perception into new cultural forms, a sign-function emerges and so "establishes itself that the painting generates habits, acquired expectations, and mannerisms. Expressive visual units become sufficiently fixed to be available for further combinations. Stylisations come into being. The painting now offers manipulable units that may be used for further sign-production." One might say that this is the beginning of a grammar which is established not only in painting, but also in other forms of media, such as photography and film.

In this chapter we take a closer look at the bases of the cultural codes through what we may call the semiotic connection, namely the signs and sign-systems which are employed as mediating devices in human communication, with special reference to the visual. Painting, as Bryson (1985) observed, is essentially a system of signs, of signs materialised. But signs also have a non-material existence in the human mind operating at different levels of consciousness. In fact they provide the stuff of dreams, and the sustenance for imagination; and through them the future can be realised, a factor played upon in advertisements which offer images of idealised future states or situations.

This in essence is symbolic man; described by Cassirer (1979), as a third link which leads to a new dimension of reality. This is how he described it, " Man has, as it were, discovered a new method of adapting himself to his environment. Between the receptor system and the effector system, which are to be found in all animal species, we find in man a third link which we may describe as symbolic man. This new acquisition transforms the whole of human life. As compared with other animals man lives not merely in a broader reality; he lives, so to speak, in a new dimension of reality … there is no remedy against this reversal of the natural order … no longer in a merely physical universe, man lives in a symbolic universe … no longer can man confront reality immediately; he cannot see it, as it were, face to face." What we may detect here is that between the natural order and the mental order, the sign or, as Cassirer preferred to call it, the symbol, interposes itself as an artificial medium made manifest in linguistic forms, in artistic images, and in mythical symbols.

But significantly, it is necessary to realise that we are now in the realm of absence, a sign or symbol is never the thing it represents. Except in those instances where it displays aesthetic form it always directs attention away from itself. It is the complete opposite of perception which as we know is founded upon presence. Admittedly, it is a fact that a material sign has presence, but its status as a sign relies upon its potential to point away from itself to other ideas or objects, to be a sign it must negate itself. Here we are on the grounds of semiotics, the terrain of codes and signs of society, through which individuals become social beings sharing codes and signs from a common pool; a pool with historical depths shaping the living present. As artefacts, signs offer infinite possibilities for coding and recoding, particularly in the field of visual images which are less syntactically formalised than is verbal language. In

fact, the production of new forms and new ways of representing the world in the visual arts is an on-going process of sign-making; in colourful language, it may be said that one man's vision can change the way we look at the world. But this can only happen when his vision has been translated into some form of sign system.

At surface level, visual images provide a ready connection with perception, but at a deeper level they operate within the field of semiotics. This duality provides a very convenient link between perception and semiotics, particularly the links which we can forge between the individual as a 'seeing' person, and as a member of society whose codes and signs shape mental processing in particular ways. Entry to a particular cultural system of codes and signs can be made consciously or subconsciously; in either case it is a product of learning, overt or covert. And it is covert learning that surrounds much of what we appreciate in visual images. There are no dictionaries, at least no substantive dictionaries, to which we may turn for support or reference; and yet visual metaphors are constantly employed in advertising, in films, and in television. The individual, one might say, imbibes certain fundamentals without formal instruction, at a level below conscious awareness.

Within this semiotic framework the artist may attempt to forge new signs, to create ways of portraying the world of things and ideas. It follows that other members of society have to learn the significance of the newly emerging signs in order to comprehend their meaning. On the other hand, an artist may choose to utilise existing signs with established conventional meanings requiring no fresh learning, and which offer immediacy of comprehension to those familiar with the codes and signs. In either case, the province is that of semiotics, of artificial media offering themselves for interpretation, of suggesting, and bearing the potential to influence the thoughts of the viewer in a particular direction. This is in contrast to natural signs, such as clouds which indicate the possibility of rain, where intention is absent. The distinction we are searching for between nature and culture can be illustrated by the metaphor of a filter: nature being perceived through a filter without intention, and culture being perceived through a filter with intention. Cultural, artefactual signs, as we have established, point away from themselves, but the direction in which they point in any particular instance is motivated by the person, artist or producer who calls them into existence. They are like tools, chosen and utilised to shape something, the something here refers to the mind or thoughts of the viewer.

The transmission of cultural values is full of vagaries. In the first place they are bound to contexts which exercise an influence upon the way they are understood. Furthermore, when the contextual background is changed they themselves may undergo a change in meaning. To this extent they carry the same burden of context as is found in non-verbal communication in its wider manifestations. However, when they are employed as symbolic images they take on the mantle of metaphor, and thus exhibit a linguistic connection which is more closely bound to abstraction, and for which a dictionary of images becomes appropriate. These are the grounds of the visual in communication, difficult to pin down in any absolute grammatical sense, but when viewed under the mantle of semiotics they share common ground with linguistics, the ground of signs, of images intended to organise thoughts in particular directions. On this basis we need to take a closer look at the general background to semiotics and to see how the visual fits into this wider framework of communication.

Semiotic Levels

Semiotics can be studied at three different levels, each level representing different forms of abstraction: the first and most abstract is that of syntactics which is concerned with the relations between signs; the second level is that of semantics which deals with the relations between signs and what they signify or represent; and the third level is that of pragmatics which is concerned with the relations between signs and their users. The common factor, it may be noted is that at each level the concept of relations is present. This is highly pertinent to our concern with communication which is founded upon the establishment of relations; in passing, we may also note that learning of whatever variety shares the same necessity of establishing relations or connections between things, ideas or events.

To return to our theme, and to connect with its implications for visual communication, we may note that while syntactics is well established within the field of linguistics, it is less developed in the area of visual communication. The difference could be accounted for by the greater degree of abstraction that exists in verbal communication, which is more detached from that which it signifies. On the other hand, artistic images can have a sufficiency which frees them from exterior signification, for example when they are valued for their internal relations as pure form. However, unlike verbal messages there is no agreed store of basic units and rules to which reference can be made. In a later chapter we shall be looking in more detail at the problems which surround the notion of a distinct visual language.

At the second level, that of semantics, we become less concerned with the inter-relations of signs as abstract entities in their own right and direct our attention to their meanings or their reference. Here we leave the closed world of grammar and connect with things or ideas exterior to the signs, we become concerned with meaning. At this level it is easier to fit visual images into our calculations, for example when the representation displayed by a visual image is obviously its meaning, in other words when it looks like what it is intended to mean. On the other hand, a visual image may bear no resemblance to its intended meaning. That is when it stands as a metaphor, for example a crown for monarchy. But in either case whether it be directly representational or indirectly representational, a relationship has to be established with something external to the actual image as sign. It is proxy for something else, while always remaining as part of a symbolic system.

At the third level, that of pragmatics, we can, as the term implies, make empirical observations of the ways that signs relate to users. We thus find little difficulty in relating this level of semiotics to visual communication; a useful example is that of road signs, where in normal circumstances one can observe a direct relationship between the response of a particular road user to a particular road sign.

Road signs, being contextually bound, provide a good example of the logic put forward by Edmund Leach (1976) in his book, 'Culture and Communication: the logic by which symbols are connected', to explain the meaning of sign. To him, its defining characteristic is that it is bound by context, it bears an intrinsic relationship to others in the set in which it is found. The following illustration, fig 4 (p. 33), of a highway sign in the U.S.A. exemplifies this requirement, it belongs to a particular context , technically speaking a set, that of highways.

Having considered the three levels of semiotics, it becomes apparent that they represent different levels of abstraction, the most abstract being syntactics, and the least pragmatics. Now when we reverse this order we can discern a connection with Piaget's (1928) stages of intellectual development and reasoning which proceeds from sensory-motor involvement, of active exploration, via perceptual involvement typically of a visual nature, to abstraction

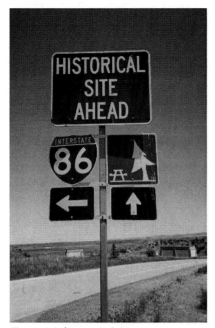

Fig. 4. Highway , U.S.A.

represented by symbolism. Furthermore, when we discount the age-related implications of Piaget's work, we can make an interesting connection with Bruner's (1966) work on instruction in which he proposed that there are three parallel systems for information processing, namely: through action (enactive); through perceptual activity (iconic); and through representation (symbolic). In either case, whether it is the developmental stages of Piaget or the modes of information processing proposed by Bruner, iconicity is placed between action and symbolism. In developmental terms we find there is a progression from physicality to abstraction, with the iconic representing the middle ground. Thus it is a reversal of the order of abstraction which we discussed in our appraisal of signs under the rubric of semiotics, which proceeded from the most abstract (syntactics) to the least abstract (pragmatics), with semantics at the centre.

It is this middle ground, the ground of iconicity in intellectual development and of images in visual communication that provides the main focus of our interest, but it is a ground without clear boundaries, it can set in motion kinaesthetic responses; thus trespassing upon the enactive stage that we have mentioned. While in its guise as metaphor, as a symbolic image, it operates within the higher level of the symbolic as defined by Piaget. Of course, words also carry the same potential to influence a reader or listener at these three levels; for example, by creating feeling, by calling upon imagery, and by their symbolic use as metaphors. But the iconic nature of visual images connects them more closely with the earlier stages of intellectual development.

While we have spoken about developmental stages, it is perhaps more appropriate to view the process as a progression in which the developing individual integrates more abstract modes of thinking within a framework which contains each of the earlier stages. The process could be described as steps in integration; like strata in geology these earlier stages could be considered as an underground presence which exerts an influence below conscious awareness. They are not discarded with development, but more correctly they become operative on those occasions when they are more appropriate for dealing with a current situation. For example, when driving a car information is processed from motor and perceptual inputs, in addition to the symbolic input from conventional road signs. From this it follows that the iconic stage is not left behind but called into use at appropriate times.

There is strong testimony to the residual power of the icon in certain branches of contemporary society, for example, according to a newspaper report in 'The Independent' on 16th November 1990, thousands of people flocked to a Greek Orthodox church to view an icon that reportedly began shedding tears following a special prayer session for peace in the Middle East. Icon veneration can be traced back to the traditions of older Middle Eastern religions (Haussig, 1971) where it was believed that by the law of sympathy the image copied by the hand of the artist was bound to the divinity and partook of its divine essence and was

capable of being communicated to others. Irrespective of the validity of such claims, it is rare to find the printed word, as material form, evoking this degree of veneration. This exemplifies the emotive power of the icon, and its potential for connecting a sign as realism with the body as reality.

Following upon the threefold categories of semiotics and the connections observed with the three stages of intellectual development, we now turn to a more detailed analysis of the nature of signs, with the express purpose of finding how visual images fit into the general scheme of things. Particularly we shall begin to appreciate that the middle ground of the icon has the propensity to trigger-off responses which are more akin to unconscious, unmonitored responses of the stimulus-response variety associated with signal learning, as exemplified in the above reference to icon veneration.

Foundations for a Theory of Signs

The foundations for a theory of signs and their meaning were laid by Charles S. Peirce in the latter part of the nineteenth century and the early part of the last century. To him we owe the use of the term semiotic, which he borrowed from the Greek language where it bears the meaning of the doctrine of signs. The theoretical implications for our study of things visual are profound. It makes possible the beginning of a general theory of signs, and as all communication proceeds from signs, it has the necessary breadth to include not only linguistics but also the whole range of other media, non-verbal, graphical and pictorial. Thus from the work of Peirce the territory of signs received its first detailed mapping, and with it the prospect of an inclusive theory of signs covering such fields as linguistics, social anthropology, communication theory, art appreciation, and indeed any area where signification is sought. However appealing as this may sound, in more recent times Barthes (1968) asserted that while it is true that objects and images can signify, they never do so autonomously, that every semiological system has its linguistic admixture, and that where there is a visual substance the meaning is confirmed by being duplicated in a linguistic message, for example in the cinema, advertising, and press photography. This assertion of Barthes makes no concession to the possibility of visual thinking which Arnheim proposed, and which we dealt with in the previous chapter, nor does it make any concession to tacit knowledge which we will deal with in a later chapter. But it does follow in the tradition of other French writers, notably Lacan and Derrida, where the stress is upon language.

Bearing in mind Barthes qualification we must return to the fundamentals of semiotics before we can assess the broader issues which he raised. In discussing the nature of the sign, Morris (1938) proposed that it possesses three characteristics: (1) that which acts as a sign, meaning the thing itself; (2) that to which it refers, its intended signification; and (3) the effect on some interpreter by virtue of which the thing in question is a sign to that interpreter, in other words, it is known to be a sign and meaning is attributed to it. The third factor highlights the fact that signs are actualised as such only through interpretation. Of themselves signs do not possess meaning, they are merely things, but things to which meaning is attributed by the sender which we call intended meaning, and interpreted by the receiver which we shall call received meaning. Of course interpretation is not always uniform, it may go in a number of different directions according to the individual receiver's interpretative framework which is fashioned on the basis of his or her previous knowledge and experience. Consequently, visual images as signs bear the same fingerprint as all other signs, including words; they are open to interpretation, and for public use they require some form of consensus which is given

in verbal language in the form of dictionaries. And here we may note a major distinction between words and images as communicative devices, whereas dictionaries are available to provide a form of consensual meaning in word usage, the same is not the case for visual images. Their meanings are construed largely as a result of tacit learning, set in social-cultural situations without explicit instruction, and thus they lay themselves more open to idiosyncratic interpretations.

Problems of Terminology

Our task is to set images as signs within the general framework of communication, and as we shall see, the confusion of terms in the literature presents us with an initial problem. For example, the terms sign and symbol are often employed in contradictory ways, or if not exactly contradictory, then inter-changeable. This can be accounted for by the diversity of contributions to the general field of communication theory, ranging from the mathematical theory of communication to that of art theory. In fact, in the field of iconology, which is part of the wider field of semiotics, Gombrich (1971) presents alternative definitions including one drawn from the neo-Platonic tradition of mystery. He wrote, " … in this tradition the meaning of the sign is not something derived from agreement, it is hidden there for those who know how to seek. In this conception which ultimately derives from religion rather than from human communication, the symbol is seen as the mysterious language of the divine." In this quotation it will be noted that the term sign is later replaced by symbol, thus suggesting some kind of elevation to a higher plane. He clarified this later by saying, "if iconology were only concerned with the identification of labels, its psychological interest would be only slight … we follow a different usage that insists that a symbol is more than a sign." Later on a logic will be given which goes some way to resolve this terminological confusion.

To continue with Gombrich, in his work the symbol is elevated to the higher grounds of mystery, to the ineffable, and the sign is relegated to the mundane. Of course we must remember that Gombrich was addressing historical aspects of sign/symbol usage in art, and it is in this context that the foregoing quotation should be understood. Nevertheless, there is need for clarification of terms in order to avoid confusion when crossing disciplinary boundaries. First of all we shall take a look at alternative schemes from the field of semiotics, with particular reference to the icon as sign, drawing upon the work of different theorists.

Semiotic as Logic

From the writings of Peirce, which was gathered together into one imprint by Buchler (1955), we can obtain useful notions of the concept of the sign. According to Peirce, as a philosopher, logic is another name for semiotic, the quasi-necessary, or formal doctrine of signs. His work provides a useful starting point because from here an imprint was laid which others have followed. Peirce used the term sign as a higher order term covering three separate factors which he labelled: icon, index, and symbol, as follows:

<u>SIGN</u> (higher order)
icon - index - symbol (lower order)

It will be seen that, unlike in the neo-Platonic tradition given earlier, Peirce places the sign on a higher plane than the symbol, thus emphasising the confusion of terms when we cross disciplinary boundaries. However, under the aegis of the sign, we shall see what Peirce had to

say regarding the terms icon, index and symbol, and against each term we shall highlight the implications for the visual.

This is what he wrote about the icon, "An icon is a sign which refers to the object that it denotes merely by virtue of characters of its own … Anything whatever, be it quality, existent individual, or law, is an icon of anything, in so far as it is like that thing and used as a sign of it." It is in the final sentence that Peirce provides the significant clue to the nature of the icon, namely that it is like something. This definition presents us with the problem about the meaning of likeness, but quite clearly it involves vision.

In contrast to the icon, the index as a sign is, according to Peirce, that which "refers to the object that it denotes by virtue of being really affected by that object. … In so far as the index is affected by the object, it necessarily has some quality in common with the object. It does, therefore involve a sort of icon, although an icon of a peculiar kind." His use of the term 'peculiar' indicates the awkwardness of his definition. Perhaps the best way of grasping his meaning of index is to take the example which he gave of the rolling gait of a sailor as being indexical of his profession. It is the notion of affect and the implication of action that provides the index with its distinguishing characteristic. Apart from moving images, such as cinema and television where cause and effect is apparent in the action, indexical signs would appear to play little part in static images.

And finally we take a look at the third of Peirce's classifications, the symbol. He said, its "character consists precisely in its being a rule that will determine its interpretant. All words, sentences, books, and other conventional signs are symbols." The distinguishing factor here is that a symbol relates to rules, but noticeably, it includes conventional signs within its ambit. And to this extent icons, when they are employed conventionally become symbols, thus justifying the term symbolic image when it is used in art history, and in those instances where icons have been legitimised into symbols through social or cultural practice.

From the foregoing it is quite clear that icons possess the potential to migrate into the territory of the symbol, that is when they become conventionalised, but the index, although also a sign in Peirce's order of things, is more circumscribed. It lives a life of affect and thus lends itself more readily, as already indicated, to film and television, where affect is an important ingredient. A good example is that of American Westerns where the actor, in his role as cowboy, becomes at least partially indexed to his part by his physical demeanour.

The transgression which we have spoken about between the different levels of signs is of particular interest to our study of the visual, concerned as we are with the iconic, the middle ground between the enactive and the symbolic stages of human development. This Janus-like quality, pointing two ways, produces interesting effects, for example, the veneration of icons, reported earlier, relies on the propensity to endow an icon with living presence, losing its status as sign and taking on, however momentarily, a natural quality. In the other direction, the icon can migrate into the territory of the symbolic when it dons the mantle of convention.

Social Science Perspective

From Peirce, whose concern as a philosopher was with logic as semiotic, we move into the wider territory of culture and communication as set out by Leach (1976), in a book bearing that title. Despite differences in terminology, we find that his work provides a broader framework and greater relevance to our concern with the visual. His overall plan ranges from the most basic signal, which acts as the stimulus in the automatic response associated with stimulus-response (S-R) theory, often referred to as Pavlovian conditioning, to the symbol,

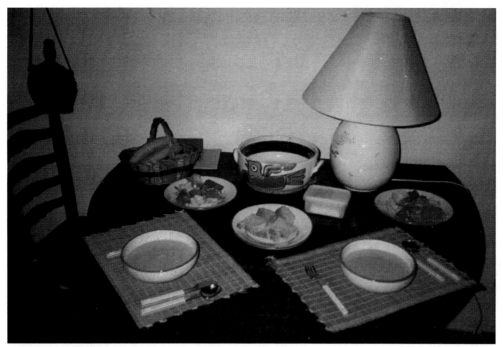

Fig. 5. Table setting.

where associations are made at a more conscious and abstract level. Within this framework we can begin to map the place of visual images and discover their semiotic characteristics and potentials. In Leach's formulation the sign becomes merely one category among others, its special significance lies in its status as metonomy which emphasises proximity and intrinsic relations, a characteristic central to that of vision where elements are always given in terms of proximities. While intrinsic relations exist within verbal modes of communication, it is the contiguity, the spatial relations, that play a special role in visual images, and thus the importance of the sign in visual communication.

The above photograph, which depicts a table set for a meal, provides a simple illustration of the meaning of the sign as promulgated by Leach. The objects depicted are related intrinsically. Meaning is obtained on the basis of this factor. Admittedly there is a cultural element, but this aside, it is the contextual relationships which define the meaning . Technically speaking, we could say that they belong to the same set.

By emphasising the spatial element we bring perception to the fore. One further point may be introduced which gives added weight to the metonymic character of visual images. They exist in frames. They are bounded by the media in which they are carried, and thus they belong to a set, the central requirement of metonomy. And although they may only belong to a unique set of one, a characteristic of paintings, it is possible that by style or typification they may belong to a wider cultural set, for example that of cubism.

A modified form of Leach's schemata is given later. It has been revised in a way which places greater emphasis upon the visual element in semiotic analysis. It begins at the most primitive level of signification, namely the signal, it progresses to the sign, and then to the more abstract level designated as symbol. In following this progression, we notice that the visual

operates at each of these levels; for example, visual signals have to be perceived, signs have to be observed, and in being observed their intrinsic relations are disclosed, thus metonomy is at work; and at the higher level of the symbol, which includes the icon, the viewer is in the realm of the metaphor, of ideas. This involvement of the visual at all levels gives clues to its propensity for eliciting responses across the spectrum of communicative stimuli. For example, a symbol as metaphor can be experienced as metonomy, with a further possibility that it can degenerate into a putative signal, thus carrying the potential to trigger-off automatic responses experienced as emotion. There are many examples of this possibility in film viewing, and it is implicit as an intention in certain forms of religious art, a good example being that of the icon.

Towards Abstraction: from the signal to the symbol
Here we are taken through the steps which lead from the most primitive form of visual communication, the signal, towards the symbol, which, as metaphor, is the most abstract.
 SIGNAL: visual stimuli which produce automatic responses, below consciousness.
 INDEX: visual stimuli which indicate relationships, but do not necessarily effect a
 response.
 They can be of two kinds:
 natural indices, e.g., smoke as an indication of fire,
 and
 arbitrary indices, which can be sub-divided into:
 the sign; a metonymic relationship which is based upon context,
 things belonging to the same set, in juxtaposition, where
 in communication terms, one thing can stand for another
 because they are known to have a proximal relationship.
 The relationship is intrinsic
 the symbol; a metaphoric relationship which is based upon a
 connection with a different set, as distinct from the
 requirement for a sign. The symbol may be an icon which
 bears a resemblance between itself as a signifier and that
 which it is intended to represent, e.g., a portrait of a saint,
 or it may be a conventional symbol which bears no
 resemblance between itself and its referent, for example
 letters which make up words.

Our interest in the sign in this formulation is maintained by virtue of its existence as a signifier characterised by intrinsic prior relationships. Vision itself, in the natural world, is always faced with the perception of intrinsic prior relationships; thus the spatial aspect of vision has a natural affinity with metonymic relations which can be both spatial and temporal. On the other hand, the symbol in this scheme of things is only a symbol when it bears no intrinsic relationship between itself and its referent. In mathematical terms they belong to different sets. It is metaphor.
 Visual images can be employed as signifiers at any level in this scheme of things, which means that their semiotic term can only be defined by contextual analysis, not in some fixed form. For example, an image is a signal when it sets in motion an automatic response; it is a sign when it belongs to a set; and it is a symbol when it refers to a different set from that to

which it belongs. From the foregoing, it will be apparent that an image which elicits no response, either conscious or otherwise, is merely a void to the perceiver. One person's symbol may be another person's sign, or vice versa, and the same applies to the signal.

Furthermore, although in this semiotic formulation we are led from the most primitive stimulus, the signal, to the most abstract, the conventional symbol; the facts are that information conveyed in one stimulus mode may produce an effect characteristic of an earlier, less abstract stage of development. And thus we can account for the signal (stimulus/response effect) which was mentioned in the description of icon veneration earlier in this chapter. The effect may be viewed as a kind of degeneration from stages higher in the semiotic structure to those that are lower. In fact concepts such as sympathy and resonance can be seen to be related to this condition; for example, when an image triggers a response as a physically 'felt' experience. Of course, this is not only a human propensity, it received its most notable demonstration in Pavlov's sign-learning experiments in conditioning of animals, but then life mediated is also subject to conditioning. The following is a diagrammatic representation of this propensity:

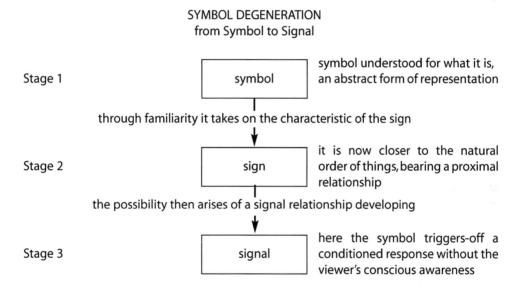

SYMBOL DEGENERATION
from Symbol to Signal

Stage 1 — symbol — symbol understood for what it is, an abstract form of representation

through familiarity it takes on the characteristic of the sign

Stage 2 — sign — it is now closer to the natural order of things, bearing a proximal relationship

the possibility then arises of a signal relationship developing

Stage 3 — signal — here the symbol triggers-off a conditioned response without the viewer's conscious awareness

The Inclusiveness of Vision

Vision is grounded in frames, the forward-looking eye guarantees this. Everything seen is perceived in relationship to something else within the frame of vision. Even a solitary element given against a monotone background is related by perceived contrast within a visual frame. This is an extreme example, normally found only in controlled environments where vision is restricted in such a way that peripheral elements are excluded, but in everyday life vision unifies a vast range of elements in a world of excessive detail, peripheral and otherwise, and it does so without any necessary conscious intent. In fact, vision is called upon to select from an abundance of elements all of which are inter-related. Thus it follows that by its nature vision is grounded in metonomy, in relations observed between items and events within a single visual field, within a set. It is on this premise that the sign, as designated by Leach, becomes central to our concern with the semiotics of communication.

This inclusiveness of vision, in which even the least significant items and their relationships within the field of vision contribute to the image received on the retina, is the natural order of things, the ultimate reality. And it is within this province of excessive detail, of extraneous information serving no apparent utility to the observer, that artists and image makers in general can generate a feeling of reality in their work. This effect receives emphasis in the work of Bryson (1981), who suggested that realism in art requires the presence of the irrelevant as part of its persuasional technique. And further, that it is in the area of excess that we inscribe 'real existence'. This real existence, he considered, lies not in a textual, and thus verbal state of being, but in that part of an image that is freed from such an association. To quote, "The effect of the real in the image insists on setting up a scale of distance from the patent site of meaning which is read as a scale of distance towards the real. Of course, the real is not involved at all, but when the image purveys to us information which is not tied by necessity to a textual function, that information then constitutes an excess, and it is in this area of excess that we inscribe real existence." Further evidence for this point of view can be found in the work on film theory, for example, Andrew(1984), in discussing semiotics and realism in the cinema, was of the opinion that extraneous detail serves to remind the viewer that the event takes place in a world which he knows, and that it is the uselessness of the detail, its apparent banality that makes it familiar and ordinary, and thus seemingly real.

Reality as portrayed here is to be found not in the realm of ideas and concepts, the textual world of sequential logic of grammar, but in the world given in its profundity to the visual sense. This is the metonymic world of vision where relationships through proximity are given without question, but for which answers are sought on another plane, that of language. The facts are that nature exhibits an inordinate amount of information given without gaps in a three-dimensional plane of infinite correlations. It is this analogical quality, this 'flow' across things which are inter-connected that distinguishes the visual from the verbal which is constructed from words, and is thus digital. Of course, there can be a metaphoric dimension to visual images, that is when they signify ideas, for example when they are employed as symbolic images. But even so, what is presented to the eye is given in metonymic form, i.e. in a spatial context.

The reality of nature as perceived by the eye is characterised by inter-relationships in which there are no voids, even an apparently empty sky is an entity which connects. This is the province of the analogue which underscores both natural and artefactual images, it is particularly exemplified in those paintings which leave a trace of the artist's hand movements in executing his or her work. But it is not only in paintings that the analogue is exemplified, it is clearly defined in all forms of photographic representation, as demonstrated by Barthes (1977) in his thesis on the nature of images, both static and moving, in visual communication. The analogue is the area of elision, whereby the semiotics which distinguish culture from nature are suppressed, or if not suppressed, then disguised. It can be a subterfuge for innocence.

The Innocent Territory

The 'shifting sands' that underlie the construction of meaning obtained from images as signifiers, and the potential this holds for triggering responses associated with earlier stages of development, has important and wider implications for our study of visual images. It brings us face to face with myth-making, which is most noticeable in icon veneration. It is this potential that we need to explore in greater depth; the potential of images to naturalise that

which is only artefact, to mimic nature and present a world without any apparent contradictions. This is where myth resides, and it is to the work of Barthes (1973) that we can turn for an exploration of its semiotic roots, with particular reference to visual elements. We can make connections not only with myth-making but also with image-making in general, where possibilities arise for duplicity by faking naturalness. The innocent territory in the above sub-title refers to the apparent naturalness that images can convey, in contrast to the verbal which is more arbitrary. The image, by its nature, involves perception which is founded upon space and time, it takes place in the 'here and now', and in this sense it could be said to gain its innocence, the innocence of presence, the enduring condition of nature, in contrast to absence wherein lie the seeds of semiotics, which is always referential.

However, the making of visual images, in whatever medium, always involves arbitrariness, and with it the loss of the innocence that we associate with nature. Moreover, artefactual images come into existence in particular moments in time, in history, where they are impregnated with cultural habits and techniques. But when these conditional factors are forgotten, or possibly not appreciated in the first place, then the image may appear as naturalised, and thus not subject to contradiction. The grounds of myth are set within this potential. As Barthes suggested, "A conjuring trick has taken place; it has turned reality inside out, it has emptied it of history and filled it with nature." And further, to connect with the theme which we were earlier exploring about degeneration from symbol to signal, "In passing from history to nature, myth acts economically: it abolishes the complexity of human acts, it gives them the simplicity of essences; it does away with dialectics, with any going back beyond what is immediately visible; it organises a world which is without contradictions because it is without depth."

Depth here is to be conceived as a plane in mental space, a space given to a consciousness rooted in abstraction, and thus at a distance from the real world. But it is in the nature of visual images to reduce this distance, to appear less arbitrary than verbal language, and by appearing real, images offer greater potential for deception, or if not deception, then illusion of reality. The ground is hereby set for myth and for the illusion of reality that we associate with pictorial media, particularly film. The critical element here is the fusion of form and meaning, the loss of distinction between signifier and signified, thus making opaque the semiotic connection and offering in its place a surface transparency of naturalness. From another perspective we can connect this state with the signal which becomes naturalised in the stimulus-response (S-R) relationships which was discussed in Leach's formulation for communication. Within his scheme we were able to accommodate various degrees of abstraction between signifiers and signifieds. For a more extended semiotic analysis we need to turn to the more specialised field of semiotics, particularly to the work of Barthes who, although doubting the legitimacy of images to stand independent of language, nevertheless provided a valuable logic for their place in the act of signification.

Signification: from Denotation to Connotation

In following the work of Barthes we find that he uses the term sign in a particular way, as a middle term between signifier and signified. In reading this section the reader needs to bear this in mind, in view of the discussion previously presented on the confusion of terms that we find in the literature on semiotics. Signification, as discussed by Barthes, involves three terms: signifier, sign, and signified. It takes place when a signifier (word, image, or object) raises to consciousness a particular thought or idea which becomes, to that person, the signified. The

sign, in this scheme of things, relates to the fusion which takes place between signifier and signified, it is not an entity. In linguistics, the signifier is the sound of a word 'heard' mentally, and the signified is that which is raised to mind by this act. The sign is the fusion of the two. However, our brief takes in the wider semiotic field which is not restricted to words, but covers images as signifiers in all their mediated forms, graphic, pictorial and filmic. In either case, the middle term sign refers to the relation, connection, or association between a signifier and signified. In this scheme of things the sign is always a mental event, never material; and because it is a mental event, it is always an individual act in which a person creates meaning in terms of his or her own mental frames of reference. One might say that in this formulation the sign is the meaning. This is a point which we will be dealing with in more detail in the next chapter.

The relationship about which we have just spoken may be based on events occurring naturally, for example, the storm clouds which betoken rain; in which case, the relationship is referred to in the standard literature on semiotics as being unmotivated. On the other hand, when the relationship is fixed arbitrarily by human convention, that is when it is contrived, it is defined as motivated, for example, the relationship between a word and its meaning, excluding onomatopoeia. However this polar distinction between signs motivated and signs unmotivated provides a too simplistic analysis for our concern.

The signifiers that cause sign relationships which emanate from art images are never completely natural, there is always some human element in their construction, and thus they are always to some degree motivated or arbitrary.

It is perhaps useful to inform the reader that the terms motivated and unmotivated have a special and restricted meaning in semiotics. For our purpose, it would appear to be more fruitful to leave aside the binary classifications of motivated and unmotivated and to consider the scaling of visual images by degrees of similitude between signifier and signified, ranging from almost complete identity to an absence of likeness, for example, trompe l'oeil to schematic diagrams of metro systems. What we may observe is that the common quality of images is that of analogue, a quality ideally suited to 'slip' across scales and the artificial boundaries of the digital. Nature revisited with varying degrees of similitude.

However, this very facility creates its own problems, not only in specifying degrees of similitude, but also by its presence at two distinct levels of signification; denotation and connotation. The image as analogue has its foot in both camps, and thus it can masquerade as a denoted image when in fact it has undergone arbitrary modifications which place it more correctly into a coded, connoted form. It is the apparent naturalness that images as analogues possess that makes possible this hidden deception, a deception that is not necessarily made with bad intent, as for instance the act of retouching photographs to enhance desired qualities or contrasts. The work of Barthes on photography and film makes a valuable contribution to our understanding of the semiotic factors which surround image-making in general. In particular he emphasised the dual role of images in denotation and connotation, which can be expressed as follows:

Sr	Sd	
	Sr	Sd

a first-order relationship, referred to as denoted

a second-order relationship, referred to as connoted

where Sr = signifier (image) and Sd = signified (idea)

It will be seen in the above illustration that the relationship established between the signifier (Sr) and signified (Sd), at the denoted level is subsequently employed as the signifier in connotation. It shows that in the act of signification denotation is primary to connotation. It does not necessarily rest on established codes. In fact, it provides the foundation for the establishment of codes. Conversely, connotation relies upon the prior existence of denotation, it always works in the borrowed territory of the denoted. We could say that the building blocks of connotation are those of denotation. But here is the rub, the analogical qualities of images means that whether they are employed to denote or connote they retain an impression of belonging to denotation, a relation closer to the natural order of things and hence reality. For example, a photograph is like a person to the extent that one does not need a code to understand that it refers to a human being.

The paradoxical nature of photographic images was expressed by Barthes as the co-existence of two messages, the one without a code (denoted), bearing analogical properties, and the other with a code (connoted), the art or the treatment involved in its production being seen as a form of coding. Images as analogues give the appearance of being value-free. But, as anybody familiar with image-making will readily appreciate, techniques and cultural styles influence the form which they take, and thus their surface innocence may conceal a variety of codes of production and cultural stylisation. These are semiotic issues, but images constantly draw us back to perceptual considerations; for example, the power of the photographic image resides in the feeling it can generate of having belonged to a real moment in time and in a real space, the two fundamentals of perception.

Variability in Interpretation

Whether we are dealing with perception or semiotics, it will have been noted that the concept of relationship is always foremost. The intrinsic relations of images are metonymic, that is, they bear spatial relations in a context, things are in juxtaposition, while those of metaphor are non-intrinsic, carried only on the basis of mental connections. As stated the common ground is one of relationships, but what we can observe is that while relationships predicated upon denotation are relatively uncomplicated, those of connotation can be manifold. In effect they can lead to third and subsequent orders of connotation, for example when one thought leads to another, and so on. The viewer has his or her own repertoire of memories which can be scanned, figuratively speaking, to produce infinite connotations from an image which is denoted.

In terms of audience viewing, it will be seen that the possibility of variability in interpretation is increased when the audience is drawn from different cultural or sub-cultural backgrounds. In such a situation, familiarity with the social codes portrayed and the codes used in the production of images is not always uniform; and thus there is increased likelihood of difference in interpretation between its members. On the other hand, even within the mind of one individual person, circumstances can create alternative forms of interpretation; for example, when current interests or motivation cause a person to focus upon certain aspects of an image, and thus set in train a different route of connotation than would be the case at another time. This emphasises the fact that although the semiotic world of signs, symbols, and conventions is given in a social context, it is always processed at a personal level.

Summary

In this chapter we have dealt with semiotics in a way that emphasises the visual component; and throughout we have been made aware of the fact that mediated visual images, while

being artefacts, have close affinity with perception. Thus they belong to a kind of halfway house between nature perceived and pure abstraction. Particularly, we have noted that images, as analogues, possess a kind of fluidity that is best measured in relative degrees, rather than by absolutes, except of course in their guise as metaphor, in which case the reference is to concepts. This apart, it is apparent that there is not always a clear distinction between an image as form and its meaning; this is best exemplified in mythology where no distinction is made between an image as artefact and its meaning. The image is consumed by nature. But it is not only in mythology that this effect can occur, on a lesser scale it operates whenever an individual is emotionally disturbed when viewing images, particularly this is so for moving images. Whether in rituals or film viewing a visual input can be transformed into a sympathetic response of a visceral kind.

On a more technical note, the reader will have observed that throughout this chapter he or she has been faced with contrasting definitions of signs and symbols. This can be accounted for by the variety of contributions from different disciplines, nevertheless there exists a need to rationalise these differences, and it would appear that the scheme offered by Leach has the most merit. For example, it develops logically from the least to the most abstract form of signification, and it has the advantage of being functional, which means that context can be used to aid definition.

And finally, access to the semiotic world of codes and conventions, signs and symbols, including visual images in all their manifestations, pictorial, graphical, static and moving, is by way of learning, sometimes overt and sometimes covert. Techniques and styles in art and in all forms of image making are subject to learning, which is given in a social context, but processed at a personal level. These two factors, social and personal, provide the basis for our continuing enquiry as we progress to a consideration of the ways in which information is processed and meaning is obtained.

3

'IN-FORMING' AND MEANING

To live in the world requires constant updating of natural signs communicated to the visual sense, it is a state in which perception is constantly modified, or, it could be said, re-patterned. However, as we saw in the last chapter, to live in the world is to be engaged also with social, arbitrary signs, or more correctly signifiers, which act similarly to modify or re-pattern perception, although in this case there exists the necessity of the receiver as viewer being familiar with codes and conventions. In either case, whether it is by direct perception or indirect perception, the result is that an individual is to some degree changed by the experience, that he or she becomes aware of something different, be it factual or ideational, on the receipt of information. This awareness of difference is the source of new knowledge, often known only tacitly, which manifests itself as a modification or re-forming of a person's mental framework.

In writing about difference as being the source of information, Bateson (1980) used the term 'news' of difference, by this he did not mean news in the normally accepted sense, but that which is meant when we say, 'that is news to me'. It is a personal issue, news to one person may not be news to another. What we are getting at is that news does not reside in material; the material, we might say may carry the potential to influence the thoughts of the reader, listener, viewer, but it is only news when the recipient is in some way changed by the event. In this way of thinking news relates to a change in mind, to a re-patterning of an inner representation brought about by difference perceived between the mind's current state and an external input, which could be from a variety of sources. Without difference there is no possibility for modification of thought, and hence no learning, and thus no information.

Information is, by this definition , always concerned with something, which may be an idea or a connection, not previously known to the recipient, but carrying the potential to be known which, when it is known, manifests itself as a modification to an existing framework of knowledge. The framework, one might say, is re-formed, or better still for the purposes of this chapter, 'in-formed'. What is being stressed here is that information is about change or re-arrangement at the mental level; correctly speaking it is only information when it acts upon an individual mind, and by so doing, broadens the recipient's repertoire of mental connections or relations. By this definition, information is not substance, it is a relationship not located in time or space, it is an idea of a connection or association, it is a figment of the mind.

In the case of direct visual perception information manifests itself as change in current awareness, while in the case of indirect perception it manifests itself as change in knowledge.

This process of change is always one of ordering, or re-ordering; it is fundamental to all creative acts which, as on-going processes of change, feed upon random, that is unstructured elements, and proceed to give them form. However, the act of informing is always a singular activity, a straight act of perception in the first case, and an act that involves social or cultural decoding in the case of mediation. This being so, we can appreciate that visual communication presents a special problem as an agent of information, because it may involve both perceptual acuity and knowledge of codes. It is a situation where the mind can be engaged in the dual role of attending to surface distinctions given to the visual sense, while at the same time being called upon to process coded elements. And furthermore, the codes may require knowledge that is not formally instituted in society in general, but possessed more by those with particular training or education.

This brings us back to the issue of difference because, to the initiated, subtle perceptual differences in an image can be noted, and codes of production understood, thus presenting a full appreciation of art as artefact; while to the uninitiated, the opposite is the case, which is expressed as incomprehension. This is a state often to be found and expressed by people when viewing contemporary art, a condition compounded by the fact that in this instance the codes themselves are often in a state of formation. However, the situation is not always as extreme as this; for example cartoons, line drawings, and schematic diagrams make small demands on perceptual acuity; by arbitrary choice their originators reduce or eliminate subtlety in surface variation, and thus direct attention more towards the idea or ideas which they are intended to represent. It could be said that they attempt to capture the essence of things.

However, for a deeper appreciation of images as vehicles in the communication process, it is necessary to consider information not only as a commodity or a material signifier, but also in terms of effect. In so doing, we shift attention from the image, per se, and focus upon its interpretative power, which is limited by the individual viewer's existing mental framework or pre-disposition. Accordingly, its influence is unlikely to be uniform when its audience is composed of individuals with different experiential backgrounds and knowledge. It is against this background of possible audience variability that the artist or image-maker, as communicator, has to contend. This leads us to consider two separate executive aspects of communication: firstly, the artist as executor expressing through his or her work some particular intended meaning; and secondly, the recipient viewer who gives meaning to the image in his or her own terms, which we may call the received meaning.

By introducing executive concepts, our discussion moves into wider areas than those formally prescribed for semiotics. Our attention shifts to the dynamics of interpretation which takes us, among other things, into the field of information processing. This gives us the opportunity to consider visual communication as an active process in which both the originator and the receiver play separate parts, which may, or may not, result in shared agreement about the meaning of specific images. Before we discuss the deeper significance of meaning, we need first of all to look in more detail at the concept of information, particularly by focusing upon the characteristics of images as signifiers and the interpretations which they institute in individual viewers. It is an interactive process between, on the one hand, images which vary in the demands they make upon perceptual acuity and familiarity with codes and symbols; and on the other hand, the viewer's mental 'resources' for processing the material image which is presented.

This, as we shall see, takes us into an ever widening circle which embraces both the material form of the image and the mental form that it elicits. We are on the grounds mapped by

Kandinsky (1979) as the 'outer' and the 'inner', whereby the work of art as image mirrors itself upon the surface of consciousness. We are also on the grounds of symbol formation which was conceived by Werner and Kaplan (1964) as involving two factors; the external, material nature of the symbol, and the inner, cognitive structure with which it is endowed by the recipient. In both cases, we are concerned with two aspects of 'in-forming': firstly, the shaping of the material image, which is constrained by the limitations of the media by which it is carried; and secondly, the patterning of the human mind, which is constrained by its previously established network of relations.

More fundamentally, it is a fact that the human brain is limited in its capacity to deal with information, the limits being set by neuro-physiological factors. Over time and through experience the unfamiliar becomes familiar, and thus the demands made upon its limited information processing capacity are reduced. When this happens, when the unfamiliar becomes familiar, we speak about 'redundancy', in Bateson's terms it is no longer 'news'. In effect it is the opposite of information, as that term is used in information theory. This applies whatever the medium of communication. Consequently, an image which offers no 'fresh food for thought', like a letter already read, can be said to be redundant; while those that serve to fashion new thoughts or insights, can be said to carry information. The essential point is that in either case the criterion for distinguishing between information and redundancy is based not only upon the material image, per se, but upon its effect. It is quite possible that information to one person is redundant to another, and vice versa. Furthermore, within any one individual, information is transformed into redundancy when it is integrated into his or her mental framework; in common parlance we say that a person has learned something, be it an idea or a fact.

The important point is that viewing images is a dynamic act in which individual differences in interpretation abound. A shared or common interpretation invariably requires a shared or similar background of experience, knowledge or education. Furthermore it is never perceived in pure innocence, its reception in each individual case takes place against an existing mental structure which itself is modified or strengthened by experience; it is an ongoing process. It is only in relation to such a structure that we can speak about information and redundancy, thus it is always a personal statement. In relation to visual images, we may analyse their potential as vehicles for carrying information, but correctly speaking, their determination can only be fully understood when allowance is made for the individual viewer's mental framework.

We have emphasised the dynamics of information, and now we must proceed to inspect the potentialities and limitations that surround the shaping of material images which are the source of information, and the psychological factors that play a part in shaping their interpretation. But first of all we should take note of the different levels at which information can be processed, and attempt to establish the place of the visual image within this wider framework.

Levels of Processing
We have been alerted to the fact that there are distinct levels of processing; namely, perceptual processing in which the eye is engaged in detecting differences within the observable form of the image, and semiotic processing, which calls for the deciphering of cultural codes, for example images given as metaphors, and the conventional styles through which they are portrayed. The processing of pure perceptual difference, of differences given

to the eye is closer to life as nature, as fact; while, conversely, the processing of the semiotic is derived from life as convention, which is closer to fiction. Hence the power of the image which can utilise the potential of parallel processing found in its involvement with perception, and serial processing which arises through its involvement with symbolism, whose ground is that of language.

However, such a clear distinction is more apparent than real; images with their strong attachment to visual perception carry a surface level innocence which, to the uninitiated, can blur the fact that they are ground in convention through styles and means of production (Barthes, 1985). The perceptual and the semiotic being carried in the one vehicle, the image, means that attention may shift from the aesthetic of the form to the significance of the symbol, and vice versa. Thus, in contrast to verbal communication, attention can be divided and indeed fluctuate between the image as form and the image as code. This is a concept that we shall explore more fully later in this chapter. In the meantime, we can extend the notion of levels of information processing by reference to the work of Berlyne (1984) whose experimental work in the field of information processing in aesthetics gave additional, if restrictive, analyses of works of art.

According to Berlyne, a work of art can be analysed as an assemblage based on four distinct categories of information:

Semantic information - characteristic of an external object.
Expressive information - psychological processes within the artist.
Cultural information - cultural norms.
Syntactic information - characteristic of other elements of the same work.

From this categorisation of Berlyne, we have grounds for analysing the information content of visual images from a wider field than the two-way analysis given previously as perceptual and semiotic. Inspection of this scheme reveals that from the field of linguistics Berlyne omitted pragmatics, while retaining semantics and syntactics. Taking each information source in turn, we may expand the relevance which they hold for the analysis of visual images.

Semantic information refers to the intended meaning of the image, its referential aspect, the idea or thing it points to; it could be said that it holds a third party in its sights. This is exemplified in road signs which are intended to 'carry the mind' to some significance beyond their material presence. And, of course, all images, including cinematographic images which 'take' the viewer into thoughts of other things or ideas, are in this sense carriers of semantic information. This includes symbolic images in their role as metaphors which signify particular meanings of a literary kind.

Expressive information refers to that aspect of the image which conveys, or at least is intended to convey, information about the emotional feelings that lie behind the generation of the image. We may say that it is intended to 'in-form' the viewer about the emotional or psychological state of its creator. It is worth noting, however, that much as we may wish to know or to appreciate the emotion which an artist desires to express, it is a fact that emotion in others is only ever known by inference, although admittedly it is possible to make fairly accurate guesses about psychological states from the behaviour of people in real life situations. However, caution is necessary when inferring expressive states on the basis of visual images, because the artist is one step removed from the viewer, it is the medium, not the artist which is observed. Furthermore, the image itself is constrained by the materials

through which it is created, and thus pure expression can never be fully realised, only suggested.

Cultural information conveys knowledge about the codes and conventions that inform visual images; it focuses not upon the artist but upon the social-cultural conditions under which it is produced. Moreover, it gives clues to the viewer about historical and geographical characteristics; for example, the style of Chinese paintings guides the viewer into an oriental perspective, while the style of Italian Renaissance paintings suggests a European historical perspective. Other examples suggest themselves whereby place and time are contiguous within the same image, for instance, the American Cowboy film located in the west of the U.S.A. at the time of the expansion of population into that territory.

Syntactic information refers to that aspect of the visual image which 'in-forms' the viewer about its elements and their juxtaposition. It assumes a restricted vocabulary of forms contained within a common pool and their interplay. To the extent that syntactic information is restricted to a particular set of elements or images, it shares similar traits to the grammar of language. Significantly, this is the source of information most clearly connected with pure aesthetics where the focus is upon relationships between and among the elements as substantial entities in their own right. A good example of this is to be found in the later work of Mondrian.

The above four categories provide useful analytical tools for describing the extent of information processing which an individual image, or images in the case of cinematographic viewing, can set in motion. While it may be possible for an image to offer information at each of these levels, it is quite possible that satisfaction can be found at just one level, for example the semantic when viewing film, or the narrative suggested in a painting. However, whatever the level, human information processing of visual images is always an individual act which is based upon two main factors; these are the complexity of the image, and the resources that the viewer brings to the task in terms of existing knowledge. From this it follows that an image which possesses some familiar characteristics to a viewer, on any of the levels previously mentioned, is less demanding and more likely to find access within an existing mental framework. We are now in a position to look separately, and in more detail, at the two principal components of form-making in visual communication, namely, the creation of the material form of the image, and the generation of a mental form in the mind of the viewer.

'In-forming' the Material Image

All images as artefacts have, of necessity, to be given form, thus they are never absolutely value-free. Image production is a form-making activity which is subject to a variety of constraints. The materials themselves constrain the artist in his or her intentions. As is the case with language, constrained as it is by grammar and vocabulary, each medium has its own limitations or possibilities which the artist has to learn. And unlike language, it is a task where competence is gained more through tacit learning than through overt instruction. Furthermore, the social and cultural conditions which surround the artist contribute additional constraints, these include historical factors which bear upon the image creator as a kind of unseen presence.

Therefore, within this broad framework of external constraints, it is clear that an artist is never an entirely free agent, particularly when his or her intention is to communicate with a wide audience. In this situation, the grammar or vocabulary of forms that make up the image has to be that of a convention clearly established in the viewing public. Nevertheless, despite

the negative influences which constrain originality in its material manifestation, the permutations that are possible in the creation of form in a single image, let alone a series of related images, appear to be boundless.

Task of the Image Maker

The formation of images involves an interplay between tools and materials; irrespective of the skills of the artist, they make their own demands and cause outcomes specific to themselves. For example, an etching is always quite distinct from a painting, and a colour film is likewise distinct from black and white, even when the same artist is engaged in either medium. The image maker's task demands familiarity with the scope and limitations of tools, which is here intended to mean anything from a paintbrush to a camera, also with the possibilities afforded by the chosen materials. It is against this background that visual images are realised; where selection is the essence; the selection of tools, of materials, of contrasts, of tones, of colour, etc. It is an intellectual activity, over and above the skills that it demands. Our interest centres upon the image maker as form maker and communicator, and the viewer as receiver, both of whom, in their separate ways, are engaged in making selections, of giving form or perceiving form within a restricted set of alternatives.

Complexity

Within one frame, images may contain a vast amount of information, for example in the work of Hieronymus Bosch; or a minimal amount, for example in the work of Mark Rothco. Furthermore, within the one image the viewer is at liberty to seek information at each or all of the levels that we mentioned previously. However it is possible, as is the case with minimalist art, that the viewer as observer has not developed the necessary facility for operating at the required aesthetic level, in which case the image appears meaningless. On the other hand, the same image may carry a substantial amount of information to those versed in its construction. It is possible, however, that an image may be dense on both levels, the semantic and aesthetic; for example, in Italian Renaissance paintings.

The complexity, and hence the demands on information processing, is governed by the overall pattern of relationships in an image, semantic and aesthetic. From this it follows that when relationships are not perceived within the image, the viewer has less to consider, or technically speaking, less to process. And when this is the case, the comment 'I can see nothing in it' is often expressed. However, from the standpoint of the image maker, complexity can be generated in a number of ways, for example the medium itself can be used in varying degrees of complexity; for example by subtlety of tone and colour contrasts, and by sensitivity of line. Furthermore, attention to fine detail, as for example in realism, creates complexity in terms of the demands it makes upon the apparently irrelevant. Complexity is often deliberately reduced when viewing time is restricted, particularly when it is necessary for the viewer to obtain immediate comprehension of the image, for example when perceiving road traffic signs, in which case, the image is generally reduced to those elements which are absolutely essential to its intention. Here the designer is aware, if only tacitly, of the need to keep the demands on information processing to a minimum. In film-making, the technique of zooming-in can be considered as a device which, by excluding information and centring upon significant detail reduces complexity, and thereby the demands on information processing. Many other examples of controlled reduction of information can be proffered, for instance, schematic diagrams, cartoons, and the like.

Cues

Another common method of reducing complexity is by the introduction of cues. We are here concerned with visual cues, but as is the case with film viewing, cues are often given via other sensory channels as reinforcement of the visual, for example, the use of sound to create mood, or to arouse visual attention for specific items or episodes. The raison d'etre of cues is to direct attention by providing markers, and thus to guide thought in specific ways. When placed within an image, they are intended to reduce the choice of alternatives that the viewer would otherwise face; in the language of information theory they are information reducers. Moles (1968) suggested two ways by which information may be reduced; by reduction in the number of elements, and by increase in redundancy through increase in predictability. While this is interesting, there are many other cueing devices for decreasing the informational demands that images may create, for example, by the use of colour which highlights a particular point of interest, or by fading irrelevant detail. Furthermore, the image maker has at his or her disposal a range of conventional cues, such as the oft repeated use of black to mark a sinister personage in western films, of stately homes to give illusions of grandeur, of type faces that suggest a particular culture, for example the Gothic type face to suggest Germanic culture. Symbolic images may be seen in this light, they represent pre-packaged forms which require no fresh processing. But to be effective, it is essential that the viewer is familiar, even if only tacitly, with their metaphoric meaning. Nevertheless, they do represent a store of readily organised forms carrying sufficient redundancy for them to be processed with less effort.

From the foregoing it is apparent that the task of the image maker in the field of visual communication is constrained on two significant levels, firstly by tools and materials, and secondly by codes and conventions. And the base is narrowed further when the audience is prescribed within a particular cultural set. We have painted a picture of the originator of images as a person concerned with choice in a number of ways; while this provides some insight into the creative or productive aspect of image-making, it is only one side of the process of visual communication. The other side, that of the viewer, has its own complications, which to a large extent can be exposed for analysis in a clinical way by applying the fundamental concepts of information theory.

The Viewer as 'In-former'

Viewing images is a dynamic process, but it is constrained in a number of ways; firstly, by the brain itself because of its physical limits; and secondly, by social or cultural factors which, through experience, give a particular bias to the way in which the world in general and images in particular are perceived. These secondary factors can be visualised as filters which give shape or form in pre-determined ways to incoming visual impressions. It should, however, be pointed out that viewing images involves a substantial amount of conscious or subconscious activity, which may manifest itself at a physical level as emotion; for example, the emotion generated by images which have the power to recall earlier feelings of pleasure or displeasure. As Berlyne (1960) pointed out, it is in the communication of evaluations that art as images can be distinguished from other forms of communication. It is a form of communication in which the audience's attention is often drawn to affective values, of feelings which the artist as creator desires to share with his or her audience. However, aside from emotive evaluations, there are a range of other factors which we need to bring forth in more detail in order to cast light on some of the hidden dimensions of viewing. To do this we

can usefully borrow ideas and concepts from skill theory, which utilises ideas from information theory and psychology. Our purpose is to use such ideas to highlight critical factors that help shape or 'in-form' a particular interpretation.

a) the viewer's capacity
It is readily understood that at every single moment we cannot attend with equal intensity to each facet of information which presents itself to our visual sense. The eye has its limits, and the brain likewise has limitations for processing the totality of stimuli given to perception. However, through experience the initially separate stimuli which go to make up a particular perception are grouped into more manageable wholes, and thus their magnitude is reduced into coherent forms, which has the effect of reducing the demands on mental processing. It is a process of schematisation, which accords with Bartlett's (1932) ideas on remembering, a process in which structure is mentally created from elements which are initially separate. We can apply this analysis whether the input is derived from direct or indirect perception. Thus, in giving structure or 'in-forming', relationships are created which have the effect of reducing separateness, and hence reduce the demands made upon mental processing.

Therefore, although there are neuro-physiological limits to the amount of visual information that can be processed at any one time, there are, nevertheless, ways in which such demands may be reduced. Particularly, as we have just noted, the propensity to group separate elements into wholes, for example the perception of a rainbow as a single element rather than a range of colour bands. In this way, the world is reduced from a profundity of atomistic dimensions into greater wholes which accord more with the limited processing capacity of the human information processing system. The world is thus schematised and given in a symbolic form which is always a reduction of that which it represents. Here we can detect a similarity between visual processing and the task of the image maker, both are engaged in schematisation, both are engaged in reducing the 'world' into manageable forms. But while it is a fact that all people are limited in their capacity to deal with the totality of visual stimuli, it is also a fact that with experience people generate additional schemata for dealing with it. For example, the development of visual perceptual skills rests upon the ability to group initially separate perceptual information into some systematic whole, likewise the 'reading' of visual images invariably demands that the beholder perceives relationships that give order and thus form, which if not perceived, may be puzzling or inconclusive to a processing system that searches for solution or meaning.

We have established that all people, as viewers, reduce the 'visual world' in accordance with perceptual schemata, but herein we can appreciate that personal experience of the 'world' as fact and symbol is not the same for everybody, that differences in schemata are likely to arise from social and cultural influences. Hence the differences that may emerge in the comprehension or lack of comprehension between people with different experiential backgrounds when faced with an identical image or images. In such a situation, we may observe that one person is 'overloaded' with information, unable to see order, while on the other hand, another person may have sufficient spare processing capacity, owing to redundancy, to be able to create an acceptable order from the same visual stimuli or image. In technical terms we may say that the latter person possesses the necessary schemata for dealing with the situation. The difference could be ascribed more to social or cultural influences rather than to some inherent genetic cause.

b) the viewer and information load
We can now see that the concept of limited capacity, while interesting as a statement of fact, fails to explain the wider issues which bear upon the individual viewer when faced with images that require interpretation. Why, we may ask, are some people perplexed and others not so when confronted with certain images? Why, we may also ask, are some people bored while others are enlivened by the same image? And furthermore, why should a particular image 'overload' one person's processing capacity, and yet be comfortably within the range of another person?

These questions are often answered simplistically in terms of motivation or interest. While such a reply may satisfy a first approximation, it fails to grasp the complexities of the nature of 'in-forming'. As we noted earlier in this chapter, there are different levels of processing, each one of which may provide a kind of satisfaction to the viewer, and each one of which can be a source of perplexity or overload, to use the language of information theory. Perplexity can arise from an inability to perceive an acceptable order, whether it is of surface details or symbolic elements in an image. This condition can stem from the fact that the viewer does not possess the necessary schemata for making sense of the incoming visual impression at either level of appreciation.

We need also to consider the related issue of boredom which may arise when the viewer does not possess the necessary mental schemata to make sense of an image; or conversely, when he or she is overfamiliar with the contents of an image, thus leading, in information theory terms, to excessive redundancy.

It is apparent that 'reading' images requires the existence of suitable schemata, without which perplexity or boredom are possible outcomes. In either case, we come face- to- face with the issue of over-load, and its opposite under-load. However, while these are useful concepts, they only have value when applied in specific circumstances. For example, given the same visual image as a stimulus, one person may be over-loaded and another under-loaded in terms of the demands made upon mental processing. While a third person could be in the more intermediate state of being neither over or under-loaded, in a state of healthy arousal.

c) the viewer and selective attention
We must now turn our attention more specifically to another means of making manageable the vast array of information that is given to the eye, the process of excluding or filtering out information that is not perceived as essential to the beholder in purposive viewing. As we are well aware, it is not possible to give equal attention to all the sensory inputs that are presented for processing. In viewing we are called upon to scan the visual field, and in so doing we have to select, to scan in particular directions rather than others. The resulting mental image is thus composed of specific or choice elements abstracted from a range of alternatives. We are referring here to selective attention, the purposive act of concentration upon certain aspects of the visual field, whether it is the limited field of indirect perception, or the wider field of direct perception. The certain aspects mentioned here are those that give clues to underlying schemata, they arise as a result of acquired knowledge of which the viewer may be only tacitly aware. There are marked similarities here with the acquisition of perceptual skills which require at least tacit awareness of significant elements, by this is meant those aspects of a skill which must be noted and attended to rather than peripheral elements which carry less importance.

Selective attention, being a personal act, displays an individual's motivation, it also gives some indication of a person's aesthetic sensitivity or awareness, for example when the choice of focus is upon the form of the image rather than its content. There may be, of course, opportunities for vacillation between form and content, but here again selective attention is at work. However, it is essential to be reminded that a 'skilled viewer' will seek out significant cues which aid predictability and thus render less demanding the processing that accompanies visual perception.

d) the viewer and anticipation
We have seen that the ability to predict aids the selective process which accompanies visual perception. To predict means to anticipate or forecast events, it goes ahead of current events, and in going ahead it gives advance notice of order to follow. Thus the surprise engendered by random elements is systematically reduced and redundancy is introduced and over-load held in check. For our concern with art and images we can begin to appreciate that there is a connection here with the rules of composition which set limits to the possibilities that can occur within the frame of an image. They enable the viewer to anticipate, to set limits which work as advance organisers and thus lessen the demands on information processing. Gombrich (1984) regarded this as a human propensity to search for regularity, which is given its highest expression in art. There is a parallel here with music which, through its rhythm, manifests pattern or regularity that is satisfying to the sense of anticipation.

In speaking about anticipation it is easy to envisage its place in the scheme of things when viewing moving images, which, by their very nature are time bound, holding the prospect of things to come. But what is less understood is the anticipatory nature of viewing static images which also includes a time element owing to the scanning that is involved. We scan with expectations, with established schemes for making particular kinds of sense, and there is always an element of anticipation in viewing static images. We envisage anticipation as a framework from the past which gives a kind of particular forewarning or guidance to unfolding perceptions, a framework bearing not only sensory qualities, but imprints of socio-cultural conditioning.

We started with the concept of 'in-forming', of the viewer giving form to images presented to vision, and we have seen that the resultant forms are shaped within a restrictive set of circumstances. The form we have in mind is the form in which the brain aligns itself in the presence of a particular image, and we have seen that this can differ among individuals. This leads us to the next step in our enquiry, the meaning of images, and we shall see that there is close correspondence between meaning and mental form. In fact the claim will be made that they are one and the same thing.

Meaning
We began this chapter with the intension of utilising concepts from information theory in order to further our enquiry into visual communication, with particular reference to the concept of 'in-forming'. In its strictest, mathematical sense, information theory is not concerned with meaning, per se, but with quantitative measures regarding the limits and amounts of information that can be transmitted in a given channel or medium of communication. We are aware that both mechanical and human means of communication are constrained in the amount of information that they can process or accommodate at any given time, and to this extent a good case can be made for drawing an analogy between

them. However, while this line of enquiry produces some useful insights into the complexities of viewing, of redundancy and overload, it fails to come to terms with the concept of meaning. In terms of visual images, it is not unusual to hear the expression, 'What does it mean', or 'I can't see anything in it, it means nothing to me'. These are questions left untouched by classical information theory, and yet they lie at the core of human communication. To ask a question about meaning is to raise the issue of evaluation, it involves the concepts of intention and interpretation, concerns which go beyond the physicality of the message whether it be word or image, and beyond the processing that they require.

Nevertheless, although meaning resides outside the physicality of the image, it is always associated with form or relationships. It has been expressed as the organisation of thought (Mackay, 1969), or the patterning of thought (Langer, 1942), both definitions relate to the concept of ordering, or in our terminology, 'in-forming'. On inspection we may detect that in visual communication 'in-forming' takes place at three separate levels, (a) at the level of the sender/image maker, (b) at the level of the receiver/viewer, and (c) at the level of convention, both social and cultural. It is possible for a particular image to produce common or agreed meaning at each of these levels; for example, when the sender and viewer give the same meaning to an image, and when such agreement corresponds with certain established norms of society or culture. On the other hand this may not be the case, there may be lack of agreement across each of these levels. This is an issue that we need to pursue in more detail, we need to seek out the correspondence, or otherwise, between the intention behind the form constructed by the sender/image maker, and the form that it evokes in the mind of the receiver/viewer. Furthermore, we must consider the correspondence with the third arm of the triangle, the conventional meaning which issues from society. This third factor raises specific problems regarding meaning, because, unlike the verbal, there are no standardised references for visual images.

However, by utilising the work of MacKay (1969) we can create a strong conceptual base which allows for analysis of meaning at the three levels which we have just mentioned. We shall see that at each level meaning is bound up with form; the form created by the sender, the mental form it evokes in the mind of the receiver, and that given in society in the form of conventions to which sender and receiver can make reference.

Intended Meaning

In any message the medium by which it is conveyed has, of necessity, to be given form, this applies with equal validity to words or images. But the uniqueness of any particular image is an outward expression of the intention of its creator, who is constrained by the medium of his or her choosing, and by the limits or reserves of his or her imagination. Within these constraints meaning is constructed, it is an active process, one of organisation, of creating relationships which make manifest an intended meaning. It is purposive, and its purpose can only be effective as communication when it manages to organise the thoughts of the recipient in the direction desired by the creator/originator. But although we may speak about intended meaning, it can only be inferred from the image, its true intention rests in the mind of its originator in the form of an idea, and thus its revelation as a material image is rarely identical to its conception as thought.

So here at the outset we become aware that the medium can interfere with the intended message. Perfect communication is probably impossible, but that does not mean that sufficient communication can never be achieved. What really matters is that the sender and

the receiver of a message should have in common sufficient mental images to ensure that the essential message at least is received as intended. In communication theory this is known as common codes, which for our interest in visual images, includes knowledge of styles.

In those instances when we speak about art for art's sake we refer to an intention that focuses upon internal relations which are made manifest in the surface qualities of the image, the aesthetic dimension. On the other hand, when meaning is found in symbolic forms, when the image is used as a metaphor, the mind is directed from its materiality towards connoted ideas or concepts. And here, in the field of connotation, there always exists the possibility of proliferation of 'routes to meaning' owing to the particular 'history' of the viewer. The routes we have in mind are the relationships or interconnections already set down from earlier learning and experience. The meaning obtained could be described as the culmination of a mental search through an existing pattern of connections. This leads us to the concept of received meaning and the idiosyncratic ways by which it can be constructed.

Received Meaning

In ideal communication the received meaning of a message, and here we include an image as a message, would be identical to its intended meaning. In this instance we could say that sender and receiver are in perfect agreement as to meaning. But such an ideal state of affairs, as we know only too well in practice, is not always the case. We have already seen that the sender, as communicator/artist suffers some loss of intended meaning when committing thought into some material form. This can be confounded by a further loss when the image as message presents itself for interpretation which we can call its received meaning. This is particularly so in visual communication which is less standardised than the verbal. However, through tacit awareness, people are often familiar with the intended meanings that surround the many icons in society, from advertising, films, and television. This is aided by the fact that visual images, as perceptual entities, may bear a closer resemblance or likeness to their intended meaning than the verbal, and thus appear closer to nature which is itself uncoded.

But to return to our theme in more detail, it may be found useful to illustrate the issue of received meaning by putting forward the analogy that MacKay drew between the use of a key to open a lock, and that of the communicator who has to 'unlock' the thoughts of the recipient with a setting which opens the door, metaphorically speaking, to his or her intended meaning. In the case of the key, its profile is such that it fits levers in the lock, which we may call its setting. And in the case of human communication, a message or image has, like a key, to fit and unlock a potential in the mind of the receiver/viewer. It can only do so when, figuratively speaking, it fits the configuration or settings that exist within the receiver's existing mental framework.

This means that the originator of a communication, which may be verbal or non-verbal, has the double task of envisaging the cognitive state of the receiver, and of designing his or her message/image in such a way that it produces the desired effect. Therefore, it follows that a message originator has to utilise a code or style with at least some degree of communality between him or herself and the recipient. And thus social or cultural factors which are made manifest in codes and styles lie at the core of the process.

But how about originality? Where does this fit into our scheme of things? From the foregoing, it follows that absolute originality, an originality that bears no connections with a viewer's existing knowledge will lead inevitably to a state of incomprehension, in other words

to meaninglessness, a state where the recipient is unable to make any connections with the message and his or her existing means of knowing.

The possession of shared codes is a partial guarantee of at least some redundancy, in other words of some familiarity, this is self-evident in verbal communication where codes are formally ascribed. But whereas in print the codes of production contribute little to the intended or received meaning, visual communication is impregnated with codes as style. Particularly this is so when part of the communication is intended to convey an aesthetic appreciation. Here the audience has to share at least a partial knowledge of the codes of production. However, as the codes of pictorial representation are less formalised than the verbal, and in many cases they are in the process of construction, there exists the constant possibility of incomprehension. We must be careful, however, not to overstate the negative aspects of images as communicative devices, we know full well, as was stressed in the earlier chapter on perception, that their ability to carry a visual likeness gives them relative immediacy in mental processing because of their access to the parallel system which operates in perception. And we also know that they have a tacit dimension whose codes are learned informally, but learned nevertheless.

It is this dual aspect of visual images that gives them a special niche in communication, on the one hand they can be made to bear a likeness to things, and on the other hand, they can be made to 'speak of themselves', the aesthetic dimension. In this way we may think of received meaning as being found at either level, the metaphoric or the aesthetic. In the case of the aesthetic, there is the marked requirement that the viewer possesses the ability and the pre-requisite disposition to search for inner relationships within the image as pure form; and in the case of the image as metaphor, it is essential that the viewer can make the requisite connection between the image and its intended ideational reference. One thing common to aesthetic and metaphoric 'reading' of images is the necessity of seeing relationships, and in many cases having to search for them.

Meaning as Organisation

We are often prone to think of meaning in a substantial way, something with an existence outside our individual being, but it might be more correct to consider that meaning does not inhere in things, printed words or images, that it has to be found or attributed. That it inheres in minds not in representations. In this way of thinking, meaning is not found but more correctly invested, ascribed to something as a result of mental processing which takes place within an already existing mental framework which influences the way in which the incoming data is understood. This, then, is the meaning to that person, or to follow our earlier discussion, its received meaning. The process could be visualised in spatial terms as that which is raised to consciousness when attention is focused on something, a word, a picture, an event, etc. From the foregoing it will be seen that media, of whatever kind, do not of themselves possess meaning. It would be more correct to say that they carry the potential to raise in their readers or viewers a particular way of seeing the 'world', of raising to consciousnes certain issues, but it is the reader/viewer who gives the meaning, it is an act not a thing. Here we can raise again the difference between intended and received meaning. The media makers, as senders, work on intended meaning, the recipients apply received meaning, with all that this means in terms of the possibility of differences in interpretation.

Direction of Thought

The state of conditional readiness, the term used by MacKay to describe an individual's 'mind set' on receipt of information, provides the ground or the springboard from which thought can reach out to make sense of that which it is called upon to attend. Images, as we have seen, possess the twin potential of carrying information at the aesthetic, non-referential (inner form) level, and the metaphoric, ideational level. In either case, the viewer in making a choice displays motivation to attend in a specific way to the properties of the image. As we have already seen, for communication to take place, there exists the pre-requisite that the viewer possesses at least partial familiarity with the codes of production or the codes of metaphor.

The following schematic diagram offers a way of visualising the idea of thought proceeding along different planes of interpretation of images. The distinction is made here between realism, symbolism and minimalism. However, it is understood that images as art cannot always be classified into neat distinctions, that as analogues their boundaries can be illusive, not lending themselves readily to digital classification, the province of the verbal. That being so, the reader is asked to consider the diagrams as illustrative of an idea, the idea of thought following in particular directions when viewing different kinds of images.

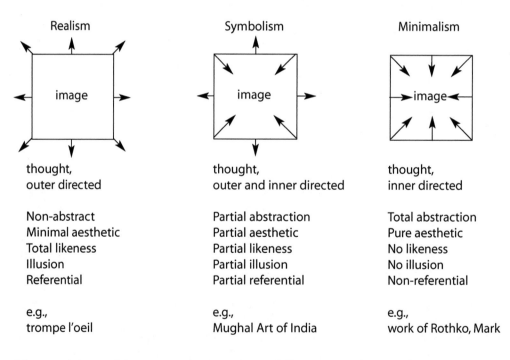

Realism	Symbolism	Minimalism
image	image	image
thought, outer directed	thought, outer and inner directed	thought, inner directed
Non-abstract	Partial abstraction	Total abstraction
Minimal aesthetic	Partial aesthetic	Pure aesthetic
Total likeness	Partial likeness	No likeness
Illusion	Partial illusion	No illusion
Referential	Partial referential	Non-referential
e.g., trompe l'oeil	e.g., Mughal Art of India	e.g., work of Rothko, Mark

Of course, it is possible to argue that intention to follow a particular way of apprehending a painting cannot be inferred quite as straightforwardly as that shown in this diagram, there are many complexities to consider. However, given this proviso, it is a fact that the direction of thought or the path that it takes is stunted when the viewer is not in possession of the necessary mental framework, which we may call knowledge, to proceed in the direction intended by the image maker. In the case of symbolism, the viewer is required to know, if only tacitly, the metaphoric meaning suggested in the image, and in the case of minimalism,

the viewer is expected to understand that the image, figuratively speaking, 'speaks only of itself'.

Summary

In this chapter, we have been concerned to develop the concepts of 'in-forming' and meaning in our search for a fuller understanding of visual communication. We noted that concepts derived from information theory, such as 'information', 'redundancy', 'limited capacity', and 'overload' make useful contributions to our enquiry. Stress was placed upon the concept of information as that which 'in-forms', or modifies a mental set, and thus it was seen as an active process with verb rather than noun qualities. In stressing the idea of meaning as a process, we connect not only with the work of MacKay, but also with that of Morris (1938) who, in his treatise on the theory of signs wrote that, "Meanings are not to be located as existencies at any place in the process of semiosis, but are to be characterised in terms of this process as whole."

We saw that too much information, which we defined in terms of decisions to be made when viewing an image, can lead to perplexity, an overload of information. However, we noted that familiarity with codes and styles reduces the information load, and thus makes for ease of comprehension of a particular image. We could say that in this instance the viewer, as receiver, possesses the necessary competence to process the image as information. We further noted that 'selective attention' has a part to play in the reduction of demands upon information processing. It was seen as a kind of cueing device guiding thought in particular directions, and thus reducing the number of decisions that have to be made. But here again, the kind of selectivity applied in a specific instance is dependent upon the resources or schemata that the viewer brings to the situation, in other words how well he or she is 'in-formed'. We linked concepts from information theory to that of meaning, and, in doing so, we drew upon the work of MacKay, which further led us to consider meaning as it unfolds in the context of communication. Of necessity this always involves a sender who is engaged in constructing meaning (intended), and a viewer, as receiver, whose task it is to construct an inner representation (mental) of an outer form, the image itself, which then becomes to him or her, the received meaning. We went on to suggest that meaning attached at either of these levels may, or may not be in agreement. We further went on to include the notion of a third dimension, meaning instituted in society, conventional meaning. But this was seen to raise a problem for visual images, because, unlike words, they are not usually listed in dictionary form. However, it was pointed out that visual images are often understood at the tacit level, established in social and/or cultural contexts, and thus one could say that they possess the semblance of conventional meaning.

Emphasis was laid upon the fact that visual images can be 'read' across two distinct levels; firstly the metaphoric, which involves a mental search for relations existing outside the material image as presented, and secondly, the aesthetic, which involves a search for relations within the material form of the image, without recourse to concepts. In both instances, it was suggested that meaning is found in relationships. And this gave us the most important clue to the concept of meaning, namely that it is a manifestation of relationships; that the relationships found are the meaning. But, most importantly, the relationships about which we speak are none other than the form of an inner mental representation.

What we kept noticing, as we have done in previous chapters in this book, is the part that tacit knowledge plays in the understanding of visual images, and it is to this that we turn our attention in the next chapter.

4

THE TACIT DIMENSION

The concept of meaning as a relationship, a relationship established at the personal level in the form of an inner representation, as discussed in the last chapter, needs further elaboration. This is particularly so in the case of visual communication where form can make demands on both perceptual and symbolic processing. The meaning of visual images may be realised quite straightforwardly at a surface or conscious level, for example in advertisements which explicitly declare their intention. On the other hand, their intended meanings may be covert, known only through implicit knowledge, which we shall here call the tacit dimension. Here we are on the related grounds of intuition, of intrinsic meaning, the place where we can know more than we can tell, to a place older than the universe of thought (Merleau-Ponty, 1964a).

It is this tacit dimension that gives the visual a particular niche in human communication, a niche that can readily combine the life of direct perception with the mediated indirect life of signifying systems, which in terms of visual communication, we may regard as quasi-perceptual. It is here at the level of the figural that implicit relationships make a significant contribution to received meaning, to a meaning of which the viewer may be only tacitly aware. The relationships are those found in space, given in time; but just as in real-life, the viewer may be only tacitly aware of certain elements, despite the fact that these elements may contribute the greatest amount of information in the construction of meaning. In other words, the perceptually peripheral may contribute an inordinate amount of information, similar to the way in which critical and significant cues are picked-up in non-verbal communication.

Of the two modes of communication, the figural and the discursive, the image and the word, it is the figural with its affinity with the life of the senses, and thus perception, that creates a ready connection with tacit understanding. From a theoretical point of view, the sensory connection adds a number of interactive issues which are not found in linguistic theorising. For example, the roots of language, according to Chomsky, are contained in linguistic universals, a deep structure which is uncontaminated by sensory influences. This is clearly not the case with the figural mode of communication; here we are involved with sensing, perceiving, and context, all of which are concerned with man's physical presence in an actual world. Thus in directing attention to the figural, to the image, we are called upon to set our sights at a wide angle, one which is wide enough to include each of these factors. In doing so we inevitably come face to face with the issue of tacit knowledge, which far from

being peripheral in the human scheme of things, is the very foundation upon which explicit knowledge is secured. It could be expressed as the 'deep structure' of visual knowing.

In exploring the tacit dimension, we are taken to the heart of experience, to the body as the seat not only of sensing but also of feeling, and thus we come face to face with concepts of empathy and kinaesthesis, with bodily responses to external events perceived directly or indirectly through some form of mediation , but known only tacitly. In taking this route, we follow paths variously marked covert, implicit, intuitive, or tacit; terms which are often interchangeable. Whichever term is employed, they all share common ground in referring to a less conscious, less discursive way of knowing. However, we must be careful to add the proviso that although there exists a clear distinction between the figural and the discursive in human communication, they share a symbiotic relationship. This is exemplified whenever printed images are accompanied by explanatory titles, and whenever the moving image, whether it is film or television, is accompanied by speech.

In a more general sense, and within the cultural demarcation of life termed the 'habitus', as distinct from the habitat of natural life, there exists an intertwining of continuous nature and discontinuous culture. As Bryson (1985) observed, there is a merger within this domain whose join with nature is nowhere visible; and further, that this involves explicit cultural knowledge and implicit cultural knowledge that exists nowhere in coded form, but remains at a tacit level. Such an invisible connection is to be found not only in cultural knowledge, but also between the tangible and the visible, an intertwining of an existentialist nature as evidenced in the work of Merleau-Ponty. For our purposes, the important point to note is that tacit awareness, the 'invisible' of understanding, is central to an understanding of the visual in communication. It manifests itself, as we have seen, at the level of cultural knowledge, but more fundamentally its roots are contained in the senses, in nature.

The Corporeal and Tacit Awareness

It is quite a common experience to 'know more than we can tell', to have a language that is unable to cope with the subtleties that are given to vision, to have feelings that are tacitly understood, but inexpressible. What we are here referring to is awareness at the sensory level, and the experience of empathy that one may feel but cannot express; a bodily feeling that manifests itself as emotion. Furthermore, owing to synaesthesia, the cross-transfer from one mode of sensing to another, a visual experience can elicit a kinaesthetic sensation, and thus generate feeling in the musculature which is close to physical presence. A vivid example of this is the feeling of active presence when viewing 'cinema in the round'. A further illustration of synaesthesia is the feeling of warmth which can be induced by redness as a colour in interior design. Such sensory cross referencing is carried out below the level of conscious awareness, at the tacit level. But as can be seen from these examples, tacit awareness can lay the seeds that generate a particular kind of conscious awareness.

Our concern is with vision, a sense that can leave its origin in the body and reach out to 'touch' its surroundings. In passing, the reader may here note the use of a tactile word to describe a visual experience, thus demonstrating the way in which the tangible or corporeal is seen to lie at the core of sensory experience. To return to our theme, we may think of the process of vision as a cyclical process which goes forth from, and returns to its seat in the body; thus bringing the outside to the inside. But once inside, the returned impressions combine with past visual memories which, together with those from other senses, create at the tacit level a gestalt or unitary awareness. This was described in colourful terms by Polanyi

(1966), as a process of expanding our bodies into the world by assimilation and integration of particulars. Vision, as a distance sense, is well equipped to 'expand' into the world, but it is to the body, the ultimate base of all our external knowledge, that information returns for processing.

In the earlier chapter on semiotics, mention was made of the way in which the artist or image maker goes forward from perception to representation; and that, conversely, the viewer proceeds in the reverse direction, from representation to perception. We can make a further extension to this by emphasising the way in which the influence of a graphic sign may penetrate beyond perception and set in motion a kinaesthetic sensation that bears a spatial orientation similar to that displayed in the sign. In this instance, it could be said that the internal representation reinstates an original motor experience. A useful example of this is provided by directional arrows in road signs which create an early orientation within the driver's somatic system. Bastick (1962), dwelt on this issue when he claimed that there is evidence that imagery and motor patterns are commonly interdependent, and that the proprioceptive feedback provided by kinaesthesis influences the hormonal system. Thus we are led to an appreciation at an even deeper level than that of the tacit.

Interesting as it would be to follow the deeper implications suggested in the work of Bastick, we need to uncover more at the tacit level before taking them on board. And here we find that we are constantly drawn back to the notion of intertwining, of intertwining of vision and movement. We have commented upon this as an internalised relationship, one which is made apparent in the feeling engendered by graphical signs. We can see the value of this mode of analysis for reporting those art forms which set out to make visible an underlying movement, for example in 'action painting', epitomised in the work of Jackson Pollock (see Fig. 7, p. 90), and in oriental paintings which emphasise the hand movements that guide the brushstrokes. In either case, it is at the tacit level, where a visual experience can be transposed into a kinaesthetic sensation, that the viewer is 'asked' to participate.

The Tacit in Perception
As we have seen, a corporeal or postural schema gives us a practical and implicit notion of the relation between our body and things. In this way we experience presence which, in the pre-verbal period of early childhood is a situation seemingly without distance, one of immediacy. It is this aspect of perception, of presence in a world without mediation, that visual communication draws upon, if only in a quasi form. Perception is always involved with presence, with presence lived not posited, but its focal object, whether natural or artefactual, can set in motion memories that carry us back in time; in this way, time past and time present fuse in the act of perception. Whether it is dealing with nature or image, perception performs the task of unifying impressions into a continuous whole; a task performed below the level of consciousness, at the tacit level.

Perception, as we have seen, is characterised by the fact that it has its object in 'flesh and bones' before it. Thus it is a privileged act, a primary intuition (Levinas, 1973). This privilege finds its way into visual communication through resemblance which is a kind of quasi presence. Here at the level of perception, of the engagement of the senses, nature and image as artefact are intertwined. In fact, art is not merely intertwined with perception, it is an extension of it, and thus it is tied closely to the natural order of things. In extreme instances, for example in trompe l'oeil', it can masquerade as nature, and thus hide its unnaturalness, but its involvement with perception is always on display. Throughout, perception and art are

characterised by tacit knowing, the type of knowing that precedes the explicit or discursive in human development and communication. In this sense their pedigree is understood implicitly, at a level below conscious awareness. Although, on the other hand, we cannot lose sight of the fact that images, as communicative devices, are generally quite explicit, leaving the viewer in no doubt as to their intended meaning. There can, of course, be a covert use of visual images; for example, when they are employed at the subliminal level which is below the conscious awareness of the viewer. This can be viewed as a form of hidden influence or, more pejoratively, as a type of hidden persuasion.

The non-linear aspect of visual images and the fact that they are always given in contexts echoes the nature of perception itself. Within their spatial contexts a multiplicity of connections and interconnections of a non-linear kind may be tacitly understood by the viewer at a level of awareness not accessible through any lexicon. They can exist, so to speak, in the territory of Zen. What we can begin to discern is that the tacit dimension in visual knowing and visual communication bears remarkable similarities to the notion or concept of intuition.

Intuition

Intuition is both immediate and subjective. These two conditions echo the nature of perceptual life itself, which is quasi perception when it is engaged in the act of viewing mediated visual images. In the same way, it would appear to be more correct to speak about quasi intuition when referring to intuition which is similarly affected. Technically speaking, it is quasi whenever it fails to fulfil the essential requirement of pure intuition which is one of immediacy, not mediated, between object and viewer. By this reckoning we could say that visual communication is a kind of half-way house, providing food for quasi perception and quasi intuition.

In assessing the relationship between intuition and visual communication it is possible to discern at least two other significant common factors; firstly, the non-linear nature of intuition and its 'a priori' attachment to space and time, which is also the ground of image-making; and secondly, its engagement with wholes rather than parts, which is also a central attribute of iconic images. In placing special emphasis upon intuition, we need to bear in mind that it is operative at both ends of the communication spectrum, within the mind of the originator and of the receiver. This raises the question of possible difference between intended and received meaning that we discussed in the last chapter. As we saw, intended meaning may, or may not, show agreement with received meaning; to this we could add the comment that this applies with equal force to meaning derived at the intuitive level, which is always below the conscious awareness of both the originator as sender and the viewer as receiver. Hence we may emphasise that differences in interpretation between originator and viewer may have their origins not only at the conscious level, but also at the more primary intuitive level that precedes consciousness.

The image-making aspect of visual communication is often regarded as a creative activity which owes as much to intuition as to directed conscious thought. However, as people involved in the field of fine or commercial art could testify, the making of images is a task involving a high degree of conscious activity and decision-making, of ordering and re-ordering relationships, of making contrasts. In this sense it is a linear process. Nevertheless, despite this affirmation, it is a fact that the perceptual element is always present, and in consequence, there always emerges a non-linear, tacit dimension which has its roots in intuition.

From this it follows that we need to attend to the many facets of intuition for an understanding of the visual in communication. As we have said, it is operative at the beginning of the process, at the level of the instigation of images, and at the point of reception where the viewer is called upon to perceive and thus intuit, albeit at the quasi level that we discussed earlier. Perhaps it is necessary to be reminded that intuition is not, as many people believe, an inferior mode of knowing, something to be assuaged whenever possible, but a form of knowing which is fundamental to the growth of understanding itself. It is, according to Kant, one of the two fundamental sources of knowledge for the mind, the other being via the way of concepts. That being said, its essential characteristic is that of involvement with the senses, but, to quote Kant (1982), "intuitions without concepts are blind". In the act of viewing there exists, in varying degrees, an intertwining of the intuitive and the conceptual. And so, as in all acts of cognition, there is interplay between the two modes of knowing. And, as Arnheim (1970) wrote, "There is no necessary conflict between intuitive and intellectual cognition. In fact, productive thinking is characterised in the arts and sciences by the interplay between free interaction of forces within the field and the more or less solidified entities that persist as invariants in changing contexts."

Such are the dynamics that intuition brings to the act of viewing and subsequent knowing. But we cannot leave it there, we must bring forward for special attention the one single concept that lies at the core of both intuitive and conceptual knowing; namely, the concept of relationships. Without relationships there is no form, and it is form that structures both intuition and concepts; pure intuition contains the form under which something is intuited, and pure concept is the form of thought, according to Kant, of an object in general. In as much as visual images are perceived, that they appear, then they are subject to the faculty of intuition where relationships are established on the basis of sensory qualities. While, on the other hand, the concepts that they cause to arise in the viewer are based on thought, of relationships between concepts. The pure forms of intuition and thought create the grounds for understanding, but the derived forms at any particular moment of viewing are subject to the individual viewer's own perceptual experience and conceptual frames of reference. While we may appreciate the thought element in conceptualisation, it is a fact that the development of perceptual acuity, of awareness of the nuances of form also calls upon a high degree of directed and conscious thought. For example, the practice of painting and photography requires that attention is paid to tonal and colour differences and similarities in the appreciation of form. Although the basis of such awareness is sensory, the heightening of sensibility is aided by conscious awareness of critical points of contrast or similarity. Here the image maker leaves the immediacy of the senses to take on board the additional mantle of conscious thought.

While what has just been said was with particular reference to the 'trained eye', the facts are that for the majority of viewers images as artefacts have their raison d'etre mainly in their ability to evoke concepts or thoughts, which take the viewer beyond the surface of the image. This, of course, is epitomised in symbolism where relationships are of a metaphoric kind; or in realism which masquerades as a kind of truth, where the relationship is one of likeness. But in both cases the referent is absent, the mind is called upon to make the connection. This is in contrast to perceptual relationships which are always concerned with things present to the viewer. And so, whether we speak about perception or conception, the concept of relationship is itself a key concept which lies at the heart of communication in general and visual communication in particular. In fact without relationships there can be no

communication. At the perceptual level the relations are carried as multiple relations within one frame (in the case of moving images they also include a serial element) without formal rules; whereas, at the conceptual level relations are linear, drawn from thought and subject to rules. However, the tacit dimension, the apparently rule free aspect of visual communication, is constantly drawn to a kind of rule making through stylisation, which is explicitly taught to the image making community, but generally left to implicit learning by the majority of viewers.

Imagination

As we have seen, intuition is concerned with the life of the senses, of immediacy and subjectivity. The synthesis it produces rests upon empirical engagement with the world, but, and this is of special concern to our interest, it is a figurative synthesis carried out with the aid of the imagination, in contrast to intellectual synthesis which is not so aided. As an embrace with the figural, with the non-discursive, the central role of imagination is that of unifying separate intuitions, but not only that, it possesses the propensity to enliven absence, to make present to the mind that which is physically absent. Thus we can see the connection with visual images employed as devices for communication; they also represent things absent, their presence is only ever symbolic. In this sense we could say that they provide food for the imagination in the form of stand-ins, created as a result of other people's imaginings. In following the logic that we developed earlier in relation to perception and intuition, which we regarded as quasi when they are involved with mediated images, we could go on to speak about quasi imagination, when it is likewise engaged. Alternatively, we could adopt Kant's two category description of imagination, in which he reserved the term productive imagination for that which is spontaneous, and reproductive imagination for that which is subject to empirical laws, which he called the laws of association. It could be argued that certain artefactual images could fall into a category between these two, being neither totally spontaneous nor given to laws as such, although, as was mentioned earlier, they are often subject to rules, to the rules of stylisation.

Leaving aside the problem of categorisation, a working appreciation of the role of imagination shows that one of its primary tasks is that of unifying the separate percepts that make up on-going visual experience; for example, the visual continuity that is experienced when driving a car. The unity it achieves is not only a knitting together of visual impressions, but also a unity of time, not only real time, but also, for example, the apparent time experienced when viewing moving images. Thus, through imagination, time past and time present unite into a continuous whole, which is a necessary foundation not only for the continuity demanded in everyday life, but also for life mediated. As we have seen, moving images of all kinds require the viewer, at a subconscious and hence tacit level, to unify or integrate past images with current ones, and thereby make a viewing experience an event, rather than a mere collection of episodes. At the perceptual level, single and hence discontinuous frames appear as continuous owing to the lag in mental processing and the after-images which remain to infiltrate subsequent frames; but as images covering a greater time span than the momentary space between frames, it is the imagination that allows them to 'fall on one another'.

We have spoken about the unifying potential of the imagination and of the synthesis that it creates in intuition, but it is the act of creating presence in the face of absence, albeit a mental presence, that gives imagination its special appeal. In fact symbolic life of all kinds,

not only that of visual images, is bound up with the notion of absence being converted into presence. As communicative devices, symbols themselves, and here we include symbolic images in all their guises, are always stand-ins for something else, be it ideas or objects. For themselves to be real, other than as cyphers, it would entail them losing their status as symbols. But as representations they require something else to create the connection with the absent idea or object, and this something else is the work of the imagination, which may be activated by conscious intent or by latent desire.

The propensity of the imagination to make present to the mind that which is physically absent means that it can not only draw from the past, but also create an idea or image of the future. It is the place where mental images are created of an anticipated future. In visual terms, they provide a glimpse of the future, which, however, is gleaned only on the basis of past and present experience. From the perspective of the image maker, imagination provides not only the synthesis of intuition that is a necessary part of the sensory aspect of his or her work, but also a kind of pre-view of an intended material image, and the stages en route to its accomplishment. For the viewer, imagination unifies the separate percepts that make up the experience of viewing; but bound as it is to the individual, the form it presents at any one time is subject to the idiosyncrasies of past impressions, of impressions from life lived and life mediated of which the individual may only have tacit awareness. This is the retrospective role of imagination , but, as we have noted it has a prospective or anticipatory role which is subject to influence not only by a material image on view, but also by the individual's own store of images. Thus we can see that so far from imagination being a vague mythical kind of enterprise, it is the essential element for the integration of sensory experience and visualisation of that which is absent; it can draw upon the past, anticipate the future, and yet it is always ground in the present; an active presence which through intent can raise to consciousness that which is absent.

As we have stressed, the past and the future are drawn together into a kind of living present through the work of the imagination, when viewing sequential images. This also applies with equal force when single images are scanned, for example paintings. But in the case of moving images, such as film, they are often presented with a supportive narrative which bears the potential to guide the viewer into particular modes of anticipation, and thus influence the route that imagination may take in creating an image of things to come. For example, the viewer can begin to imagine action unfolding in particular contexts or circumstances from cues given in the narrative. Furthermore, in the making of film, the camera itself can be directed in such a way that it causes the viewer to anticipate particular outcomes; but it is only through imagination that the viewer can carry forward the implications of such manipulations. As things or events to come or to be experienced, the future is only ever a figment of the imagination, but one which can be influenced by the media through the cues provided. An extreme example of mediated intervention is that of 'virtual reality', the computer-based technology that allows people to enter an artificial world of vision in which they interact with computer graphics, but even here the outcome is subject to the influence of imagination.

From the foregoing it will be seen that all viewing involves imagination. It is an engagement involving past, present, and an anticipated future; but such an engagement, although it may take place in the presence of others, is always singular. Each individual has a reservoir of images which may be known to them explicitly or only tacitly. In terms of audience reaction or interpretation, the imagination that is brought to bear in viewing

images always bears an individual footprint. On the other hand, when people have shared the same or similar backgrounds of education, interest, etc., they could be disposed to similar imaginative constructions. For example, familiarity with the work of certain film directors can create an expectancy about their projects across a broad spectrum of people who have been exposed to their work, and thus their style. Much of this expectancy is shared at the tacit level, which, as a place beyond the realm of language, is closely involved with understanding of a non-formal kind, derived from non-verbal modes of communication, which is contextually bound and largely associated with vision. The contract is with an analogical world in which images appear uncoded, and yet, unsuspectingly to the viewer, they can possess another foot in the territory of the coded, stepping across the territorial boundary that separates the coded from the uncoded by virtue of their apparent naturalness, and thus shading the distinction between the implicit and explicit in visual communication.

The Material Image

The mental image about which we have spoken in connection with imagination is a construct without any externally visible qualities; unlike material images, such as photographs and film, which have concrete existence outside the life of the person. Nevertheless, as analogues, as continuous images which resemble what they represent, they share common ground with that of imagination in 'making present' something which is absent, for example an event on television some distance from the viewer. In the case of pure imagination it is carried without any material aid, whereas in the mediated instance it is aided or assisted by images provided by others.

As analogues, material images have a passport to the territory of the uncoded, and thus they are privileged to occupy the same territory as perception, which in its unmediated form, away from human intervention or manipulation carries the aura of innocence; the innocence of nature, the place where questions are neither asked nor expected, and thus where doubt is excluded. This relationship between the image as artefact and perception was stressed by Merleau-Ponty (1946b) who, on writing about film, said that, "If we consider the film as a perceptual object, we can apply what we have just said about perception in general to the perception of a film … film is not a sum total of images but a temporal gestalt …The meaning of a film is incorporated into its rhythm just as the meaning of a gesture may immediately be read in the gesture: the film does not mean anything by itself. The idea is present in a nascent state and emerges from the temporal structure of the film as it does from the coexistence of the parts of a painting. The joy of the art lies in its showing how something takes on meaning, not by reference to already established and acquired ideas but by temporal or spatial arrangement of the elements … a movie has meaning in the same way that a thing does: neither of them speaks to an isolated understanding; rather both appeal to our power tacitly to decipher the world … They directly present to us that special way of being in the world, of dealing with things and other people, which we can see in the sign language of gesture and gaze." This of course is the world of non-verbal communication, the precursor of the verbal and largely given to tacit understanding. Film, as a material image, is an ideal medium for conveying nuances of gesture and gaze, it can be made to focus upon them and thereby highlight the non-formalised but highly relevant tacit information that they embody. Not only that, their frames can carry an abundance of detail of an informal kind, for example, the spatial ordering of furniture and décor which, given without comment, nevertheless carries a wealth of information to the viewer.

It is not only in the medium of film that tacit knowledge contributes to understanding, it plays a part in the appreciation of paintings. It could have relevance to the point made by Bryson (1985) when he expressed dissatisfaction with the use of the linguistic terms, langue and parole in art appreciation. Specifically he mentioned the lack of any mediating term between langue and parole, and thus exposed the limitations of this linguistic form of analysis. It is in this discontinuity that the tacit can find a foothold. As with Merleau-Ponty before him, Bryson took his cue from non-verbal communication when he wrote that, "The rules that are at work in the reading of the face, body, costume, posture, in other words the rules responsible for the connotation of the image, may be without their definitive summa or codex, but this absence should not be taken as evidence of a fundamental deceptiveness in social life. Rather, the rules are immanent within contextual situations, cemented into practical techniques."

The intention here is to stress the tacit factor in the appreciation of material images, be they moving or static; but as the reader is more than likely aware, many material images are quite explicit, leaving the viewer in no doubt as to their intended meanings. But such images, explicitly understood through the codes of society, nevertheless require decoding. This applies to insignia and all those symbolic images that go to make up the stock of visual images that exist in society. However, and this is the critical point regarding the material image as a means of communication, it has the potential to carry at one and the same time both explicit and implicit information. This leads to the conclusion that for extrapolated meaning to be consonant with that intended, the viewer or audience needs to be familiar with the formal codes presented and with the informal, tacitly understood information given at the same time. In either case, the viewer searches for meaning within the framework of his or her own repository of symbolic and tacit knowledge. Lack of familiarity at either level is likely to lead to incomprehension, partial when familiarity is only at one level, and total when it is at both.

From Denotation to Connotation

Images, like words, denote; they stimulate, or are intended to stimulate a direct mental connection with something. As signs, this is their initial or primary responsibility, but as signs they also possess the propensity to set in train a range of secondary significations additional to that denoted. And thus, the way is opened for connotation, the building of additional significations on the basis of an existing denotation. The denoted aspect of an image is usually quite explicit offering itself as a sign to be taken at its face value, unambiguously pointing to its intended meaning; on the other hand, its connoted meanings are more of a tacit kind, indicated but not formally expressed. It is in the region of the figural, outside the codes of iconology, that the tacit factor emerges. This is the untutored part of visual communication, which is acquired as a result of learning which may appear natural, and yet possess elements that are culturally determined.

The apparent naturalness of that which is implicit can, by association, impregnate that which is explicitly cultural, and thus influence the viewer into a more ready acceptance of that which is denoted in the image. This then is the power of the figural; the power to denote, to be overt, and yet at the same time to carry within itself secondary attributes of connotation which rest not upon formal knowledge, but upon the informality of the non-verbal, of life lived in a practical way, but possessing implicit cultural knowledge that remains at a tacit level. From this position the figural can commandeer the halo of innocence that surrounds

the life of the unmediated. However, such innocence is soon brought into question when the viewer is familiar with, or alerted to, the means and styles of production that surround the making of images. For example, the manipulation of background in television production which enhances the credibility of the presenter (Baggaley & Duck, 1976).

We cannot leave the issue of connotation without mentioning the proliferation of connoted meanings that visual images can set in train. It is often the case that thought does not follow a clear linear pattern when faced with an image; at the tacit level, below that of consciousness a proliferation of connoted meanings can route the individual viewer through a maze of pathways which have not been envisaged by the image maker as communicator. To fix, as it were, these floating chains of connotation, anchoring devices are employed (Barthes, 1977), such as titling of press pictures and 'voice-over' in filmic images. These devices can be seen as route markers, routing the viewer into certain prescribed pathways of interpretation rather than others, a necessity that would not arise if viewers were not prone to deviate from the pathways to meaning intended by the sender. We could say that anchoring devices, such as titles to pictures, are attached to the image in order to guide the viewers, rather than allow them to follow their own inclinations. This could be explained pejoratively as putting a slant on things, and less sinisterly as guidance.

It now becomes clear that the roots of connotation are to be found in the fertile soil of the tacit, and that it is from this base that the viewer issues forth to add a personal meaning to that denoted in the image. It is the place of interiorised knowledge, the place, as Polanyi would say, of indwelling, in which resides the totality of the viewer's tacit knowledge, and through which, at a level below conscious awareness, the world, including the material image, is filtered. In the world of viewing, the material image acts like a signpost denoting or focusing upon an intended meaning which may be overt or covert, but it is one where the viewer, through his or her store of tacit knowledge, constructed on the basis of life mediated and unmediated, can, as previously mentioned, deviate along personal pathways of secondary connotations. In such a situation the gaze or focus of interest is inner directed, contained within the viewer's store of tacit knowledge. Here we may find clues not only to the deeper roots of connotation, but also to empathy and aesthetic appreciation. In furtherance of our quest we turn to the work of Polanyi (1966, 1969). We shall find that his ideas provide not only a theoretical basis for tacit knowing, but also the necessary unity to the various strands that make- up this chapter.

Polanyi's Proposition

Throughout this book we have frequently been drawn to the perceptual element in visual communication, which, as we have seen, is a two-way process in which the viewer reaches out or focuses upon a visual image, and then via a return process incorporates his or her impressions within an existing framework of knowledge. Perception understood in this way is an integration of experience, which, taking place without formal argument, places it in the domain of the tacit. It is this aspect of knowing, of an interiorisation that resists specification, that gives the work of Polanyi a significant place in our deliberations. For example, he wrote that there exists a wide range of not consciously known rules of skill and connoisseurship which comprise important technical processess that can rarely be completely specified, also there are many different arts that man knows how to use, comply with, enjoy or live by, without specifiably knowing their contents. He was writing about cultural factors in general, but to the extent that visual communication is part of this generality, we can usefully apply

his theorising to our particular concerns. In his work he stressed the tacit nature of skill and connoisseurship, concepts which are central to our theme. Skilful viewing can be consciously directed, but it entails a large tacit element. Likewise, we may speak about skilful representation which requires, among other things, familiarity at a tacit level with techniques, tools, and equipment such as cameras. From this it follows that when a viewer possesses a similar range of tacit knowledge to that of the originator of the image, there will be a deeper sharing or appreciation of that which is presented: in other words, the situation is one where communication has the chance to prosper in a fulsome way. Whether it is by sympathy or empathy, the viewing situation is more rewarding when the viewer shares, through identification, the communicator's tacit involvement with both the means of production and the particulars that form the unity of the message.

The territory in which we are now encamped was portrayed by Polanyi as that of 'indwelling', the place in which we accommodate those aspects of knowledge of which we only have subsidiary awareness, and in which there exists a large visual element. This is the domain of the tacit, constructed from both physical and cognitive involvement with the world. In the viewing situation, the observer naturally dwells in his or her own body, which incorporates all the particulars that make-up tacit knowledge. From this origin, the viewer, we might say, reaches out to incorporate that which is observed; meaning is obtained when it is interiorised or indwelt. It is possible to link the concept of indwelling (or dwelling) with its counterpart in French, with habitation and then habitude, which on translation into English becomes habit, that which can be performed without conscious attention. Thus, through language, we can highlight the connection between indwelling, and that which is below conscious awareness.

This observation aside, it is possible to construct a developmental schema of indwelling which progresses by stages from the primary level of pure physical embodiment, through visual perception of life unmediated, to the perception of mediated images, the realm of the symbolic, that which is only a representation of an idea or a thing. The point being made here is that tacit knowledge is a process of integration of particulars, of particulars of which the viewer may not be consciously aware. In this sense, viewing involves more than vision. The viewer has a repository of experiences gathered from a variety of situations, many of which do not demand formal argument, and of which the viewer may only have tacit awareness. On the other hand, knowledge or visual awareness may initially be overt, given to consciousness, but it may later subside into the realm of the tacit. The reader will be well aware of many acts or skills that initially demand conscious attention, and which, with the passage of time one is able to perform without conscious effort; the label we give to this, as previously stated, is habit, which, for our purposes, includes the habits brought to viewing.

We should, to use our own terminology, dwell a little further on the concept of indwelling because it is an essential concept in visual knowing. A developmental schema could be formulated as follows:

1st Indwelling in the body, no external input.
2nd Indwelling in perception, visual input from outside.
3rd Indwelling in techniques of representation: in tools, methods and styles.
4th Indwelling in the particulars that give life to symbols.

The above steps are to be understood not as incremental stages in which a person ascends from the lower to the higher, but more correctly as steps in integration in which later stages

are integrated with those formed earlier. In this way we can consider visual knowing not as a route to abstraction which leaves the earlier stages by the wayside on its onward progress, but more correctly as a 'house' whose floors are interconnected, and in which the dweller, for our purposes the viewer, can scale the floors by interconnecting stairways, moving upward or downward as appropriate. A vivid example of this 'movement', in which the observer descends from the fourth to the first stage, is to be found in the Byzantine tradition where, through icon veneration, a 'holy' personage is presumed to dwell in the symbol. In this instance, however, it appears that we need to add an additional category to run parallel to the primary stage promulgated here, in order to accommodate the notion of embodiment by others. This is ultimate reverence, inexplicable in any formal terms, contained in the realm of tacit knowledge, where as intuition, it possesses an intentionality whose intrinsic meaning consists in it being able to reach its object and face it as existing (Levinas, 1973).

Such is the power of vision, which in giving its objects in a direct manner, is its own reason. However, the objects that we have in mind are icons and thus they carry the mark of mediation, and as such their appearance is through the agency of what we termed quasi-intuition; therefore, a reason of a kind might be expected, at least by those who do not share the faith.

The icon veneration about which we have spoken arises quite clearly from specific cultural factors which demand visual awareness of the icon as icon, and tacit integration of particulars which produce a joint or shared meaning in co-religionists. In a less dramatic, but still potent way, the symbol works through all societies. For example, in the veneration of national flags which can set in train emotive responses that defy formal analysis, and the images of film stars and other popular entertainers who achieve celebrity status and become icons, if not in the absolute sense of Byzantium, then a close parallel to it. Visual images, as vehicles of communication, are ideally suited to produce this effect, they can slide across the boundaries that distinguish concepts, combining at the tacit level a range of particulars that are not easily articulated. The particulars we are concerned with are those subsidiaries that make up the vast range of tacit knowledge gathered through the agency of vision; they may be acquired culturally or socially, imbibed in an apparently natural way; or they may owe their origins to natural causes and events, such as those signs that are the portents of storms. We, as viewers, live in this inner world of subsidiary knowledge, of particulars of which we are not necessarily aware. At all times, the viewer is called upon to interiorise an exterior visual stimulus, to withdraw into the interior pool of the mind where tacit knowledge flourishes and contributes to meaning.

In addition to the primary denoted meaning of the symbol, secondary meanings additional to those overtly portrayed in the image can be set in train. Here the image, although initially the focus of attention, may fade so that attention can focus upon the subsidiary factors with which it is associated in the mind of the viewer. This is the world of evocation where the viewer is truly on his or her own. Although we have been concerned here to describe the nature of tacit knowledge as portrayed in the work of Polanyi, we can see that it holds implications for the concept of communication which we dealt with earlier. Connotation, as we have seen, is a form of additional meaning, a secondary meaning that trades upon denotation made manifest in the image. As a second order relationship, it carries a covert potential for seeking relationships, and thus at the level of the tacit it finds a willing ally. This is the ground of evocation, always a personal space in which lies the individual viewer's pool of tacit knowledge, formed through an amalgamation of natural and cultural experiences. It

is against such a background that symbolic images enter the life of the viewer. But, as viewers or audiences differ, the evocative power of the image will also differ. For successful communication, the communicator's task is to employ those images that will strike a chord, and resonate similarly in the audience's pool of tacit knowledge; the more specific the audience, the more specific can be the image as symbol. Conversely, audiences composed from wider cultural or social backgrounds require to be presented with symbolic images of a more general type, a type that falls within the range of their experience, which is likely to include a large tacit dimension. Thus we find national flags used as symbols in many different contexts, for the reason that their evocative potential covers a wide spectrum of audience.

What we have been considering is the reflective quality of the visual image, the way in which interest is directed away from itself as material form, and the way in which it becomes a vehicle for evocation. In such a situation intrinsic interest is found not in the image as such, but in that which it evokes within the viewer's pool of knowledge, overt or covert. While the impression given here may be one of individual freedom for tacit inference, the fact is that images as symbols are presented with an intention to organise the thoughts of viewers in particular ways, in ways desired by the communicator. Nevertheless, because each viewer brings a personal history to the act of viewing, constraints are placed upon the organising power of the image as symbol, forcing it to operate in a territory already mapped in the mind of the beholder, a territory with tacit dimensions which elicit particular connotations and evocations.

In contrast to the connotative meanings that we have been stressing, and aside from their denotative function, images as material forms have a life of their own. This we might say is the province of art, where intrinsic interest is sought or found not in referential qualities, but in the actual physicality of the image, on relationships within its frame, or frames in the case of moving images. Even so, a tacit dimension is still apparent, exerting its influence beyond conscious awareness. This is more marked when the viewer can identify with the skills that have been employed, and with the sensory nature of the materiality of the image. In such a case, the viewer can be seen to be identifying with the skills and connoisseurship which were mentioned earlier. It should be said, however, that as much as viewers find intrinsic interest in the material form of the image, the mind is constantly subject to infiltration by tacit factors not connected with the surface qualities of the image. Thus at a level below conscious awareness we can identify two streams of tacit influence, one flowing from evocation, and the other from bodily identification with the making and sensuality of the image as form. The fact is that symbolic images, as well as being advance organisers of thought, their fundamental role, possess these dual attributes, which means that attention may fluctuate between the image as image and the image as reference. It would appear that in practice the focus of attention reflects personal commitment, which is governed to a large extent by the viewer's familiarity with styles and techniques, the artistic element, and interest in meaning when it is used as a metaphor.

It is obvious that in visual communication the kind of attention desired by the communicator is not always reflected in the kind of attention actually given by the viewer. An explanation for this state of affairs can at least partly be found in terms that we have discussed in this chapter.

Summary
In this chapter we were concerned to chart the place of the tacit factor in visual communication. This led again to a consideration of perception which is markedly engaged

in the territory of the tacit. We further went on to connect perception with intuition, both concepts connected with visualisation, and here again we found a crucial connection with the tacit. We did, however, find it necessary to qualify our assessment of the place of perception and intuition which, technically speaking, are concerns of the immediate. Nevertheless, we went on to propose that it might be useful to speak about quasi-perception and quasi-intuition when the situation involves visual images given through an intermediary. This proposition was based on the fact that in their pure and quasi forms perception and intuition are non-discursive. They operate in the realm of the analogue, within contexts which are non-linear. In this area the tacit flourishes.

We were further led to consider the role of imagination, where at a level below conscious awareness, and thus in the realm of the tacit, different intuitions are unified; not only that, we found that imagination gives unity to separate material images, for example, film, and the parts that compose a single image, such as paintings and all forms of static images. And furthermore, we were led to consider that it is only through imagination that that which is physically absent can, in a quasi way, become present, and thus enliven mediated images; this is true of all referential images, but it is best exemplified in live TV sports broadcasts. In this way, we can consider visual images as prompts for imagination; but although they are prompts given by others, their efficacy rests upon the individual's repertoire of knowledge, both overt and covert. From imagination we went on to consider the role of the tacit in connotation, and we found that in addition to that which is denoted, the viewer possesses a stock of subsidiary knowledge composed from natural, social, and cultural experiences of life, which form the basis of connotation. Viewing can set in train connoted meanings, many of which are created at the tacit level, where meaning may, or may not, accord with that desired by the communicator.

We went on to apply the concept of 'indwelling', a metaphor that describes the range of tacit knowledge available to the viewer, and of which at any moment he or she may not have conscious awareness. This knowledge includes tacit awareness of the skills involved in the production of images and the variety of non-verbal factors, cultural and otherwise, that inform the image. Particularly, we should note that overt, conscious awareness can, with the passage of time, descend into covert awareness; in this way, culturally determined knowledge can be mistaken for natural knowledge. In the territory of the tacit, at a level below conscious awareness, there is no argument.

In the next chapter we move from concern with the tacit to aesthetics, and here again we find ourselves in the realm of something apparently beyond words and yet a vital part of the whole field of visual communication.

5

THE AESTHETIC DIMENSION

Here we are presented with an image which has no overt meaning, no symbols to decode, no hidden meaning, but it has form, a form given by the artist. It is there before the eye to scan, to act as a stimulus for the contemplation of form, it exists in its own right without any necessary recourse for verbal explanation or reasoning.

Fig. 6. Print by Derrick Hawker, 1975.

Here we find ourselves in the realm of aesthetics which resists verbalisation except in terms of value judgements, which themselves are only expressed in terms of degrees, and therefore, one might say the experience is 'untranslatable'. Nevertheless its importance in the general scheme of things related to visual communication demands careful appraisal, particularly in relation to art and art appreciation. Like the tacit factor, it is closely tied to sensory perception, and thus to those aspects of communication which touch upon man's natural state of being, to feelings and emotion.

The role of the image in communication can be not only one of signification where attention is deflected from the image towards other thoughts or associations, but also as an instigator of feelings that arise from an awareness or contemplation of the image as pure material form, or, as one might say, the discovery of intrinsic interest in its physical properties. In the image's signifying or semiotic role attention is directed to a world external to itself, while in its aesthetic role attention is focused upon its inner form. We may contrast this state of affairs with that of verbal communication where, in general, the printed letter/word, as a graphic entity, usually lacks an inner or aesthetic dimension, except to those with an interest in typography.

Broadly speaking, the more the reader is unaware of letters and words as things in their own right during the act of reading, the more efficient is the act; in effect the reader is not usually aware of any perceptual involvement. This is in marked contrast to the visual image which demands that it be scanned, not in the linear fashion associated with reading, but in a multi-directional search that possesses both conscious and subconscious elements. The image may, in fact, be presented as a unique display freshly invented and existing outside any formal lexicon. And while it may instigate semantic associations, the image always engages perception in a more demanding way than that of the letter as print; albeit, one might add, in the quasi way that was suggested in the previous chapter. In viewing an image, the thoughts of the viewer may turn, consciously or subconsciously, in the direction of signification, while at the same time and by the same token the visual aspect of the image as material form presents itself for parallel processing.

In terms of communication, it is the semiotic potential of the image that assumes primary importance, here its service is to thought and concepts, to the language side of communication; but, as we have seen, the image offers an aesthetic potential to viewers by virtue of the infinite possibilities of its inner form, a form that can create a particular resonance in the viewer and thereby present a dimension additional to that of signification. In its referential role as metaphor or symbol the image does however point beyond itself to something else, e.g., a flag for a country, but in its aesthetic role, as we have noted, it points to itself, an inner direction without exterior motivation. This is where art lies; notice for example the simplicity of the referential aspect of many great works of art, but the intensity of their inner relationships, e.g., the work of Van Gogh and Cézanne. Art, as Barthes (1985) proclaimed, exists the moment our glance has the signifier as its object. By this he meant when the focus of interest is centred upon the image as a thing in itself, and not upon what it is intended to mean.

In opening this chapter on aesthetics two contrasting facets have been presented with regard to the visual image:

(a) referential aspect: external relations; the image points away from itself; satisfaction or meaning is found in that which the image evokes; the physical form of the image is of little consequence. (non-aesthetic).

(b) non-referential aspect: internal relations of the image as pure form; satisfaction is found by the viewer in the feeling engendered by the contemplation of the form. (aesthetic).

Stress has been laid upon these aspects of the image because they represent its dual potential, as a form whose intended meaning lies outside itself, and as a form which is sufficient unto itself. But in point of fact, the act of viewing cannot be separated quite so easily into these two distinct modes. The unity of the mind that apprehends a visual image is composed of determinations from a variety of sources, including interest, expectations, and cultural influences, which bias the individual viewer's mode of apprehension and thus interpretation. Furthermore, the viewer's attention might fluctuate between either of the image's modes of being, without any conscious awareness on his or her part. That being said, we need to delve deeper into the general field of aesthetics in order to uncover some of the broader issues that an enquiry of this kind raises. In doing so, we shall widen the conceptual base of our enquiry, and this means that we begin by focusing upon the elemental nature of aesthetics which is one of primary processing. From here we shall go on to develop a number of related ideas while re-introducing relevant concepts from earlier chapters.

Before unfolding steps for a theory of aesthetics that can be usefully applied to the study of visual communication, we had better clarify the variety of meanings with which the term aesthetics has become surrounded. It is often applied as a term covering value judgements that arise from cultural determinations, for example when things are spoken about as being 'in good taste'. And although visual communication may be concerned with the inculcation of values, our concern involves more than matters of cultural taste. But having said that, we cannot discount the fact that value judgements of taste can arise at any time when an individual is engaged in the perception of images, and that such judgements may be purely personal or be determined on the basis of cultural conditioning of an aesthetic kind.

The word aesthetic has its origins in the Greek language where as 'aesthetiki' it refers to the theory of sense perception and feelings. In this sense, its frame of reference is that of the individual, irrespective of cultural values. However, we find that on transposition into English the term is broadened to include notions of good taste, and thus it enters the realms of the socio-cultural where arbitrary standards determine the notion of goodness. For example, in the Oxford English Dictionary the word aesthetic is defined as, "received by the senses, or of pertaining to the appreciation or criticism of the beautiful, or having or showing refined taste, or in accordance with good taste." If we were to be guided by this definition, then we would be engaged not only in the study of sensory perception and feeling, but also in the study of relative cultural values. Such an approach would be fraught with social/cultural/educational implications that go beyond the objectives set for this book.

Technically speaking, the direction of this chapter is towards 'aesthesis', the perception of the external world by the senses, and 'aesthesics', the abstract science of feeling. But, as the word aesthetics has now become an umbrella term to cover the general field in which our interests lie, it is this word that we shall use, bearing in mind the liberty that we are taking. Others, notably Zettl (1973), found it necessary to apply their own yardstick in defining aesthetics. In his book on television and film he presented a media oriented definition when he wrote, "Nor do we consider aesthetics to mean merely the theory of art. Rather we have taken the original meaning of the Greek verb aisthanomai (I perceive) and aisthetike (sense perception) as the basis for our examination of the specific television and film image elements: light, space, time-motion, and sound. Aesthetics then means for us a study of certain

sense perceptions." In this definition there is no concession to right and wrong, good or bad, it is not value loaded, it strikes at the heart of aesthetics which is sustained at a level below conscious awareness where, as we found in the tacit dimension, there is no place for argument. It is a place of the immediate and of intuition.

Later in this chapter we shall be applying ourselves to functional aspects that arise from such media considerations. But, as the work of Kant (1951) so clearly demonstrates, aesthetics is rooted in the notion of subjectivity, the subjectivity that gives rise to feelings of pleasure or pain, experienced without the aid of concepts. This is the place where life is lived without the formality of social or cultural codes, experienced without objective references; it is both subjective and personal. It is within a world lacking in concepts that aesthetics finds space; a world where negation is unknown; cast in libidinal terms by Freud where there is exemption from mutual contradiction, and a replacement of external by internal reality.

The concept of inner forces or inner directedness is a consistent theme in the conceptualisation of aesthetics. For example, it is prominent in the title of a book 'Inner Vision', in which the author, Semir Zeki (1999), a neuro-physiologist, explores the relationship between art and the brain, with particular reference to vision. And from a less scientific perspective, we may note that Kandinsky included the notion of inner forces when he spoke about the inner pulsation of a work of art. Static works of art cannot naturally pulsate of themselves; the pulsation of which he spoke is none other than the mind of the viewer responding, or in his terms pulsating, to the connections or associations which can be found in the image. The point is that Kandinsky is asking the viewer to 'stay' within the image, and not to use it as a place of departure for external reference. In this instance, the image as signifier then becomes the focus of attention in its own right; art is born. Although he did not emphasise the term aesthetic, it is implicit in his thoughts about art which are best summarised in his own words. He wrote (Kandinsky, 1977), "We must find a form of expression which excludes the fable and yet does not restrict the free working of colour in any way. The forms, movement and colour which we borrow from nature must produce no outward effect nor be associated with external objects. The more obvious is the separation from nature, the more likely is the inner meaning to be pure and unhampered. The tendency of a work of art may be very simple, but provided it is not dictated by any external motive and provided it is not working to any material end, the harmony will be pure."

Here we have the idea of art with no semiotic or referential import, art as pure form, to be experienced as an inner force without objectivity. No doubt the reader could object that a work of art cannot escape conceptualisation, that it stands as a category, the category of art object, and thereby it is a member of the semiotic family. This apart, we can, for the purposes of study, place Kandinsky's ideas at one end of a spectrum of aesthetics, noticeably with the end which is concerned with the image as material form with inner tensions. While at the other end, which we may regard as the true place of pulsation, stands the individual, the individual viewer composed of inner potentials which create the grounds for aesthetic sensibility. It is here, the place of primary processing, where perception is registered and intuition unfolds, that aesthetics is transcribed.

From the perspective of those whose concern is with art as artefact, interest has quite naturally centred upon the first of these conditions, that of the image as material form, its structure and interconnectedness, and through iconography to the concept of decorum. While on the other hand, those concerned with the individual viewer as a responding agent have tended to focus their attention on psychological factors. Despite these understandable

differences in orientation, we can find in the work of Kant a thread that connects. In his work we find not only references to art as artefact, but also insights into the basic source of aesthetics within the individual. Thus armed, we can make a ready connection with the more recent ideas that have stemmed from psycho-analysis, particularly the concept of primary processing. The significance of the work of Kant, and those in the tradition of psycho-analysis, is the stress placed upon its non-conceptual nature, its positivity, and its employment of intuition. To which we might add the figurative component. As the reader might see, the grounds are set for the introduction of notions of the unconscious and preconscious, the territory par excellence of psycho-analysis. It is here that the fundamentals of aesthetic sensibility are to be found, within primary processes that precede codes and codification.

Primary Processing
A visual image may, as we have seen, have its feet in two camps, one of which is inner directed and the other outer directed. The inner direction refers to the potential it possesses for providing visual stimuli whose interconnections can be processed without reference to meaning, that is meaning of an objective or referential kind. In such instances, satisfaction or dissatisfaction rests entirely with the form of the image. In this way, visual images are always ranged in the field of positivity, the raw positive presence of the image as a material form, given to the eye here and now, whether through the agency of paint, film, print, or any other medium of communication. In contrast, the outer direction is one in which the viewer is required to leave the immediacy of the image, if only through imagination, and engage with things absent from the immediate viewing situation. In this case we could say that the image serves as an instigator of thought, propelling the viewer away from the actuality of the image as a material object, towards that which is absent; for example, in the way that a photograph can serve to direct thought from itself as an image, towards a person portrayed who is no longer present. Thus, in the case of the image's outer direction, we are dealing with negativity, with absence rather than presence, the opposite of that which was proclaimed for the image's inner directedness.

But what is of special interest to our concern with the aesthetics of visual communication, in whatever medium it is conveyed, is the significance of its roots in the primary state of immediacy and positivity that precedes the negation that comes with the onset of concepts. Aesthetic judgement may be subject to overlays of cultural conditioning, but like intuition, its origins lie in a pre-conceptual world that knows nothing about negation, its nature is one of subjectivity and of feeling. This is not to suggest that feelings cannot arise from symbolic forms, they clearly do so, but the determining ground of aesthetics is not one of concepts, but of the internal sense of harmony or disharmony in the mental state produced by the representation.

The paradox is that although we have, of necessity, to employ concepts in our portrayal of aesthetics, it is itself concept free. Its determining characteristics are those of pleasure and pain, satisfaction and dissatisfaction, cast in the primary territory of subjectivity, a place where the world of art and images is judged not by thought or reason, which are secondary attributes of knowing, but by the feelings they arouse. Pleasure and pain are always felt experiences, directly involved with the body in its primordial state, the primary state of being. And it is at this level that we can find a significant connection with the work of others who have been concerned to establish aesthetics, not merely as a cultural entity, but more significantly within the primary processes that are present in the mental apparatus from the

beginning. For example, we can find in the work of Lyotard (reported in Benjamin, 1989), who was concerned with the problem of representation, reference to the work of Freud, who, in his book 'Beyond the Pleasure Principle', suggested that situations which have an increase in pleasure as their final output could form the object of aesthetics conceived as an economy. But what is of greater significance to our interest, is that in the work of both Kant and Freud, aesthetics is cast in the primary state of being. In Kant's case it is contained within the pre-conceptual state, whereas in Freud's case it is within the libidinal, where things do not stand for anything, and where nothing is concealed, which is the very reverse of symbolism. In both cases, it is pre-cultural, although it must be admitted that in a developmental way socio-cultural factors begin to influence aesthetic awareness or sensitivity. However, the essence of aesthetics lies within the territory of primary processing, the place of the subliminal, in which as Ehrenzweig (1967) explained, unconscious scanning is able to handle open structures with blurred frontiers. As such it is the place of the analogue rather than the digital, and where, should measurement exist, the appropriate scale would be a continuum with polarities of pleasure and pain, or satisfaction and dissatisfaction.

Pleasure and pain as such are not thought, they are felt, and while they are made manifest to consciousness, they belong to that sub-strata of awareness that engages the unconscious, and hence the relevance of Freudian concepts to our theme, which is echoed in the work of Bateson (1980). For example, when writing about images, he suggested that images are structured on the basis of two general facts, firstly, the fact that a person is unconscious of the process, and secondly, that it is an unconscious process in which a range of presuppositions are brought into play. However, while putting forward these general facts about image formation, it is interesting to note that Bateson was uncertain about the surface on which a theory of aesthetics could be mapped. And yet, he confidently expressed the view that it is within the primary definition of mind that accommodation has to be found for theories of aesthetics. Thus we find reinforcement for the idea that aesthetics belongs, at least at its centre, to the primary order of things; that while it may be spoken about in relation to art and art objects, it does not belong to them, it is lodged within the subjectivity of the viewer's mind.

In taking up the thoughts of Bateson, we are able to provide ourselves with what is perhaps the most succinct and appropriate definition of aesthetics in relation to the viewing situation. He wrote, "By aesthetic I mean responsive to the pattern which connects." Here is the first clue to the idea that aesthetics is about response, which, for our purposes, means perceiving and then responding, not necessarily consciously, to a visual image. The second clue is contained in the notion of pattern, and as such it implies awareness of relationships and order, which may or may not be known consciously.

There are similarities here with the processes of perception, where a mass of separate stimuli impinge upon the retina before order of a mental kind is imposed, which may then manifest itself as pattern. The pattern which is thus perceived is carried on the strength of connections or relations, which themselves may induce feelings associated with harmony or disharmony, satisfaction or dissatisfaction, pleasure or pain. Although it is as a response that aesthetic feelings are given to presence, it is an active response, one in which the viewer is required to perceive relationships; to search for order or pattern, often at a level below that of conscious awareness. It is the feelings engendered by this process, the feelings for form, in all its manifest ways, that we may regard as aesthetic experience; it is an experience structured in man's fundamental being. It is primary. In certain circumstances such experience may be

felt in a rhythmic way, a patterned experience which through kinaesthesis can engage the body in a more physical way than the purely mental. A good example from the world of art is that of Jackson Pollock whose works (see Fig. 7, p. 90), although naturally static as paintings, may generate sympathetic responses of a kinaesthetic kind in the viewer.

We have taken the stand here that aesthetics is not concerned with notions of value judgements, at least not value judgements given by others and derived from notions of right and wrong, or correct and incorrect. On the one hand we have emphasised the engagement with the materiality of images, their form and their inter-connections; and thus we have stressed their concrete nature as things to be taken in their own right, given immediately to the viewer. On the other hand, we have emphasised the viewer's contribution which is subjective, self-referenced, and which manifests itself in terms of feelings which exist at the primary level of awareness, which knows not of negation or concepts, but only contents. Whether we focus upon the material image or the mind of the viewer, we can detect communality of interest in the notion of presence when defining aesthetics. Firstly, there is the requirement of presence of an image, of a form offering itself here and now for immediate perception; and, secondly, there is the requirement that the image produces an immediate and thus present feeling in the visceral system of the viewer. Such a situation does not easily lend itself to measurement of a discrete, digital kind, but more readily to the fluidity of a continuous scale running from, for example, the polarities of pleasure and pain, or satisfaction to dissatisfaction.

Form

We have seen from the work of Bateson, the term aesthetic described as a response, a response to a pattern that connects. The response to which he alludes can be taken to be the feeling experienced through the perception of relationships, or in his words with connections, which in their totality are experienced as pattern or unity, from which some sort of satisfaction is derived. Here we are speaking about form, that which is more than the sum of the parts. The form of material images consists of elements in spatial juxtaposition, but it requires the mind of the viewer to perceive the interconnections between and among its various elements. The elements themselves do not make the connections, although through proximity they appear to do so, the fusing of the parts is a job for the mind, to connect the separate. And although in a semiotic sense the mind of the viewer can create connections with things or ideas outside the image, it is with the image as physical form existing before the eye of the viewer that we are here concerned.

In speaking about the form of images we are concerned with two distinct kinds: firstly, as mentioned above, there is the physical form of the material image given in external space, which may be composed of lines, colours, tones, or shapes cast in two-dimensions; and secondly, there is the mental form cast in the inner, mental space of the viewer. It is here, in this space of the mind that aesthetics resides, it is here that harmony or disharmony, satisfaction or dissatisfaction is felt. Thus we can say that although material images can create circumstances in which aesthetic sensitivity may flourish, it is in the actual dynamics of perception that aesthetic feeling is generated.

The making of images is essentially that of spatial ordering of elements, putting marks in particular relationships on a two-dimensional plane on a material surface, which cannot of itself know feeling, and thus, by our definition, be aesthetic. But that which is perceived, and perceived on the basis of inter-relationships within the form of the image opens the grounds

for aesthetics. Therefore, we might say that the image maker, through his or her own sensitivity to the nature of form, offers the viewer a framework, a series of proximal inter-connections which present opportunities for the viewer to experience an aesthetic response. However, if such opportunities are to be taken fully, the viewer must be equipped with the motivation and heightened perceptual awareness that is necessary to deal with the intricacies of the form which is proffered. When these conditions are met, then an aesthetic response can be generated which accords with the intention of the image maker, assuming that such intentions are present in the first place. The proffered relationships may produce satisfaction or dissatisfaction of varying degrees, whenever it is a response to the form as form it is aesthetical.

From this it follows that aesthetics is not necessarily associated with enjoyment, but more correctly with experience, which is one of feeling. Thus we can explain why art is still art when its subject matter is violence. For example, the painter Francis Bacon, whose work at a semiotic level could be said to possess violent undertones, is on record as saying, "You don't need to have a clue for a painting. If it's got anything, it's there." What is there of course is pure paint on a two-dimensional surface, a physical presence set in a particular way, a particular form which can be judged without the need for concepts, that is when attention is focused upon the relationships or form contained in its material being. This is the direction of aesthetics, and it is this that makes the work of Bacon significantly different from violence portrayed in the popular media. It confirms the view expressed here that aesthetics originates in the relationships found in the concrete form of the image which is before the viewer, here and now; a physical presence that offers itself to perception.

The direction that vision might take in the face of a particular image is of course motivated by the viewer's personal interest or concern, it can, as Cassirer (1965) pointed out, stand in an entirely different sphere of vision when it is taken as a mythical symbol or as an aesthetic ornament. Viewed as an ornament it is remote from signification in the logical-conceptual sense and the magical-mythical sense. Its meaning, as Cassirer acknowledged, lies in itself and discloses itself only to pure artistic vision, to the aesthetic eye. This is in line with the viewpoint that we have established, a viewpoint that places emphasis upon the image as a source of satisfaction or dissatisfaction, in its own right. The primacy of form in artistic appreciation was expressed well by Cassirer (1979) when he wrote, "…the awareness of pure forms of things is by no means an instinctive gift, a gift of nature. We may have met with an object of our ordinary sense experience a thousand times, without ever having seen its 'form'. We are still at a loss if asked to describe not its physical qualities or effects, but its pure visual shape and structure. It is art that fills this gap. Here we live in the realms of pure forms rather than in that of the analysis and scrutiny of sense objects or the study of their effects." There are echoes here of Kandinsky who, as we have already seen, was concerned to promulgate the idea of pure forms in the visual arts. But it is not only in the fine arts that we can detect interest in form for its own sake. It can be observed in the more mundane world of television and press photography, when the images presented display evidence of their creator's concern with the image as pure form; for example when lighting effects are deliberately engineered to produce tonal contrasts that add little to the image's semiotic potential, but a great deal to its form as pure form. In such circumstances, we could say that the obvious meaning is clouded or subverted by the aesthetic.

In the normal run of events, in life lived in its day to day tedium, where televised images are scattered in profundity, filling screen time in much the same way as the press fills a daily

ration of newsprint, merely out of custom, the consciousness of the general public is, one could guess, not usually concerned with aesthetic issues, that is with satisfaction obtained from the form of the broadcast (cast broadly) image. Although, in fairness, it could be argued that specialised art programmes generally aim to fill this role; but even here one is often aware of the need for popularisation. For example, when stress is placed upon the biographical details of artists rather than on the form that their work takes. It generally takes the ambience of an art gallery, the specialised cinema, or their equivalents, to heighten aesthetic sensitivity. In such situations the viewer is framed by an expectation, the expectation that one who enters such premises does so with the purpose of regarding the images on view in a certain way, an aesthetic way. In such circumstances, often at a level below conscious awareness, the mind of the visitor as viewer, is 'in-formed', framed by unseen co-ordinates that guide the viewer into a particular mode of appreciation, that of aesthetics. In this mode, priority is given to the observance of form, in all its manifest ways. When it fails to do so, the viewer may be perplexed, or, as is often the case, attends to the image solely as a semiotic entity. In this mode, the search is for connections elsewhere than in the image; what the viewer desires is resolution of meaning, in which case the image is a 'stand-in' for something else, within a territory which lies outside the scope of aesthetics.

The direction of aesthetics, as we have seen, involves a search for relationships within the observable form of the image, a task whose remit is the perception of relationships, of similarity or contrast, harmony or disharmony, and of scale. While the alternative mode, that of semiotics, requires the viewer to go beyond the physical form of the image there before the eye, and on to relationships which require thought or connections to be made through the agency of symbolism. Nevertheless, in neither mode, the aesthetic or the semiotic, is the territory a tabula rasa; existing perceptual forms or frameworks and mental maps, gathered in life's experience, influence interpretation in specific ways. Thus there is always the possibility that, irrespective of the communicator's intention, the viewer will attend to that aspect of the form, the aesthetic or semiotic, that he or she finds most satisfying. And indeed the viewer's attention might oscillate between the two.

It is a fact that through guided learning viewers can become more sensitive to the nuances of form, to relations and inter-relations which would otherwise pass them by. Such guidance helps to create an additional source of interest in the image, per se, over and above the obvious one of meaning. In terms of information theory, it can be seen to open avenues that provide extra sources of information and arousal. Furthermore, it is the heightening of awareness of form in all its manifestations that provides the basis for what we might term aesthetic growth, for intrinsic interest being found in the observed form rather than inferred meaning associated with representational art and symbolism.

Intrinsic Interest

As we have seen, visual images carry the potential to inform viewers in two distinct ways: firstly, by their material form, by the relations that are perceived in their immediate presence, there as they stand or are displayed before the eye; and secondly, by their form as signifiers, clothed in codes and conventions, which require deciphering at another level, where their role is that of 'stand-ins', assuming a kind of pseudo presence. Broadly speaking, viewers are not usually aware of this dichotomy; their first concern tends, quite naturally, to be one of attributing meaning, rather than generating interest in form for its own sake. Given that the visual sense, in its normal encounter with things within its scope, is usually engaged in a

'search for meaning', that whenever possible it eschews ambiguity, we can appreciate that the apportioning of signification and the resolution of doubt are primary objectives. However, as cave paintings of early man show, there exists a latent propensity to articulate the form of observed objects in ways which demonstrate an interest that goes beyond that of pure concern with signification. Despite this early manifestation of interest in form, the fact remains that perhaps then, and almost certainly now, when faced with a visual image, the majority of people are, quite naturally, more interested in what it means, rather than in its surface qualities.

What is it, we may ask, that guides viewers into one direction of interest, say the referential as against the aesthetic? And how about the oscillation between the two that we have already spoken about; where does that fit into the picture? And how do such oscillations, when they occur, create more or less information, when measured in terms of information theory? These and perhaps many other questions are easier to ask than to answer; truly satisfactory answers would require empirical evidence, which itself poses difficulties, owing to the subjective nature of data gained from human inference. However, by borrowing ideas from the work of Polanyi, which stemmed from his concern with personal knowledge, we have, as it were, a ready made schema for dealing with the concept of interest, and one that can, with some modification, be usefully applied to our special concern with aspects of visual communication.

From experience we are usually aware that attention to an image, or images in the case of film or television, is guided or informed, largely on the basis of personal interest, and that, over time, it may wax and wane. And, generally speaking, we need no reminder of the fact that motivation is a prime factor in generating attention. Thus we can appreciate that interest and attention are blood brothers, or, more accurately, that interest plays a major role in directing or strengthening attention, particularly in the type of 'free viewing' situation, such as one finds in television viewing in the privacy of the home, where one is not monitored by others. In less free environments, for example formal educational settings, where commitments are not wholly self-determined, interest may still be present, but it may owe more to the determinations of others, the controllers. We may also notice that gaining attention and creating interest is one of the key factors in the armoury of the advertisers, the same could be said of political propagandists who likewise employ techniques to arouse attention, and retain interest.

Though the implications of advertising and propaganda are quite central to visual communication, our concern here is to 'tease-out' in more detail the role that interest plays in determining the alternative ways that visual images can be perceived. And it is from this perspective that we shall set out to recast Polanyi's ideas on the place of intrinsic interest in personal knowledge, and, in doing so, to show the relevance they hold for visual communication in general and images in particular. Polanyi suggests that there are two distinct kinds of signs, indicators and symbols, and that they produce a different focus of attention. In the first place, visual signs, in his way of thinking, may be intended and perceived solely as indicators, possessing no intrinsic interest in their own right. In this case interest is only found in that upon which they bear, which may be classified as their intended meaning, for example, a road sign bearing only an arrow. Secondly, they may present themselves as symbolic images, bearing a pictorial likeness to some recognisable human act or activity, but intended to portray an idea or principle; in this sense they are metaphors. Here interest is sustained in two ways; forward, towards the ideas that they bear upon, their intended

meaning, and backward, towards their inspirational source. In this way, symbolic images possess a twofold source of interest; but they do require the viewer to have a mind prepared with the necessary subsidiary knowledge for the image to function as a metaphor.

While visual indicators are, generally speaking, only interesting through that upon which they bear, and while symbolic images offer an additional source of interest through their metaphoric connection, we can recognise a third dimension, the aesthetic. A good example is provided by historical, religious pictures which contain rich painterly qualities. On the other hand, it is quite possible that a viewer may perceive no metaphoric connections in a symbolic image, and yet still find interest in its factual contents. While a further possibility exists that, to certain viewers, interest may only be found in the form; in which case we would speak about appreciation of the pure aesthetic.

We are now in a position to amplify the three separate dimensions of intrinsic interest:

1. Sign as indicator (e.g. road sign)
 intrinsic interest found solely in that which it denotes; aesthetic interest in its form is at best minimal.
2. Symbolic image (e.g. religious painting)
 intrinsic interest found in two directions, that which the symbol denotes, and that which it connotes; aesthetic interest in its form may be extensive.
3. Image as art object (e.g. gallery painting in the modern style)
 intrinsic interest found solely in its form, the pure aesthetic.

It will be seen that the aesthetic factor rises on an ascending scale of importance, beginning with its almost non-existence in images when they function as indicators, to symbols, that, although primarily intended to signify, may, in their form, offer strong grounds for aesthetic appreciation, and finally, to the image when it is intended as pure form, devoid of meaning, except of itself as an art object.

Although intrinsic interest can be found at each of these levels, it is in appreciation of the form of the presentation that aesthetic interest lies. And furthermore, it would appear that the more the image is intended, as it were, to turn upon itself as art artefact, the more deliberately must attention be focused upon internal connections and associations. Aesthetics resides in the viewer not in the image; the image, one could say, is the prompt, the viewer is the respondent. For the vast majority of people, it would appear that interest in the image's form, in its aesthetic, is of lesser concern than that which it denotes or connotes. This is not to imply that aesthetic feelings are generated only in those formally prepared by way of education or training, but it does mean that a heightening of sensitivity to form, as pure form, is enhanced when the viewer is consciously aware of the relationships contained in the image's material form. Its 'signifiance', as Barthes would say, 'requires a trained eye', an eye that can search consciously for similarities or contrasts, to make the most of what is on offer. In extreme circumstances, commonly known as minimalism, where meaning of a conventional kind is absent, the eye is called upon to seek maximum information in minimal conditions. Thus we are led to consider aesthetics as a kind of conscious or subconscious search, where rewards are found in the discovery of relationships or oppositions there before the eye. To the extent that the form of the image provides the viewer with differences, to that extent ideas from the field of information theory provide another means for analysing the aesthetic factor in visual communication.

In Search of Information

The amount of interest that a visual image generates is naturally determined by what the viewer can 'see in it'; thus if a particular viewer, colloquially speaking, 'sees nothing in

it', then it is to him or her, obviously uninteresting. But as we are now aware, 'seeing' can take two directions. Firstly, it may take the path of signification, in which case the journey is one in which interest is found in its meaning, or intended meaning, in which case the image is purely instrumental. Secondly, it may take the alternative path which leads to an exploration of its aesthetic dimension, in which case the form of the image becomes the source of interest. Whichever route is taken, whether it is towards signification or aesthetics, the viewer is engaged, consciously or subconsciously, in a 'search for information', which is defined in communication theory terms as that which adds to representation (Cherry, 1961). In either case, the implication is that the viewer is changed by the experience. In the case of signification, the mind is called upon to search its memory bank for conceptual relationships; while in the case of aesthetics, it is called upon to perceive relationships, there within the form of the image. In the latter case, the viewer has to scan the image in a search for information, scanning, for example, for contrasts or similarities, and for differences in planes and tones, which together form a unitary experience. But in both cases, when new or additional relationships are established, the experience is one of change, a change in the viewer's existing conceptual or perceptual matrices.

Whichever way the issue is approached, the search for information can be construed as a search for difference; the difference is the information; without difference there is an infinity of nothingness. To the blind, estranged as they are from visual stimuli, the world is naturally empty of visual differences, and thus of visual information. And while this is patently true of the blind, it is still true in a less dramatic way of those sighted people who have no expectancy of finding subtle differences in the form of the image, or in a more general sense, when they are unaware of the significance of the differences that the eye perceives. It could be argued that in such a situation the viewer is without the ability for selecting the difference that makes the difference. To perceive is to select, but selection always implies an awareness of difference, and although the human visual system is geared to the perception of differences, it does not necessarily raise the fact to consciousness. It is when the differences are raised to consciousness, when they rise above the subliminal, that aesthetic pleasure or displeasure is at its highest. The search for information, as we have already stressed, involves searching for difference. But while there are an infinite number of differences in any given image, they are not all equally capable of generating the difference that makes the difference, which in communication theory is known as a unit of information, technically speaking a binary unit, a 'bit'.

Moreover, the differences that we have in mind can never be localised, a fact illustrated by Bateson (1973), when he wrote, "There is a difference between the colour of this desk and the colour of this pad. But that difference is not in the pad, it is not in the desk. The difference is not in the space between them. In a word, a difference is an idea." It is, as he went on to say, a psychological input; the difference is in the mind of the viewer not in the image itself, although naturally, the image is the source from which difference is either intuited or conceived as fact. While ideas and aesthetic discriminations are both sustained by difference, there exists a significant problem when we come to apply information theory concepts to aesthetic discrimination. Whereas information based on linguistic criteria is digital, with boundaries defined by convention and contained in a lexicon, the situation is more open in

the case of aesthetics, whose criteria is analogical, expressed in terms of magnitude, for example, by such terms as 'more' or 'less'. Thus the subtlety of the senses is sacrificed for communication purposes when it is expressed in verbal language.

To the individual viewer, who is not called upon to portray his or her feelings about a representation, the analogical basis of aesthetic awareness presents no problem. The body itself, through feeling and emotion, is the yardstick by which it is known, or more correctly felt. It is only when the experience has to be expressed formally in a verbal way that a problem arises, here, that which is experienced as analogue has to be transposed into the digital; and thus, we might say, it loses something in the telling. But, significantly, it is in the territory of the analogue that fine distinctions can be made. Who can, for instance, find words to express all the subtleties of colour that the eye can detect even in one given range? And who can adequately give verbal expression to the complexity of relations that can be found in any one of the great paintings in traditional western art? Thus, if we are to apply those concepts from information theory which are embedded in strict binary distinctions, and measured in 'bits', then we should do so with caution. Information theory, as is well-known, was established as a technique to measure the capacity of communication channels for discrete verbal messages, and while later writers, for example Berlyne and Moles applied its methodology to aesthetics, there is still something about aesthetics that makes information theory a less than adequate technique for analysis, given the non-discursive nature of aesthetics. What is necessary for its analysis is a methodology that can encompass its essential form as analogue.

To the present writer, skill theory based on the work carried out at the Applied Psychology Research Unit at Cambridge University into human perceptual skills is an obvious candidate to serve this function. It not only incorporates ideas from information theory, but, in addition, it has the necessary conceptual breadth to accommodate the non-verbal characteristics that are germane to aesthetics. It is involved with decision-making, but like aesthetics, it operates in situations that cannot be clearly defined in verbal terms. To the extent that aesthetics involves decision-making, that it is supplied with sensory inputs, that it is associated with learning, discrimination, and anticipation, it displays similar characteristics to perceptual skills. And when time is a factor, as is the case with moving images, the relevance of research into perceptual skills to aesthetics becomes even more relevant. The unfolding and the time bound nature of many perceptual skills produces a continuous search for information from an ever changing array of sensory stimuli, but out of this array, each piece of information is not equally important for the successful execution of the task. A useful example is that of car driving; at the outset the sensory information to be processed appears, to the novice driver, to be extremely demanding, because at this stage the learner is unable to distinguish between that which is important and that which is irrelevant to the skill. But, with practice, the learner develops the ability to discriminate between the variety of visual inputs that the task presents, and to respond in the correct way. Although verbal hints may speed up the actual process of learning, it is essentially one in which the learner has to rely on non-verbal cues.

The fundamentals of perceptual skills that we have just outlined can be seen to be at work in the development of aesthetic awareness or sensitivity, here the viewer is called upon to observe relationships, to pick out that which is significant from the insignificant; in information theory terms, to distinguish between information and redundancy. But although aesthetics does not call upon physical responses, as in the aforementioned example, it does call upon a mental response, an awareness of interrelations, some of which as in other

perceptual skills contribute more information than others to the unity of experience. In this way visual aesthetics can be considered a skilled activity, which demands that the viewer acquires the ability to discriminate between that which is significant and that which is insignificant. It is always engaged in a search for information within the form as presented, but it is guided by previous knowledge. An important consequence of this state of affairs is that, to the prepared mind, information can be found in that which, to others, may be barren, or of no significance. In this way we can explain the difference between those who can 'see something' and those who can 'see nothing' in the form of an image, particularly this is so with minimalist art.

A concept central to perceptual skill theory is that of anticipation. Perceptual skills are guided by anticipation, by pre-determined expectations of the way in which events are likely to unfold. Likewise, we may observe that aesthetic appreciation is similarly affected. The viewer carries pre-formed expectations, ready-made mental schemata that tend to channel attention in certain ways, to certain expectations. It is an inevitable fact of life, it pervades perception, and thus narrows the possible range of choices that can be made. Its function bears some similarity to that of the hypothesis in scientific work, which narrows the possible alternatives through which things can be found or known. This being so, we can see the inevitability of people, as viewers with particular experiential backgrounds, gaining or not gaining aesthetic satisfaction from specific visual representations. Aesthetic awareness is always conditional, conditional not only on biological factors that give rise to feelings, but also on learned factors, that pre-dispose people to view images or representations with an eye to form. By raising to consciousness the variety of hitherto unseen differences, more information is generated, and more interest can be found in the form. But, as is the case with all perceptual skills, there is an important learning element. Educational experiences that encourage students to be consciously aware of differences that would otherwise escape their attention, to become aware of fine discriminations and contrasts, create the conditions in which information of a sensory kind can be magnified.

The prepared mind, as we can appreciate, can anticipate relationships, and thus approach an aesthetic experience with some sense of expectation, an expectation that the form has something to offer in its own right. Music, as an art form, as Kandinsky suggested, is the exemplar of the pure aesthetic. And it is here that anticipation plays a significant role. As we know from experience, it is through expectation that we can project a particular sound series into an anticipated future, a rhythmic projection. Likewise, when viewing moving images, the mind casts forward in anticipation of patterns to come, and in the more limited case of the single image, even here, scanning is involved, and thus a sequential element is introduced.

When the experience is gained from the form of the image, or images in the case of moving images, it may be felt in terms of satisfaction, or possibly dissatisfaction (either state is allowable in aesthetics). In either case the feeling is one which is never verbally expressible, except in a limited way. The analogical relationships observed in the form have their counterpart more in the resonance that they evoke in terms of feeling, it is more one of sympathy than objectivity. Its roots are in man's biological being, beyond and before the onset of verbal communication, but which, nevertheless, can be enhanced through a deliberate act of learning. We might describe this type of learning as heightening of attention to those critical differences which, although already there, have value only when they are raised to consciousness. This is the basis on which human perceptual skills develop, it is also the way in which aesthetic sensitivity is enhanced.

Concerning the Media

For aesthetics, the seat of interest and the focus of attention centres on form. This is the case whether the image is intended to perform the role of symbol, or whether it is intended to be purely self-referential, serving solely as a vehicle for artistic expression. In either case, images are always artefacts, and being artefacts they are subject to the constraints and possibilities of the materials and techniques with which they are constructed and presented. Although the possible forms that images may assume appear to be infinite, carrying with them the prospect of an unending creation of new forms, the media by which they are produced have definite limitations. But, as is common with artistic activity in general, these limitations provide a challenge to originality, a challenge not only to competence in the handling of materials and techniques, but also to the permutations that can be extracted. Moreover, they create a challenge not only to the competence of the image maker, but also to the viewer who is given the opportunity to find meaning and/or aesthetic pleasure in the form of the image.

Creating images, through whatever medium, is always a task of form-making, and hence it always carries an aesthetic dimension, however slight this may appear. Our concern is less with incidental or coincidental effects, and more with deliberate and conscious manipulation of materials and tools, for example, the manipulation of cameras, pencils, and brushes. Appreciation of form, as we should expect, is aided substantially when the viewer is familiar, through practice, with the materials, tools, and techniques from which the image has been created.

In viewing images there is always an element of skill, of giving conscious preference to certain attributes at the expense of others. And while we may speak about the skill employed in seeing the significance of particular attributes in symbolic images, we may also speak about perceptual skills that bring into prominence significant aspects of form. In the former case the contribution is towards meaning, and in the latter it is towards aesthetic appreciation. In either case, the level of awareness may be overt or covert, which means that at a level below that of conscious awareness, at what is often referred to as the subliminal, mental events take place that are not translated into formal understanding.

But when conscious attention is paid to the form, per se, the chance of satisfaction, or dissatisfaction, is substantially increased when the viewer is familiar with the means by which the image has been produced, it also leads to the prospect of shared appreciation between maker and viewer. As is well known, it is imperative in verbal communication for sender and receiver to share a common code, such as a common language. And while in aesthetics codes play no part, and are not therefore an issue, there is, nevertheless, a requirement for sharing of another kind in aesthetic appreciation. The styles of production themselves add a further aesthetic dimension. For example, the pleasure that may be felt in the style of films directed by say Jean-Luc Godard, whose forms assume a uniqueness which has aesthetic appeal to those sensitive to his nuances. While for convenience we may separate style and production, seeing the latter more as a craft than an art, there are times when they are so closely interwoven that the technique of production is the style. A good example of this is to be found in the style of painting, known as action painting, in which the fluid technique by which paint is applied to the canvas is the style; this is best exemplified in the work of Jackson Pollock (Fig. 7, p. 90)

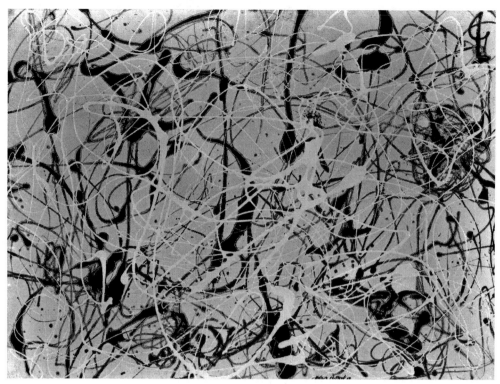

Fig. 7. Number 23, 1948, Jackson Pollock (Tate, London 2005).

While this is not the place to attempt to articulate the immense range of techniques which are employed in visual communication, attention can be drawn to the fact that the media themselves offer different forms of aesthetic satisfaction. For instance, knowledge of the way in which Roman lettering has its origins in chiselled inscriptions in stone can add to the appreciation of its use as a typeface. In a similar way, pleasure can be gained from acquaintance with the technique of silk-screen printing, particularly the influence it has had on poster art. In this process the artist is called upon to simplify forms by restricting planar and colour distinctions, and thus producing effects peculiar to the process. To those familiar with the technique, attention more readily focuses on its special qualities, such as the balance of flat areas of colour, and the contrasts or harmony to which they give rise. But to those not so informed, aesthetic appreciation can still 'seep through', owing to cultural influences which, at a tacit level, and through familiarity, help to inform the individual about style without him or her being necessarily conscious of the fact.

We can go on to give further examples of gaining pleasure from the form. For instance, we can cite the effect created by brush strokes in oriental paintings and designs; but here again, it is when the viewer, as beholder, is aware, though not always consciously so, of the tactile/kinaesthetic qualities suggested by the brush strokes that feelings of pleasure can arise, it is an aesthetic pleasure found in the form not the meaning. One could go on to enumerate feelings for form and the importance of familiarity with techniques in a vast array of media. For example, in film, particularly before the introduction of colour, lighting effects were crucial not only in dramatisation, but also in the creation of the independent forms

within the frames, shaping contrasts and highlighting specifics. And to those with an 'eye for form', the age of black and white in film continues to hold a special appeal.

It becomes obvious that the characteristics of particular media impose themselves upon the ways in which the world is represented. They are all, of necessity, given to form-making; and thus, irrespective of any meaning which they are intended to convey, the form can provide a seat of interest in its own right. Interest or satisfaction in the form, as we have seen, is increased when the viewer identifies not only with the styles, but also with the means of production. Here we may infer a relationship between observing and responding. The observation is an act of perception, the response is an act of imagination, the bringing to mind a memory of the techniques by which it has been produced; in other words, the transformation of a perceptual experience into one of corporality. It is found not in words and concepts, but in identification with skills and techniques.

The world as represented in an image is always a world at a distance from that to which it refers, it is a re-formation, the re-formation of a fact or an idea. It always stands there in its own right, given as form but constrained by the means of its production. Nevertheless, as form it carries an aesthetic dimension which can be appreciated for itself, an appreciation which is likely to be strengthened when the viewer can relate to its means of production.

Summary

In this chapter, aesthetics was centred within the human state known as primary processing, in which concepts play no part. It is the place of feelings, feelings of satisfaction or dissatisfaction, of pleasure or pain. It was suggested that such feelings can arise as a response to satisfaction being found in the form of an image, without the necessity of attributing meaning. It was further suggested that it is the place where, if values are attributed, they are self-referenced, independent of social or cultural mores. Thus when satisfaction and pleasure were mentioned, it was always in terms of a personal judgement. However, because as humans we are endowed by nature with a similar facility for primary processing , it would be reasonable to infer that visual stimuli would evoke similar aesthetic responses in people at this innate level. But one cannot discount the fact that with learning an individual can begin to be aware of differences not previously noticed, which, by heightening sensitivity to form, can increase aesthetic satisfaction.

Throughout, emphasis was placed on the perceptual connection in aesthetics and the primacy of the visual sense. But the most significant factor to which attention was drawn was that of form. It is from the appreciation of form that aesthetics derives its being, the image as it presents itself there before the eye, sufficient to itself as inner form, and thus without any requirement of satisfying the role of signifier. The multiplicity of relations of a non-linear kind that images offer means that the viewer has at his or her disposal a rich source of information of a non-verbal kind. In terms of information processing, and apart from the search for meaning, information, and here we use the term applied by Bateson, 'news' of difference, is derived from discriminations, which can be improved by conscious learning, for example when attention is drawn to fine degrees of contrast between items that make up the whole. In this way more information is generated from the same image; perceptual information generated by sensitivity to aspects of the form. And thus we may speak of viewing and observing through the aesthetic register as one of information processing. But, as a sensory task, it was seen to be closer to perceptual skill theory than linguistic theory.

In addition to the importance given to form in visual aesthetics, emphasis was placed upon 'interest' in the act of 'attention'. It was pointed out that intrinsic interest may be found in various aspects of an image: in that to which it points as an indicator; in that to which it refers, its metaphoric meaning; and to itself as pure form, its aesthetic. And finally, attention was drawn to the influence of media in providing specific grounds for aesthetic appreciation; it was suggested that awareness of techniques of production and reproduction might heighten aesthetic sensibility to aspects of form which might otherwise go unnoticed.

In the next chapter we move from concern with aesthetics, per se, and concern ourselves with the frames and framing within which the whole enterprise of visual communication has its being.

6

FRAMES AND FRAMING

Our journey into the aesthetics of visual communication took us to the point where the visual image as form was the primary focus of attention, to the place, one might say, where the image communicates about itself. Thus we were concerned with the figurality of the image, which, as a term, has its roots in figura, from fingere, to form. And accordingly, whether we speak about form or figure, it is to the inner properties of the image, to that which is physically there, whether it be on canvas, screen or paper, that provides the focus of attention. In such circumstances the viewer foregoes 'search for meaning', which is in the register of signification, and finds satisfaction in the image's form. However, when viewing an image, the mind, metaphorically speaking, may encounter a 'T' junction, one arm of which is signposted aesthetics and the other meaning. Although in reality the possibility always exists of attention fluctuating from one direction to the other, similar to the figure-ground effect in perception.

At such an intersection, it is the purposive frame of mind that dictates the route to follow. When the intention is to explore 'form', the result is heightened awareness of harmonies and contrasts, of colours, and the balance of light and shade. It involves a particular frame of mind; one that sheds light on the relationships it observes in a special way, the way of aesthetics. This fact was neatly illustrated by Cassirer (1979) who, on writing about the concept of beauty, said, "(it) cannot be defined as mere percipi, as 'being perceived': it must be defined in terms of an activity of the mind, of the function of perceiving and by a characteristic direction of this function ... I may experience a sudden change in my frame of mind. Thereupon I see the landscape with an artist's eye." Here he is referring to the way in which given alternative ways of attending to that which is before the eye, the chosen mode is aesthetical.

To be guided by such a frame of mind is to be involved in the dynamics of form, which, as we know, is the nature of the aesthetic experience. But, like filters in photography, the mind has at its disposal not merely the two frames labelled 'aesthetics' and 'meaning', but a veritable array of frames, derived from personal, social and cultural circumstances. Their influence may be known consciously or only subconsciously, in the latter case, the viewer will only have covert knowledge of the purpose behind the direction of his or her focus of attention.

Owing to the weight of social and cultural conditioning, which includes education in its broadest sense, the viewer, one might say, is enmeshed in a web of frames whose co-ordinates

provide settings by which things are both known and appreciated. They are there at the outset of perception, and new ones are slotted in as the individual proceeds through life's experiences. This applies equally to both direct and indirect perception, thus setting a 'tone' to the individual's engagement with the visual world.

The central fact is that the eye, the forward-looking eye, is always subject to framing, to delimiting the totality of visual information with which the individual is surrounded. The media merely echoes this propensity by adding a frame to the frame which is there by the nature of vision. Thus we might say that life framed in all its divers ways echoes the natural disposition of the visual sense.

The three-dimensional world in which we live is always, at any one moment, visually reduced to a single frame. The unity that is perceived when viewing sequential visual inputs whether they be direct unmediated or indirect mediated, as for example moving images, requires the temporal integration of separate frames, a mental fusion in which the gaps between the distinct frames become blurred. In this way, the bounded and the digital is fused into the analogue, the discontinuous appears continuous.

The process could be visualised as one in which frames become embedded in other frames, losing their separate identity within a wider framework, like bricks in a wall. On the other hand, the process of framing can be in the reverse direction, from, as it were, the outside to the inside. Take, for example, a visit to a traditional art gallery; its facade provides a primary frame to the visitor, suggesting through its classical architecture its cultural purpose; then, on entry, the visitor is enclosed in a secondary frame, the gallery as a spatial entity along with its ambience; from here the visitor proceeds to separate rooms which then provide a form of tertiary framing which delimits the exhibits to specific periods or styles; and it is here that the visitor encounters the fourth and last frame, the actual frame of a painting which serves not only as a support, but also a covert statement that what is contained within the frame, the painting itself, should be viewed differently from the wall upon which it hangs.

Furthermore, frames tell us not only where to start and where to end, but they also carry a non-verbal message telling us how we should understand their contents. Take, for instance, the religious painting with its elaborately gilded frame; through its opulence it 'gives off' or sends a message to the effect that what is contained within should be regarded in a special way, the way of awe or reverence. Similarly we may notice the way in which portraits of aristocrats and rich merchants are often depicted in elaborate frames in order to enhance the standing of the person depicted. Seen in this way the frame, we could say, aids in the orientation of values, it adds nothing to the contents, but attempts to guide the way in which they are judged.

Returning to the theme of gallery visiting, we can now visualise the event or occasion as one of successive framing which proceeds by steps from the actual appearance of the building to the intimate frame of an individual exhibit. It is a recession from a whole to a part, with, at each stage, the larger and more inclusive frame casting its shadow upon the smaller. At each stage the frame 'says something' about the way in which its contents should be understood. It could be illustrated diagrammatically as follows:

Frames within Frames

Art Gallery

The framing about which we speak operates at the level of the visual and spatial, both combine to signify a desired mode of apprehension, a mental set appropriate for the occasion. Thus we can explain why common house bricks, which formed the core of an exhibition by Carl André at the Tate Britain Gallery in London, can take upon themselves a different connotation or signification from the same bricks arranged on a building site. The context in which they are found or framed exerts a particular influence, aesthetic in the gallery and functional on the building site.

In presenting these ideas on the nature of cultural framing we may note the relevance of the work of Bryson (1990), and of Lyotard ,as reported in Bennington (1985) who used the theatre as a paradigm for an analysis of representation. This provides reinforcement for the ideas being expressed in this chapter. This is how Lyotard expressed the concept of framing with an example from the theatre, "The 'real world' is outside, the theatre is inside. Walking into a theatre means walking into a different sort of space: … the real world and that of the theatre is guarded by a place of passage, the foyer, where one prepares for theatricality .. Within the theatre comes a second limit or division, separating the stage from the audience, marking off the place observed and the place from which it is observed .. this division is strongly accentuated by such features as a proscenium arch … A third essential limit separates the stage from the wings or back-stage .. the place of theatrical machinery." Here, in this quotation, we can see a parallel with the point made earlier about the art gallery, that is, the notion of recessional frames, the passage from one stage to another, and how, in the process, the mental framework of the observer or beholder is re-aligned or delimited in specific ways.

While these observations on the experience of the theatre and art gallery provide vivid illustrations of the concept of framing, our intention, as was that of Lyotard, is to face the broader issue of representation. In this we include art-books, newspapers, film, television, and all material forms of visual communication. As material forms they have at least one thing in common, the inevitability of being framed, of being bound by a context and the physical restrictions of the media which conveys the message, and by the maker's range of alternative ways of portraying an intention.

In a wider sense, we may consider viewing as a process in which the individual is led through a labyrinth of frames with outer (observable), and inner (unobservable) characteristics. Outer

frames refers to the material forms which occupy two-dimensional space, for example, the press, film and television, and to those which occupy three-dimensional space, such as the gallery, the theatre, and those other physical spaces which frame social and cultural conventions. The inner frames, on the other hand, are those found in the 'space' of the mind, and thus they are unobservable. For a fuller understanding of visual communication, it is necessary to take account of both the outer and the inner, in this way we may avoid the simplistic error, often made by political commentators, of judging media in terms of content without reference to the range of frames to which they may be subjected en route from perception to interpretation.

Frames are operative at the point where images are conceived, in the mind of the creator, who, knowingly or unknowingly, is bound to limits which inform the final product. Likewise, at the point of reception, the viewer is propelled into a particular interpretation owing to the existence of personal, mental frameworks of known and unknown dimensions. While, at the same time, the media that connects sender and receiver has it own material limitations, its own frames beyond which the image cannot trespass without difficulty.

While the three factors of framing which we have just mentioned provide useful categories, they do not, of themselves, provide the full story. We also need to know something about the dynamic nature of certain frames, of those frames that straddle the territorial boundaries that we have hitherto described as inner and outer. In particular, we are speaking about those social and cultural frames that help to organise perception, thought, and behaviour. They are not genetically inherited, and yet, over time, may appear to be so. In many divers non-verbal ways society and culture present outwardly observable frames which are intended to produce particular ways of seeing things. The frames themselves may be understood , overtly or covertly, as metacommunicative devices, ordering the way that things should be understood, thus introducing ethical considerations. Thus we may say that society presents to its members not only 'things to think with', for example, languages, images, particularly symbolic images, and rituals, but also frames or boundaries inside which to think.

These boundaries or frames operate throughout all forms of visual communication, there is no space free from their influence, it is in the very nature of human perception and human thought to operate within their constraints. For example, we know from the work of Gregory (1970), that perception is guided by hypotheses, which are a form of framing. Likewise, we know that words, as the material of thought, are framed entities which we know as concepts.

In setting the scene for a more detailed scrutiny of the place that framing plays in visual communication, we shall take as our starting point the inner (mental) frames. This is in keeping with the ordering of chapters in this book, where perception, as a mental event, has been given primacy. Next we deal with the notion of inner/outer frames, the social and cultural factors that, although outer in our terminology, possess the potential to migrate into the realms of the inner. And finally, we focus upon the frames that shape the material means of visual communication, the media as a physical entity. This is an arbitrary schema, which could be approached from either end of the continuum, but as human communication is, in the final analysis, a personal affair, an inner concern, it is from this standpoint that we make our entry.

Inner Frames

Here we focus upon the frames that are set within the mind of the viewer, the portals through which all forms of visual communication must finally pass as they proceed from sender to

receiver, from illustrator to viewer. Being of the individual, inner frames carry the distinctive marks of the viewer's personal history, thus allowing for idiosyncrasies in interpretation, and the distinction that can exist between intended and received meaning. Inner frames, which may be conscious or subconscious, shape both thought and feeling, and although other viewers may possess similar frames, or frames of reference, received meaning is always influenced by the viewer's own repertoire of frames. It is an affair of the individual, and although through aggregation and statistical techniques collective accounts may be given showing the influence of visual media, such procedures always introduce a loss of those subtleties of thought and feeling for which there is no expression in standardised forms of information gathering about media response. Take for example the wide range of differences that vision, as a sensory device, can detect in any one colour range, and compare this with the paucity of words available in a standard lexicon to reflect such subtleties. Words, as framed concepts, are rarely ever able to convey the fine degrees of difference that the eye can detect. Thus there exists a qualitative difference in communication between the visual and the verbal which is unbreachable.

Although we have stressed the role that framing plays in accounting for individual differences in interpretation, we cannot escape the fact that the act of viewing has biologically determined features which are common to all viewers. As Gregory suggested, visual perception is biologically programmed to utilise hypotheses, which he called 'perceptual hypotheses'. And, as is true of all hypothesising, it is an act of framing, of placing restrictions in advance on the way that things are to be interpreted. From this it follows that visual inputs to the human perceptual system are defined by some form of initial expectation, an expectation that constructs a kind of advanced schema for the way that things are to be interpreted. In this sense, we may consider the viewer as a quasi-scientist, utilising, admittedly at a level below consciousness, perceptual hypotheses which give order of a certain kind to the flux of information which flows to the mind. This is part of the natural order of things, a biologically determined order which frames and particularises, and in doing so gives to perception something which is beyond the physicality of the eye and its neural connections. However, like these physical features, the perceptual hypotheses about which we speak owe nothing to the acquired social and cultural frames that encompass the viewer in his or her engagement with the world, whether it be direct, or indirect through the way of media.

In man's phylogenesis the propensity for utilising perceptual hypotheses may be considered a precursor to language development. Thus the visual as a thing of the mind, of the ground of perceptual hypotheses, not only shares the deep structure of language, in the sense that the latter is known through the work of Chomsky, but it exists, in an archaeological sense, at a deeper level, pre-dating and paving the way for the later development of language. However, our concern here is not with language development as such, but more with the frames that shape perceptual awareness. Nevertheless, we cannot escape the fact that language shares with perception 'deep structures' which are beyond the realms of consciousness. At this level, frames influence the viewer beyond his or her awareness. Like lines of latitude and longitude in navigation, such frames provide the co-ordinates by which the mind imposes some kind of order. To use a colloquial expression, they are 'frames of mind', an all-purpose expression that conveys, with some vigour, the common understanding that frames of mind are vital components in the way that information, visual or otherwise, is received. And, in fact, the construction of an ecology of mind, a task that Bateson (1973) set himself, is permeated with the notion of framing. Here we refer to the frames that shape

premises; the frames that surround metacommunication; and the organisation of perception itself as a framed entity. As a mental event it inhabits an inner world, a world in which sender and receiver, image maker and viewer, have common biological roots; thus it makes itself felt at both ends of the communication process, where images are created and where images are received.

Frames Inner and Outer

From emphasis upon inner frames we broaden our theme to include outer frames. In making this transition we move from concern with the biological or genetically given towards the social/cultural frames through which visual communication finds concrete expression. And, as concrete expression, it becomes a surface affair, displaying the uniqueness of a given society or culture in the way that it represents itself to its members. But, and this is the critical point, the way that it is framed can, through habituation, make it appear, in Barthes terms, to be a 'message without a code', not given to conventions, there by nature, not artefact. Everyday language is a good example of this state of affairs. For example, when we speak, we are rarely conscious of the fact that we are employing a code, a code that distinguishes our mother tongue from others. It seems as natural as a limb of the body, an integral part of the self, and yet, apart from the deep structures upon which all human languages are founded, each specific language has to be learned. They are framed by conventions which are external to any one individual, but through conditioning, which is a type of learning, they become internalised. The outside, as it were, becomes inside. The cultural is naturalised.

We can draw a parallel with visual communication. Here deep structures are at work underpinning perception, while, at the surface level, styles and techniques of representation display the uniqueness of specific cultures. Thus, as in language, there are both deep, unlearned, and surface learned elements. The paradox is that while language learning at post nursery school level usually involves some formal instruction about the structure/framework of a specific language, it is rarely the case in the acquisition of knowledge about things visual. Apart from specialised courses in iconology and media, the styles and modes of production that surround the making of images is usually a closed book. It could be argued that the beguiling surface level innocence of images, the way in which they can look like that which they represent, means that they are more readily taken for granted. This apparent transparency hides an opacity, and thus guarantees that their origins in specific techniques and modes of representation are more in the shadows. Without awareness of such factors, nature can, as it were, creep in to consume culture; and thus, the outer, culturally determined frames, can slide into the inner.

A good example is that of perspective. The realism that it evokes is usually accepted without question; its origin within culture is rarely brought to consciousness; its surface level is quite literally seen as depth. Thus the surface and the depth, being seen as one, echo the visual in its normal commerce with life unmediated. However, the oneness apparent in perspective becomes more complicated when the object of visual attention is a symbolic image. Here we are not only concerned with elements given to perception, but also with concepts for which the symbol is merely a stand-in for some intended meaning. In this instance, we are concerned with two distinct frames; the frame there before the eye, the physical layout of the image, and the cultural frame which the symbol, as metaphor, is intended to evoke.

But while we have made a distinction between the symbolic image as physical form, there before the eye, open to perception and its metaphorical connection with absent forms, symbolism is at work throughout. The retinal/neurological system itself, by transposing sensory inputs into other forms, by making one thing stand for another, is thereby engaged in a type of symbolism. As we saw in the chapter on perception, it is only in symbolic form that the world is finally represented in the mind. This means that symbolic images, far from being alien to inner processes, are a reflection of its nature, which is that of representation, a process which carries an idea, thought or event by other means. Thus we might say that the transmutation of outer into inner via the route of symbolism is facilitated by a process which already has its feet in the natural order of things.

By such a process, the surface frames of visual communication, those created in society, stealthily enclose the individual, until the connections between self and society seem to become invisible. Thus the images which serve as agents of communication between its members can be invested with particular powers. Magic and mythology can take hold, that which is absent can take on a pseudo-presence, noticeably in the cinema. Advertisements can offer the prospect of another kind of self. The future, which is always absent, can, in an illusory way, be offered now. This is symbolic man and woman framing and being framed, living in a world where outer, surface frames can fuse with inner frames. It is a place where visual communication is very much at home.

Inside the Frame

Frames, as we have seen, enclose and delimit. This is so when frames are presented in the form of physical boundaries, such as those that surround paintings, posters, and newspaper photoprints. In addition, there are the non-physical boundaries of the mind, the conceptual boundaries that symbols, as iconic metaphors, call into being. At this point we switch attention from the frame as such and look inside at the way in which the space is organised. In doing so, we enter a territory in which the visual as a form of communication asserts superiority over the verbal. Such a claim rests upon the multi-directional relationships that the surface of an image can sustain. In contrast, words flow in a linear direction, left to right in English, but in a different direction in some other languages, Arabic for instance, which flows from right to left. Whatever the cultural base, the flow of words is always one-directional.

Whether the communication is verbal or visual, spatial relationships are at work influencing meaning. For example, by a linear re-arrangement of words, 'The red boat in China' to 'The boat in red China', we change the intended meaning of the word red, purely by changing its spatial position within the sentence. Likewise, the spatial relationships that exist between elements that constitute a visual image influence the way in which the whole is perceived. But, in contrast to the verbal, visually perceived relationships spread across the surface plane of the image modifying colour and scales in a variety of directions. A good example of this can be found in the work of the English artist Bridget Riley, whose paintings, commonly referred to as 'Op Art', from the connection with optics, provide a clear demonstration of the way in which the same colour can advance or recede, depending on its proximity to its neighbours, and the way in which the general impression of a painting is more than the sum of its parts.

When we move from the abstraction of 'op art' towards visual images of a more representational kind, we find that spatial proximity still influences perception, but in a different way. For example, a painting or an illustration in which a crown is shown on the head

of a particular personage introduces a symbolic element. The crown as a symbol is endowed through convention with a particular significance which, through spatial proximity, is presumed to be transferred to its wearer; a kind of halo effect, mythical no doubt, but one that demonstrates the importance of the spatial characteristic of proximity in visual symbolism. And, in fact, it is not until such a relationship is physically performed at a coronation ceremony that the monarch in Great Britain is deemed to be fully invested with the powers of the office.

While monarchical ceremony provides a useful illustration of the way in which spatial ordering influences interpretation, we can observe similar tendencies nearer home. The relationships that we find or create for ourselves have a way of defining us. It is not only the setting, but the relationships within the setting that provide a source of inference. Notice how status is accorded on the basis of spatial proximity and order in institutional settings. Who is next to whom, and who is next to what, can give visual clues that may need no further explanation. Such real-life examples find their counterparts in life mediated through film, television, and other visual media. Here the contents of the presented image can be manipulated for positional effects. For example, people or things can be shown in relationship to other people or things who are considered to possess desirable attributes of a social, cultural or other kind. Such manipulation is particularly noticeable in advertising; here commodities are often shown in close proximity to some well-known person or cultural setting. The advertisement is the frame, but within it the image maker can juxtapose elements, seizing on 'value by proximity' as a special persuasive device. In this way, social or cultural icons are borrowed and exploited for commercial purposes.

Thus we come to see the way in which the spatial proximity of elements in visual communication affects not only the perception of abstract works of art, but also the meaning that we attribute to things and people in general, including the way in which life is portrayed in representational art and in advertising. The world of non-verbal communication, whether it be in real-life or mediated, is penetrated throughout by the effect of visually perceived relationships. Such relationships offer the viewer information over and above that given by speech or in print, it is closer to the natural order of things, where spatial relations play a dominant part, and where the concreteness of the here and now suggests veracity. The natural order is non-symbolic, and, except for those insects and animals that effect camouflage, it is unable to lie because it cannot speak of itself as otherwise. Thus we may speak of nature as innocence.

The realist novel attempts to trade on this innocence. As Bryson (1981) suggested, "The basis of the realist novel, where an unstoppable flood of information, in apparently no order at all, except simple succession, persuades us because it betrays no signs of censorship or ordering, (an) artlessness divorced from any ulterior pattern-making." And further, with reference to still-life painting, "Language has no point of purchase or insertion into the seamless syntagm, ...so polished is its surface that words cannot penetrate it, they fall away into a discursive void." Or, as Barthes (1977) colourfully expressed it, "Through the syntagm of denotation: the discontinuous world of symbols plunges into the narrative scene as into a lustral bath of innocence." Here we are introduced to the idea of the syntagm, which, as a term, has its roots in linguistics, but it can be applied to good effect in both verbal and visual studies.

Linguistics is defined on two major axes: syntagmatic (the sequence of words in a sentence); and paradigmatic (the relationships between individual words in the sentence and words outside it). Both are concerned with relationships, the syntagm, as we have noted,

with the spatial ordering of words, and the paradigm with relationships through metaphor. In visual and verbal communication both kinds of relationship may be operative. For example, in poetry the sequential and thus spatial arrangement of words plays a significant part in creating effect; while at the same time, the words in the poem, as metaphors, introduce another dimension, one that relies on associations at the conceptual level. A similar process is at work with things visual, here the spatial ordering of elements exerts influence at one level, the syntagmatic; while at another level, the paradigmatic, the viewer is called upon to connect through metaphor.

We may notice, however, that in realism the syntagm dominates over the paradigm, this is particularly so in cinéma-vérité which attempts to portray things as artless, they are there, or so it seems, as though in the natural order of things. It is here that spatial relationships gain ascendancy over symbolic relationships, the eye over abstraction, presence, if only assumed, over absence. Why should this be so? It could be argued that it reflects man's more primitive state, of being in a world where an awareness of physical relationships is vital for survival; where the eye provides essential clues of events taking place in the here and now, a world less governed by symbols and abstraction. On the other hand, we may look for an answer in the philosophical writing of Kant (1982), who proposed that the ultimate 'a priori' condition of all knowing is based upon space and time. The here and now is always in space and time. That being so, we have to face the fact that although mediated images have a physical presence, perceived in real space and in real time, that to which they refer is always absent, it is brought to mind as an act of imagination, thus creating what we might call pseudo-presence. In this sense the image, as artefact, acts as a kind of prompt or aid for imagination. Through imagination the 'then and there' can take on the characteristics of the 'here and now', the absent can assume presence, if only in the mind of the viewer. Be that as it may, the construction and manipulation of images takes place in real time and space, and by real people; space has to be filled, and in the case of the moving image presented over time. In the final analysis, the task of image-making is always one of filling space. To this we now turn our attention.

Media Manipulation

In this chapter, we have followed a path that has taken us from the inner frames of the mind that are there by nature, the unlearned 'deep structure' of perception, towards those frames that the viewer incorporates, knowingly or unknowingly, through the normal processes of social learning. It was a route from the inner to the outer, from deep to surface structure, from the unlearned to the learned. But, as we noticed, the distinction or line between the learned and the unlearned, between that which is there by nature and that which is there by culture can become blurred. Non-verbal communication, particularly that of gesture and facial expression, is a good example of this condition. It is at once a primary form of human communication employing natural signals and signs, for example, the instinctive cry of the child, while social learning adds a further dimension to that given by nature. But the critical fact is, whether they are the product of nature or nurture, non-verbal signs of gesture and expression stem from actual bodies, and whether they are contrived or not, they carry the authenticity that goes with naturalness. Staged theatrical performances are a good example of this propensity; there we are faced with actors, who, as real people, display for effect a range of contrived non-verbal signs which we normally associate with natural emotions or feelings. And, in fact, the more the audience is deceived into accepting the contrived gestures and expressions as being natural, the better is the performance.

In a similar, but slightly different way, the visual trades upon connections with nature; and, in fact, through photography, film, and television those non-verbal aspects of gesture and expression that were mentioned above can be amplified for effect. Thus, although the material visual image arises in society and culture, it can be bathed in nature. Its foremost power lies in its propensity to look like that which it represents, seemingly uncontrived. A good example is that of photography, where the fusion of subject, light and location at a single moment in time may appear seamless, without awareness of the separate elements involved in photographic production. This is something that image making shares with gesture and expression as non-verbal forms of communication. They can both be manipulated for particular effects; trading on the reality principle, while at the same time hiding those aspects that speak of artefact. And, as in the theatrical profession, the image maker has at his or her disposal a range of techniques that, although looking artless, may contain covert persuasive influence.

All this takes place within a frame; the proscenium in the traditional theatre, the screen in the cinema and television, rules and borders in the press. But, whatever the medium, the task calls for spatial ordering of elements within a restricted space, this could be of people, things or abstract shapes. But there is more to it than this, each medium makes its separate and distinctive demands on the handling of materials, tools, and other ancillary equipment. This manipulation arises not merely as an option, but as a necessary part of the task of production and reproduction, irrespective of the intention behind the communication.

In the course of time, and with repeated usage, styles evolve, but always the task of image construction is that of ordering elements within a restricted space. Such elements may be included purely for syntagmatic purposes, gaining value on the basis of their relative position within the totality of the composition or design. On the other hand, elements may be included for their symbolic value. But while it is generally understood that symbols stand for something, and thus require decoding, what is less obvious, is that the techniques of image-making themselves introduce a coded element. This follows from the fact that culture, even in its non-verbal form, can be seen as a code which has to be learned, if only implicitly. As cultural products, the techniques and means of production are subject to the same forces, introducing what we might call the codes of production. The picture that emerges is that besides the obvious codes that symbols introduce, the means of production themselves introduce their own codes. And furthermore, like architecture, which can hide its basic structure, such codes may be concealed and operate as a form of hidden persuasion, or less forcefully, as a form of hidden influence.

But always, whatever the medium of visual communication and whatever the intention, informative or propagandist, fictive or non-fictive, manipulation is integral to the whole process. Here the word manipulation is used in a non-pejorative sense, meaning, as its roots imply, handling. As artists would attest, the materials and techniques at their disposal place a constraint upon the realisation of their intentions, whether through film, television, graphic design, commerce, or the fine arts. And in fact, we may admire the way in which a medium's potential or limitation is skilfully exploited in its own right; an admiration that may be increased the more the viewer is familiar with, or knowledgeable about, the processes of design and production.

Because image-making is an artefactual process, it opens a range of possible means for deception. This may be benign, for example the thriller film which is intended to provide vicarious pleasure. On the other hand, it may be used to deceive for commercial or

propagandist purposes. Another example of deception is that of montage in press photography where the printed image can, and has been used, to show people in contexts which are forged. But always, the viewer is presented with an image which, though existing in real space and in real time, is only ever a signifier. At one extreme, it may stand unashamedly as an art object that denotes itself as such without making any claim to connotation. A good example of this is the work of Kandinsky and other non-representational artists. Conversely, the purpose of the image could be to direct attention away from itself, requiring that it be read as a symbol, enticing the viewer to construct or reconstruct thoughts on the basis of metaphor. But in either case, whether it be that of the pure aesthetic, the non-referential, or that of the symbol; the material image is only ever a signifier, an artefact, a product of human ingenuity.

Such ingenuity is made manifest in a variety of ways; from photography to film, from litho to screen printing, and in the painterly arts from watercolour to oils. But always in the making of visual images there exists the task of ordering, constructing, and manipulating materials, tools, or equipment of one kind or another for specific effects. This has led to a variety of practices in the framing of images, which we shall illustrate here with particular reference to film and television.

Practical Issues
The moving image, as displayed in film and television, lends itself to a number of techniques which serve to illustrate the power and influence of framing. Being based in space and time, the moving image echoes, in some way, the natural human condition of existence in space and in time. But as artefacts, such images can, if only in an illusory way, be made to subvert the natural sequence of time; and by spatial rearrangement of the elements of which they are composed, guide the viewer into particular pathways of interpretation. Through, for example, editing, cutting, and insertion, a sequence of events can be re-ordered. And in television, through 'keying', a device whereby the elements from separate cameras are electronically fused, contexts can be falsified, and impressions manipulated accordingly.

a) background
In all visual experiences, direct (unmediated) or indirect (mediated), things are seen against a background, even though the background may be essentially white, as for example, that of an illustration on a white ground. However, the concept of what is 'fore' and what is 'back' ground is open to interpretation; that which is 'back' can, through a change of focus, (whether this be of the human eye or that of the camera) become 'fore'. In this way, the periphery can take centre stage. But it is not always necessary for the periphery to take centre stage for it to impress itself upon perception; it can act covertly, influencing perception at a level below that of conscious awareness, providing implicit clues, or cues, as to how that which is in the foreground should be interpreted.

A background provides a difference, the edge upon which information is constructed; whether it is there by nature or merely as artefact. In natural situations it is uncontrived, but in the image as artefact it is subject to choice, thus to manipulation. Even with an apparently natural background, for example a shot on location, a choice of terrain has to be made about an appropriate setting, a background that will reinforce or give tension to the action that takes place in the foreground. While in the studio similar choices have to be made, but here

the possibility arises of having a formless background, for example a backcloth devoid of colour and design.

The normal situation is, of course, for things or people to be shown against a ground containing information of one kind or another. But what the viewer may not know overtly is the influence that the background has upon the perception of that to which he or she is attending. For example, it is common practice in television interviews, where it is desired to portray the interviewee as academic or learned, to create a background of bookshelves lined with learned volumes. This is intended to create an aura of academic or professional competence, despite the fact that the shelves may have been wheeled onto the set for the occasion. A further example is that of the political interview which is arranged to take place against a background of prestigious buildings; for instance, the Capitol in Washington, or the Houses of Parliament in London. Whether the interview is for academic or political purposes, the background carries a metacommunicative message, it can be thought of as a backcloth which spreads its mantle across the foreground, offering or suggesting credibility or authenticity to the events in the foreground.

In this context it is worth noting the research into the effects of background in television carried out by Baggaley and Duck (1976). They arranged for two versions of a recording to be made of a report on an archaeological dig. In one version, the speaker was shown against a plain studio screen, and in the other against a landscape background which was 'keyed' in. In reporting the effects of the two versions, the authors went on to say, "When presented against the picture background, the speaker was construed as significantly more honest, more profound, more reliable, and more fair than when set against the plain background. The keying process clearly had the effect of heightening his credibility as a performer in this context, and of increasing the amount of trust which viewers were prepared to invest in him." Thus, despite the fact that the performance in both situations was identical, the difference in background created a difference in the viewers' perception of the performer. The spatial relationship between performer and ground, the context, and thus the syntagm of which we spoke earlier, can be seen to have played a vital role in determining the viewers' attitudes.

From looking at the effect of spatial relationships within the frame, we extend our brief to looking at the way in which frames are 'stitched' together and presented in a sequence that bears an imprint of contrivance.

b) linking frames
All frames define a space, whether the frame be that of film, television, photograph, or picture. But when the spatial factor is allied to that of time it reflects more perfectly the two-factor state of being which is composed of time and space. For each of us the sequence of our past life is non-modifiable, its place in particular sequences and at particular places is fixed. And although it may be etched in memory and retrievable in the form of a mental image, or available in some artefactual form as, for example, a photograph or film, as a historical fact it is a fixture. However, when the past is subject to representation it may be given out of its true sequence. In the first place we may notice this in verbal recall, and more vividly in dreams where at a subconscious level past events may be experienced not only out of sequence but illogically. (In this respect we may note that the art movement known as surrealism played upon this propensity, but there it was employed openly as a means of producing effects, perhaps the best example is the work of Salvador Dali). In this way, episodes from the past can be linked together in an altered sequence, a new order can emerge, new stories unfold.

It is on the basis of events or episodes taking place in time, of one thing following on from another, that much of realism in the moving image as a form of communication has its raison d'etre. It is only one step from the perceived natural order of things progressing in time, to the creation of moving images which follow the same logic. As we have seen, people have the propensity of being able to recall events in a way that does not accord with their real time sequence, a facility that is echoed in those media, particularly film and television where, apart from live broadcasts, events can be shown 'out-of-time'. In both cases, the mediated and the non-mediated, imagination is brought into play. It is only through imagination that the mind can see things as otherwise, see things 'out-of-time', and re-construct events into a new unity, a new way of 'seeing things'. Likewise, in the creation of programmes involving moving images, the image maker is called upon to use his or her imagination in piecing together the parts into a unified sequence, into a sequence that may bear no factual correspondence with reality.

In this way a world is opened up to the unreal, and more markedly to the surreal. The fountainhead of the unreal is the imagination, a kind of free-wheeling agency, which although it appears to have unlimited scope is constrained by the resources it can call upon. These resources consist of the individual's stock of experiences and signifiers. Into this arena sets foot the image maker as creator and provider of images as signifiers, as 'food for imagination'. And it is here in the realm of the signifier, the image as stand-in, that things can be shown 'out-of-time' and 'out-of-place', and yet seem to be real. Thus the prospect of pseudo-realism arises, as for instance in those documentaries that marry true reports with false. In this way the borderline between the system and the world, that is between semiosis as system and the world as actuality is exploited. From this perspective, all kinds of possibilities arise for image-making; the real can be interspersed with the unreal; the past can be linked with the present, as for example in the use of flashbacks; and the whole can be shown in an imaginary future, as for example in science fiction.

Pseudo-documentaries, documentaries in which genuine film material of an event is linked to invented material, provide a good example of the interspersion of the real with the unreal. It can be illustrated in the following way:

Likewise we could go on to illustrate the linking of time past, present, and future within one single viewing episode. And here again we can see the connection with imagination, which possesses the potential to fuse past, present and future into a unitary experience.

Another technique to which attention should be drawn is the use of flashbacks. Here, however momentarily, incidents from the past can be re-inserted into current viewing as a reminder or reference that is intended to draw the viewer's attention to significant items from the past which have a bearing on the present. The links we have been dealing with are those of seriality, frames in time, and their possible inversion. Now we turn our attention to space, to that which is known as 'onscreen' and 'offscreen' space. When viewing moving images the onlooker is always engaged with these two spaces, which we may define as the space framed by the screen, and the space framed in the mind of the viewer which can draw upon

possibilities or events that, although not given on the screen, are called to mind. This is no different from normal life where, although we may be framed by particular circumstances, we carry expectations of things beyond them. These expectations, we could say, bring the outside to the inside, and in doing so create a link or continuity to life. In this way we could consider that things 'offscreen' are part of the 'onscreen' of mental life. This inner space is a psychological space that has the potential to complete or fill gaps in partially given structures, which is known as 'gestalt' in psychology. Not only that, there is the human disposition to 'search for meaning' when there is ambiguity. Thus the film maker has a ready accomplice in providing the links that create a meaningful whole to separate events or episodes during the process of viewing. Of course, when the disparity is too great between the presented frames and the inner mental resources at the disposal of the viewer to deal with the presented images, confusion can arise.

In a more practical sense, the viewer is generally given clues or cues that link one frame with another. The most obvious devices are those non-verbal forms of communication , such as gesture and gaze, which can lead the viewer into some form of expectation of the way things are unrolling, of anticipating things/events/happenings to become 'onscreen', although currently absent. This reflects a normal aspect of real life, which is full of expectations of events or happenings that follow from non-verbal or tacit cues which people pick-up without formal instruction.

In the foregoing we were presented with the notion of on-screen and off-screen space, one of which was concerned with presence and the other with absence. And as we know, that which is absent is only grasped through imagination, and then only in a quasi way. Even when presented with an image of a person, such as a photograph, it requires the imagination to link the photograph, which is only ever a signifier, with the absent person. But visual and other cues are often employed to assist the viewer in film and television. We have already mentioned that of gaze, but to this we could add other factors which direct the viewer from action taking place on the screen to an anticipation or expectation of something to follow.

Here are some such cueing devices:

visual cues: eyes looking (from ⎯⎯⎯⎯⎯⎯➤ to);
 people moving (from ⎯⎯⎯⎯⎯⎯➤ to);
 camera panning (from ⎯⎯⎯⎯⎯⎯➤ to).

audio cues: change of mood in music;
 change of rhythm.

These are but some of the techniques through which those engaged in the making of moving images can influence expectations. But there exists a two-factor aspect of space in television viewing that does not call for cueing. Here we refer to the technique of presenting within the main space of the screen a smaller frame which, although distinct, is part of the total message. The best example is that of televised news reporting in which a presenter occupies the main, first-order space, the screen itself, and then goes on to address a person framed within an inset, second-order space. With the introduction of a second-order space, the presenter then becomes an intermediary between the figure in the inset and the viewer. In some interviewing situations, the presenter may even appear to represent the viewer's interests or concerns.

Zettl (1986) expressed this in more intimate terms when he wrote, "the humanizing effect of first-order space, coupled with the customary intimate close-ups, may cajole us into perceiving the anchor person, or anyone else operating in first-order space, as a real person rather than as a TV image, and to relate to these 'first-order people' psychologically, if not socially, as extended family members or the close friends one is used to having around the house. Persons in second-order space, however, are inevitably perceived as being on television. This incarnation process of bestowing upon the person in first-order space the flesh-and-blood qualities of a real person, I will call personification ".

What is special about this analysis is the identification with the home, the site of most television sets, where through familiarity, whose etymological base is that of family, screen faces can appear to become part of the furniture, part of the home. So in addition to the two spatial orders that were mentioned we should add a further dimension, the domestic room and designate this first-order space. In this way, the TV presenter is shown in an intermediary position between the room, the family room, and the framed inset. It could be illustrated diagrammatically as follows:

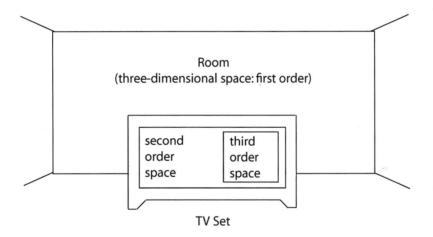

In the light of the foregoing, it would appear to be more accurate to re-define the spatial orders of domestic TV viewing in the following way:

1. first-order: the room which domesticates the viewing experience;
2. second-order: the main screen, the intermediary between the viewer and the person or place in the inset;
3. third-order: the inset, in which images seem to be inhabiting a more 'distant' space.

In this sub-section we have dealt with linking in two distinct ways; namely the contribution of the viewer through psychological processes, and that of the media specialist who, through a variety of techniques, including suggestion, can connect the disconnected into some form of greater whole.

Summary

In this chapter we were led to consider the role that frames and framing play in visual communication. And as our brief is that of communication, which is wider than that of media, we were led to consider different aspects of framing. For convenience, three aspects of framing were distinguished: firstly, the innate, unlearned frames that provide initial structures to visual experience, irrespective of social or other factors; secondly, the frames of society and culture, which, although initially external to the viewer, become internal as a result of overt or covert conditioning, which is a type of learning; and thirdly, the frames of the media which, as artefacts, are open to manipulation in a variety of ways. While these three types of framing were considered separately, they become part of a higher order framework when they are placed under the aegis of visual communication.

In addition to the three factors just mentioned, attention was constantly drawn to the notion of space: the metaphorical space of the mind; the on-screen and off-screen space of film viewing; the various orders of space in domestic TV viewing; and the spatial relationships that exist between elements within any one frame. It was suggested that the importance of space as a factor in visual communication can be linked to human experience which is always set in space. In this way, a link is established between visual media as artefact and life as nature.

Interest in the notion of space led to a connection with linguistics and syntagmatic relationships which, being concerned with the effect of spatial ordering on meaning, has relevance here. Consequently, the term syntagm was borrowed and placed in the context of visual communication, not only to demonstrate a relationship with linguistics, but to illustrate its centrality in things visual, where it serves to 'in-form' at two levels; namely, meaning and aesthetics.

We went on to cast our net wider and in doing so we drew upon studies in non-verbal communication where, under the banner of 'proximity', space is observed as a determinant of social values, for example status. And, as we would expect, the spatial characteristics that define live social intercourse find their counterpart in the spatial ordering of elements within those aspects of visual media centred upon human interaction. The notion of obtaining value from spatial proximity was also mentioned in the context of the perception of colour, where values can change purely on the basis of proximity; the example given was that of 'Op Art'.

In a different but related vein, attention was drawn to the way in which advertising plays upon spatial relations for effect. This is noticeable whenever a product is shown in close proximity to some esteemed social, cultural or environmental setting which is intended to spread its influence to the way in which the product is understood. In colloquial terms it is known as 'getting into the picture', and, in our terms 'getting into the frame'. Framing a product with something or somebody of note is an attempt to gain value by association, a parasitic relationship, 'feeding' off others.

While attention was drawn to the primacy of spatial relations within and between frames, we noticed another relationship, that of the paradigm, which requires the viewer to search at another more abstract level. Thus we were introduced to the symbolic element, which, as metaphor, relies upon the viewer to make the necessary connection between the symbol and its intended meaning. This introduces an element of decoding. Such decoding may be done overtly as a conscious search for meaning through an established repertoire of signs and frameworks. On the other hand, it may take place below the level of conscious awareness. In either case, the search takes place largely within frames inherited from social and cultural conditioning.

While attention was drawn to the syntagm (the spatial) and the paradigm (the symbolic), we should be aware that they can combine to form a total impression. The example given of books as background material to create an academic impression is a case in point. There the book filled background provided the proximity factor that we have highlighted, and the books themselves symbolised learning, but this is only true for those who make that connection. It does not necessarily follow that all members of the public will derive the same meaning. It is necessary to point out that decoding may be called for on the two separate axes of the syntagmatic and paradigmatic. In the case of the syntagm, where meaning is gained on the basis of spatial proximity, the viewer has to pick-up non-verbal cues which, generally speaking, are learned non-formally in social life. And, in the case of the paradigm, where meaning is found on the basis of metaphor, there is a more formal element of learning through language. The point being emphasised is that the codes of society find their way into images and that they call upon the viewer to 'read' them in order to construct meaning. The meaning construed will, to a large degree, depend upon the viewer's ability to decode the codes which the image displays.

From engagement with space we went on to consider the concept of linking. This was mentioned in two ways; firstly, the techniques which can be employed in film-making, and secondly, the part that imagination plays in viewing moving images. Through imagination time past and time future can be contemplated in the present, in the here and now. It is only suggested in the moving image, and it requires the viewer's imagination to give it 'life', but it is a real illusion nevertheless.

To take us on to the next chapter on the language of vision, the ideas we have discussed on frames and links provide an interesting link themselves. As we have seen, frames delimit, and by delimiting define their contents in particular ways; this is a characteristic of pictorial representation and of words which, as concepts, define particular sets. And although images and words delimit, they are often linked together into some greater whole, for example the film frame into film sequence, and words into sentences. And although the frame and the link are different in the visual and verbal, as concepts they apply equally to both forms of communication. But to what extent it is legitimate to apply the term language to visual communication is a question to which we turn our attention in the next chapter.

7

LANGUAGE OR SYSTEM

As we saw in the last chapter, the act of framing serves not only to direct the viewer's attention to a prescribed space, but also to make a statement to the effect that what is observed is different from its surroundings. In this chapter we take a look at the implications that language holds for visual communication, and ask questions about what it means to 'read' an image. By pitting ourselves against the verbal we have to avoid the tendency of playing the game solely in its court, and thereby losing sight of the fundamentals that give the visual its unique place in human communication. Accordingly, we have chosen to give a more open title to this chapter, one that while containing the word language also includes system. This gives us the advantage that we can go beyond linguistics, which is of course one kind of system, and draw inferences from other systems or modes of perceptual knowing such as are described in skill theory. It is a move into the world of the analogue where things do not exist within discrete boundaries; where there are no lexicons to define the subtle gradations of difference that the visual as image offers.

As language, the visual is less prescribed, it is more like language in the making, or even more like a game. As Baxendall (1988) wrote, " … in painting a picture the total problem of the picture is liable to be a continually developing and self-revising one. The medium, physical and perceptual, modifies the problem as the game proceeds. Indeed some of the parts of the problem emerge as the game proceeds." But it is not only in paint that this phenomenon occurs, the same could be said of film and all other media where the process is one of re-formulation in the light of fresh or emerging contingencies.

While there appears to be more freedom in visual production, it is not unrestricted freedom; as in all games, if we might use the expression, limits are set. In the case of visual images, graphic or photographic, there are two kinds of constraints; those set by the chosen medium itself, and those set by the limits of the imagination of the image creator. These restrictions, set alongside the five elements of form, colour, line, tone, and texture, which comprise visual composition in the painterly arts, create the framework from which the material image arises, notwithstanding the additional limits imposed by conventional ways of representation. Like grammar there are constraints, but unlike grammar the rules, such as they are, are less specific.

Within these parameters the image unfolds, but when it is reviewed as a work of art, it is often expressed in relation to the verbal. Here, for example, are comments made by the art

critic of the 'Independent' newspaper, in which the term language is used in a broad way to express thoughts about the organisation of paintings and sculpture.

With reference to an exhibition of the work of Toulouse-Lautrec held at the Hayward Gallery, London, he wrote:

> "In his posters, Lautrec adapted the visual language of the avant-garde of his time – the telescoping of near and far and the odd conjunction of details, framed with arbitrariness, found in Degas – and made it the language of popular art."

And with reference to the work of the sculptor Anthony Caro, which was shown at the Tate Britain Gallery, London, he wrote:

> "His (Caro's) more horizontal works are often said to be language-like, almost resembling sentences in their disposition of discrete elements, separated by pauses across space. Caro gives you language without words."

This speaks more about the way or ways of doing things, of putting things together in particular ways, of creating relationships between items or parts in order to produce particular effects. To the extent that verbal language is engaged in a similar exercise of putting things together, words, for a particular effect, then we may say that the verbal and the visual as devices offering themselves for interpretation are both engaged in the same enterprise, of creating relationships between elements. The main difference is the nature of the materials used, and the existence, or not, of rules for their usage, in other words, an agreed grammar. In both instances, verbal and visual, the task is one of creating relationships, which are then offered in some form or other to the reader or viewer for their contemplation. Seen in this light, the term language, when used in reference to the visual, fails to express the deeper significance of relationships which lie at the heart of both the visual and the verbal in the construction of forms. The mode of mental processing may be different, given to the right or left hemisphere, but it is still a cognitive affair engaged in a search for relationships.

While it might be said that art critics as wordsmiths are positioned to think in literary terms, we may ask to what extent it is appropriate to describe communication through the agency of the visual as a language. We know, as it has been pointed out by Merleau-Ponty (1964) and others, that the beginnings of language have their roots in non-verbal communication. And while we can recognise the place of gesture and other non-verbal characteristics as agents in the communication process, to what extent is it legitimate to speak about language when we are dealing with visual communication?

This question goes to the heart of the matter, but it is made even more problematic when it is defined in terms characterised by another discipline, that of linguistics. On closer analysis, the deep, genetically endowed structure that lies at the core of Chomskian linguistics can be seen to be an expression of a much earlier perceptual structure. This is apparent in the work of Gregory (1970) who wrote, "It is tempting to suppose that the deep structure of language is the expression of the much earlier 'perceptual hypotheses' used to order and predict the world of objects. If the structured perceptual hypotheses were taken over by the newly developed language, the difficulty of supposing that language deep structure could have developed by natural selection since the chimps largely disappears, for we may regard it as a 'take-over' operation from what already existed in animal brains.

Also, the close connection between how we see and how we think becomes less mysterious."

Given this perspective, we can begin to appreciate that the visual, far from being a country cousin, provides a foundation for the onset of language. And should this be disputed, it is a fact that the ever-changing patterns of light and shade that impinge upon the retinal system are actively classified in accordance with an 'internal grammar'. And while the mechanism that constitutes this grammar may be unclear, it is one, like the verbal, which is called upon to make sense of something that it has never previously encountered. In the case of the visual it is making sense of patterns, rather than sentences. The uncertain is made certain, sense is made out of non-sense.

At the deepest level the significance of art is to be found in this area of prelinguistic certainty. And although what we mean by art and what we mean by language are in various instances continuous, parallel, or overlapping relative to one another, at the deepest level they are dissimilar (Summers, 1991). It is at the surface level that relationships between the image and the word are made manifest, for instance between the image as symbol and the narrative or story for which it stands, as for example between a cross and the story of the crucifixion. At this level, the visual can raise to consciousness a range of associated ideas or words. Likewise, words possess the same potential, but in the reverse direction. In this way we may speak about words and images impregnating each other. It is a condition of mind.

The following diagram is intended to portray these connections. Here there are no claims for the primacy of the perceptual over the verbal at the level of deep structure, only as factors that influence surface interpretation. In this schema, the deep structure of perception is shown as exerting influence on the interpretation of pictorial and symbolic images, irrespective of any verbal links; and likewise, the deep structure of linguistics is shown as a force acting upon the surface level of language, irrespective of perception. It is at the surface level that interplay between word and language is shown. And it is here that the codes and conventions of society make themselves felt. This is the place of specific languages, English, French, or Arabic, for example. It is also the place of specific styles in art and image-making:

Deep structures;
innate/genetic

Surface structures;
learned/experiential

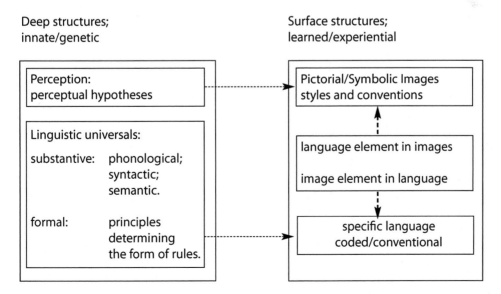

Whether we employ the term visual language or the more encompassing term of visual literacy to describe the framework of things visual, when we enter the territory of visual communication we find ourselves in a place where perception is paramount, if only as indirect perception. At times the viewer is called upon to perceive the form of the image in ways never previously encountered, and to be familiar with cultural codes of production and symbols which require a form of decoding which has never been made explicit. And because the representation to be viewed is figurative and non-linear, the demands it makes can veer towards fine degrees of perceptual discrimination. This is in marked contrast to the verbal, which is digital and linear, composed from an alphabet, referenced through dictionaries, and formalised in grammar.

Thus it will be seen that the visual as a form of representation offers itself for 'reading' at many levels: firstly, it always makes demands upon the perception of difference within and across its form; secondly, it may carry symbolic elements that require specific cultural knowledge before they can be 'read' as intended; and thirdly, through its existence as pure form, it offers itself as a vehicle for aesthetic appreciation. Thus as a source of information the image carries rich potentials on the basis of the three factors we have just mentioned.

This informational richness, however, may be a source of mental overloading to the viewer. Take for example a painting by Hieronymus Bosch; here the viewer needs to scan for some considerable time before all the detail can be digested, and the symbols decoded. Likewise , a frame in a film may carry a vast amount of detail which cannot be 'taken in' in the time available. However, through selective attention the viewer can restrict his or her visual search and thus reduce the demands made upon information processing. Of course, when the viewer lacks interest in the image before the eye, then it will be scanned, if at all, with little attention to its refinements, and thus the demands upon information processing will show a corresponding reduction.

The opposite occurs when the viewer is able to find additional sources of information within the image itself, within its form. This is the ground of aesthetics which, as a source of information, is additional to that generated by the image in its life as sign or symbol, as metonymy or metaphor. Thus when people speak about 'reading' an image it may be at each of these levels. The image presents itself as an object for the abstraction of information at more levels than the verbal. Its 'reading' is not a linear 'one way affair', but one which is multi-faceted. And the formulation of a language of vision has to take this into account.

However while both types of communication , verbal and non-verbal, provide unique informational sources, they intertwine or cross fertilise each other. For example, as was mentioned earlier, images may cause specific words to be raised to consciousness; and conversely, words may cause images to be so raised. This is a well-known phenomenon, but whether the image can have a life as thought independent of verbal language has been open to question. For example, Barthes, on writing about semiology, went on to proclaim that "despite the spread of pictorial illustration, … it appears increasingly more difficult to conceive of images and objects whose signifieds exist independently of language", and that "linguistics is not part of the general science of signs, even a privileged part, it is semiology which is part of linguistics". From this verbo-centric standpoint, visual representations, which are part of the general family semiosis, exist in a hierarchy at the apex of which is linguistics.

On the other hand, when we go beyond linguistics and into the realms of neural science, the separation that is apparent between word and image begins to disintegrate. Here (Damasio, 1992) we find that the term language is employed to describe interactive processes

in the brain, especially those within and between the specialised areas or structures devoted to language and non-language. A hierarchy is not promulgated; the whole is seen as a machine which represents language as it represents any other entity.

In discussing the wider issues that lie behind the concept of a visual language, which, correctly speaking, should be in parenthesis, we are constantly drawn to the part played by perception, to contextual figurations of a non-linear kind, and to styles and techniques of production and reproduction all of which contribute to the experience that we know as visual communication. It is these considerations that make the visual a more problematic arena for the construction of a grammar than we find in the verbal. And it is these factors with their surface level appeal to natural life, as opposed to the abstraction of the verbal, which complicates the task of formulating a language of vision. Whether it is possible to construct a coherent theory of visual communication with the same degree of certitude as that accorded to linguistics is open to speculation. Should we be able to do so, we would have gone some way to refute the scepticism of Gibson (1966) who said, "Although much has been written about language, there is no coherent theory of pictures." And while our brief is wider than that of pictures, it has the same implications.

If in searching for a language of vision we find ourselves assisting in the creation of a theory of visual communication, then that would help the wider purposes of this book. And while it may seem inappropriate to employ the term language in a non-linguistic content, the precedents for this are well established. For example, the geneticist, Steven Jones, in a talk broadcast on the B.B.C. Reith Lecture Series on genetics, claimed that, "Genetics is a language, a set of instructions passed from generation to generation. It has a vocabulary, the genes themselves: a grammar, the way in which the inherited information is arranged; and a literature, the thousands of instructions needed to make a human being. It has a simple alphabet the four different DNA bases." What has been spoken about here is a system, a non-social system of communication. And while it has been found appropriate to borrow the term language as a broad title in genetics, it would not seem inappropriate to take the same liberty for visual communication.

But although we may follow this logic, it would appear that our purpose would be served even better by following Nelson Goodman's (1968) example. On writing a book entitled 'Languages of Art', he added the rider that, strictly speaking, languages in the title should be replaced by 'Symbol Systems'. By adopting this approach, we can consider visual communication as an assembly of symbols gathered in some systematic way for some systematic purpose. But whereas the verbal follows a linear pattern, the visual, as form, is non-linear. While they differ in this respect, they are, as systems, both sustained by relationships. A symbol, figurative or alphabetic, is only a symbol by virtue of the fact that it bears a relationship to some thing or idea; and likewise, a symbol-system is none other than an assembly of relationships between symbols. Therefore, by considering language and 'languages' within the wider framework of symbol systems we not only free ourselves from the imperialism of linguistics, but correctly identify their communality under the general concept of relationships.

What we wish to convey is that languages, whether they be verbal or visual, are systems, and as systems they exist by or through relationships. What we need to find out is something more about the elements that go towards the construction of relationships in visual communication, and about the conventions through which they are prescribed. We shall find ourselves led into the territory of the ineffable, the area where the tacit predominates to the

extent that articulation is virtually impossible. In this space words fail to translate properly the relationships that the signs evoke. The 'language' of vision is here. As figure it transgresses the laws of discourse, and refuses to respect the invariant spacing and rules of substitution which define the system of langue. The relations are 'dense', given continuously across a surface, this is in contrast to the verbal which is fundamentally discontinuous. This distinction has the effect of making visual representations into a certain kind of 'text' which is 'read' in a different way.

Visual Image as Sign

The twenty-six characters of the Roman alphabet, plus blank spaces, along with punctuation marks, are all that is needed to write or print a message in the English language. And because these Roman based letter forms, as signifiers, bear no obvious relationship to that which they signify, they lend themselves to abstraction, detached from the particular or the specific. The power of language consists not only in this characteristic, but also in the extensive articulatory and combinational flexibility which can be obtained by joining these highly standardised, discrete units , into some particular order. Such is the verbal world that we know; a world in which the relationships between word and idea or thing, signifier and signified, is, generally speaking, arbitrary and conventional. But although it is so constrained, it does nevertheless provide almost infinite scope for the creation of new and original messages. Such is the territory of the verbal, which undergoes double articulation, firstly from phonemes into words, and secondly from words into discourse.

In contrast, the first 'language' we learn is one of single articulation, non-verbal, composed of expressive gestures that directly correspond with events. It is learned in real-life situations and related to specific events in which there is a direct relationship between the gesture as visual sign, and the meaning which it is intended to convey. It is not abstract, but concrete; it takes place in the here and now, a world of immediacy where there is direct correspondence between signs and events, and being contained within real space and real time it partakes of those 'a priori' conditions that lie at the foundation of all human knowledge. This is the space where perception rules, the place of physical presence, where signs are non-arbitrary, and thus apparently natural. This is man, as animal, living as though by nature, where the body itself is used as a source of social signs, commonly called body language. Such signs may be generated below the level of conscious awareness, but man, as thinking man, has been able to turn these signs to his advantage and to employ them consciously. The units of which they are composed, and here we refer to gesture, facial expression, and posture as units, are not discrete as in the verbal, they resemble more the analogue, and should they be learned, it is more as a performance.

The characteristics that have just been ascribed to unmediated non-verbal communication bear a close relationship to those found in mediated visual communication, particularly in film and television, which, as moving images, are able to simulate time and space, the fundamental conditions of being. Another characteristic common to both is the way in which the contexts in which they are embedded define their significance. A change of context can create a change in their meaning. Furthermore, they share the same multi-directionality in 'reading', in contrast to the uni-directionality of the verbal. And although the signs generated in real life are concrete, mediated images can give an impression of concreteness, they can appear as a true representation of external events. As signifiers they can be associated with naturalness, to seem artless, and yet be unnatural.

Although we have observed a number of similarities between the mediated and the non-mediated in visual communication there are important differences. The most obvious is that the mediated image is only artefact, and as such it lends itself to concealed manipulations and an arbitrariness which is characteristic of the verbal. In this respect, we may consider images as signs to be a kind of half-way house between reality and abstraction; being identified with the perceptual they partake of a pseudo reality, and being semiotic entities they can refer to things or events in their absence. Take, for example, a photographic portrait, the person portrayed is given to perception without an apparent code, and the result is pseudo presence. And yet the means of production of the image have involved arbitrary choices by the photographer; choices of camera angle, lighting, and printing. All of these add up to a style of production which involves choice from alternative ways of creating a photographic image. And although the choice is less conventionalised than that employed by the print compositor confronted by a case of type or keys on a computer keyboard, there are, nevertheless, choices to be made, and thus an element of arbitrariness is present. The 'language' or 'voice' of the image maker speaks through these choice units. It varies with each medium, but it is always present.

The image's combinational flexibility is governed not by rules but by the limits imposed by media, and the inventive power of the image maker in utilising the potentials of a particular medium. And thus, when we speak of a visual 'language', we have to bear in mind the scope and limitations of media, and the ways in which they can be employed. The 'grammar' employed can be more correctly identified as an unwritten convention that surrounds the usage of a particular medium, rather than as a set of rules prescribing combinational constraints. And while there are conventional ways of using particular media, there is always scope for creative potential, introducing ways never previously employed, an avant-garde, so to speak. Thus we may speak not only about language but 'language in the making', an evolutionary process of visual representation. All this leads us to a position where we can say with Eco (1977) that these considerations force one to recognise that it is wrong to believe that every sign system is based on language similar to the verbal, and that every language should have two fixed articulations. The relationships between the elements that go to make up a visual image are direct, a single articulation, which can be illustrated as follows:

It is only when the image is to be 'read' as metaphor that the idea of a second articulation arises, for example:

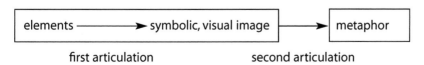

In this sense a language related element is introduced, but the articulation is different from that of verbal discourse whose first articulation is that between the phoneme and the word, for example:

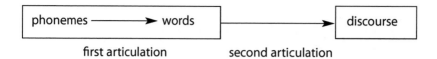

first articulation second articulation

While these articulatory differences provide interesting insights into the differences between the visual and the verbal as forms of communication, it is through the concept of arbitrariness that we are provided with what is perhaps the most significant bridging factor between the concreteness of bodily signs and the abstractness of the verbal, when it is given in print. In terms of the three modes of communication which have been described, the least arbitrary, because it is associated with human presence in space and time, is that which we described as body language; the next is that of mediation via the visual, which although it is detached from nature is nevertheless engaged with perception; and finally, the most arbitrary , because it bears no resemblance to things, is the verbal. From this we can construct a three-way classification of degrees of arbitrariness for communication:

1. The non-arbitrary; the immediate connection between sign and event which is generated without conscious awareness, for example, the uncontrolled blush associated with self-consciousness.
2. The partially arbitrary; a pictorial representation in which the connection between image as signifier and that which it signifies is identified through resemblance.
3. The fully arbitrary; letter forms which bear no resemblance to that about which they 'speak'.

As our concern is with the middle term, we find ourselves in shady territory. On the one hand it veers towards the analogue, the natural, and on the other towards the digital and conventional. For example, it can show the blush on a face, thus it can be classified as analogue; and in the guise of the symbol it connects with narrative. This of course is one of the strengths of the visual image as a form of communication. And another strength is that it can range across a scale measured in terms of what we might call degrees of likeness. For example, from the trompe l'oeil painting or the photograph, bearing almost perfect likeness to that which it represents; to the schematic diagram, where there is no recognisable physical likeness, only a visualisation of concepts. The idea is represented below in schematic form:

photograph	line drawing	ideogram	schematic diagram

near visual likeness only conceptual likeness

A scale of this kind, which runs from the least to the most arbitrary, is also one that represents increasing degrees of detachment from the visual image as a representation and that for which it is a stand-in. But there is a paradox here. As artefacts, images are always separate or detached from that which they portray, they are no more connected than the printed word is to an idea, it is the primacy of perception that guarantees the closer bond between the material image and the 'inner' image.

In addition to the notions of arbitrariness and detachment which we have just dealt with, it is important to consider the greater breadth of meaning which can be attached to the image as a single sign unit, in comparison with the letter, or indeed the word. The work of

Metz (1978) on film language, which he called the semiotics of the cinema, provides us with some useful insights. He said, with respect to an image, that, far from being equivalent to a word, it corresponds rather to a complete sentence of which it exhibits five fundamental characteristics:

1. Film images are like statements and unlike words, infinite in number; they are not in themselves discrete units.
2. They are in principle the invention of the speaker (in this case the film maker), like statements but unlike words.
3. They yield to the receiver a quantity of indefinite information, like statements but unlike words.
4. They are actualised units, like statements and unlike words, which are purely visual units (lexical units).
5. Since these images are indefinite in number, only to a small degree do they assume meaning in paradigmatic opposition to the other images that could have appeared at some point along the filmic chain.

From this analysis, which is grounded in linguistic theory, images are seen more like statements than words. Their life, as Metz pointed out, is centred more upon syntagmatic considerations, less embedded in the paradigmatic networks of meaning which is, par excellence, the province of the verbal and symbolism. And although the image as syntagm is crucial for an understanding of the cinema and television, it is likewise central to an understanding of images in general.

The Importance of Syntagm

The sign, whether it be verbal or visual, always involves a relationship between at least two terms, between itself as signifier and that which it is intended to signify. When this condition is not fulfilled, when the sign as signifier fails to induce any particular meaning in the mind of the viewer, a state of incomprehension or indifference can ensue. An example of this is the incomprehension that unfamiliar visual signs engender in visitors to foreign countries. A sign is only a sign to the extent that it can cause a relationship between itself and some other idea or thing. When it fails to do so, it loses its status as sign and becomes merely a presence.

Signs show themselves in many ways, and they can be interpreted in many ways. They appear in nature as natural signs: for example, the cloud as a portent of rain; and in society as conventional signs intended to guide thought in particular ways, as for example, road signs, or the police uniform as a sign of authority. But whatever their origin, their life as sign is bound up with interpretation. In the first place they need to be 'read', the result of which is to cause the viewer's thoughts to be aligned in a specific direction, which then becomes the meaning to that person.

The visual image, as a sign-vehicle, can be exploited at two levels, the paradigmatic and the syntagmatic, but it is at this latter level that its particular qualities exert themselves. It is here that the viewer can be perceptually engaged without the need for words, engaged with relationships there before the eyes, observing things in two-dimensional space, with, at times, the illusion of the third dimension. It is this ability to show features in spatial proximity, to include the apparently irrelevant without explanation, and to give the illusion of presence, that ties the syntagm to realism. And while it may prompt evocation, it is not a necessary

condition of its being, in contrast to the paradigm, which as symbol always makes this demand. The whole was neatly summarised by Bryson (1981) when he wrote, "Language has no point of purchase or insertion into the seamless syntagm. So polished is its surface that words cannot penetrate it: they fall away into a discursive void."

At the surface level things belonging to the same set are easier to comprehend, this is how vision works, it sees things in contexts. But the apparent artlessness of the syntagm, which can present things with no apparent prior ordering, can be deceptive. There can, in fact, be a greater number of planned spatial relationships; for example, on locations, between props, and between colours. Such relationships can generate significance at a level below that of conscious awareness. As signs they may be enmeshed in multivariate ways, in an extreme denseness which requires 'close reading', or fine perceptual acuity. From this it follows that for a proper understanding of the syntagm as sign, it has to be understood not only in terms of simple relations, but more importantly as a whole set of spatial relations that are apparently uncoded and ineffable.

Syntagmatic signs as contextual relations in the image have their counterpart in the wider field of non-verbal communication. In both cases visual signs of a purely contextual kind are offered for interpretation at levels which may be above or below conscious awareness. And in both instances spatial relations are a significant factor: in the image it is two-dimensional, which through illusion can appear three-dimensional, for example through perspective; while lived space is always three-dimensional. In this space, vision sees things as in front, behind, by the side of, partially hidden, near or far. This is the natural order of things, it is not conditional upon signs; signs follow upon it. In this way the syntagm as sign, as a thing concerned with proximity, bears closer affinity to the natural order of things than the paradigm.

Nevertheless, when it is conveyed via media the syntagm inevitably loses its innocence, and becomes at least partially coded, for example the deliberate placing of items or people in contextual relations which create specific meanings. For example, as mentioned earlier, the interviewee framed by books is intended to give the impression of scholarship. In this way, denoted relationships of a contextual kind can 'give-off' a range of desired connotations. And while many such relationships can be spelled-out, made effable to the viewer, there are many instances where words fail to convey the nuances of the signification. It is here that people often speak about knowing through intuition, but this belief can cloak the part played by non-verbal cues in the act of viewing. This is an understandable state of affairs when one considers that such cues are often received and interpreted at a level below that of conscious awareness. The reading of images at the level of the syntagm is in large part at this level, it is thus more like a perceptual skill than reading a book. It goes beyond language, but like language, where the reader is aided by emphasis or stress being placed on significant words, for example italics, capitals, or by underlining, the viewer is often aided by stress of a visual kind, for example close-ups or lighting. But when no such aid is forthcoming the viewer has the task of personally identifying significant features or critical cues. There is a learning element here, which like perceptual skills in general, can be aided by words, but is never fully satisfied by them. It is not a language, but a system of knowing. Here we can see a connection with the findings from research into perceptual skills.

A Matter of Skill
Apart from dealing with symbolic elements carrying literary overtones, the process of viewing moving images can be seen to bear some of the characteristics which, from research,

have been used to define perceptual skills in general. In both cases the person involved has to extract information from an array of visual features which are presented first of all to vision and then for brain processing, and it takes place over time. And in both instances that which is presented to the eye may be spatially complex or dense, with some features being more important than others in terms of the contribution which they make to meaning. When the information presented exceeds the processing capability of the observer/viewer, then an element of selection is necessary. In such cases the skilled person is able to focus upon the key or master elements in the display, to bring them sharply into focus, one might say, and accordingly, relegate inessentials to peripheral vision. In a similar fashion, the skill of viewing could be defined as the ability to detect from a range of alternative foci the significant or essential details that contribute most to an understanding of the whole series.

What is particularly significant about perceptual skills and viewing is the part played by tacit knowledge. Although it resides at the level of the ineffable, it nevertheless plays a vital part in perceptual skills, and in the understanding of moving images in their various formats. Here cues of a non-formal kind play an important role in both guiding attention and giving meaning. In this respect there is close similarity between 'reading' moving images, and 'reading' visual events in the performance of perceptual skills.

A good example of a non-mediated perceptual skill is that of car driving. It is time and space bound, vision is imperative, events happen in sequence, the driver is called upon to 'read' tacit information of a sensory kind, and to read obligatory signs which route him or her in controlled directions. It is a passage through space and time, aided by learning, which manifests itself as experience; it is self-guided, and guided by others in the form of regulatory signs which are usually placed at points of high information or of vital importance. Thus in terms of 'reading' there are natural and artefactual signs to be processed, for example weather conditions and road signs. The 'smoothness of flow' that a skilled driver in this situation exudes is, in large part, dependent upon a correct reading of the various signs, and the making of appropriate responses.

Skilful viewing of moving images follows a similar pattern, it calls upon the viewer to perceive signs, and to be aware of their significance in a particular context. It is experienced over time; given in space, two-dimensional but with an illusion of the third-dimension; presented to vision; sequential, one thing following upon another; it has a tacit element; it is assisted by cues or markers which may be there in a natural way or by deliberate design for the purpose of routing the viewer in planned directions of thought or interpretation. Apart from the fact that no physical responses are called for, it will be seen that reading the moving image is like reading the signs that guide visual perceptual skills.

In summing up the relationships between perceptual skills and the viewing of moving images, we can list some of the more important concepts that have been used to define perceptual skills and show them in relationship to the moving image:

perceptual skills	skill in viewing moving images
key elements	aspects of the image which are high in 'information', the essential features
selective attention	regard for critical features in the face of alternatives in the frame
anticipation/expectation	forecasting things or events, based upon signs or pre-knowledge

information load	the demands placed upon mental processing
cues	information which directs the viewer into prescribed paths of attention and interpretation.

The last in the list, cues, holds particular significance for the image producer. They can be employed in a number of ways, for example: to direct attention; as aids to anticipation; and as stereotyped aids to recognition. In these and other ways they help to organise the thoughts of the viewer, to simplify choice when faced with alternative foci, and thus to reduce information load, a term borrowed from information theory. In addition, they can be used to link moments or episodes, and thus be aids to continuity. In this way they serve as route markers, overtly or covertly guiding the viewer along intended pathways of interpretation, denoting in specified ways, and thus reducing the prospect of wider connotation.

Of course, in film and television the visual can be accompanied by narrative and sound, which can both serve as cueing devices. But as our interest is in things visual, it is towards this mode of awareness that we have to set our sights. Here is a simple list of factors which can be employed as cueing devices:

background; costume; fittings; furniture; lighting; colour; relative size; zoom potential; camera angle.

In addition we could add those other visual cues 'given off' by the body, as for example, facial expressions and body orientation. Together there is a rich source of tacit information which has to be picked up and attended to for the experience of viewing to be total. Each clue 'gives off' meaning and it is understood without reference to a lexicon, but like perceptual skills in general, and non-verbal communication in particular, tacit awareness plays a major role in the process. Over time the cues themselves become like a language, a systematic way of ordering attention for the purpose of aiding interpretation; and like language they have to be learned, if only tacitly. Stereotyping takes a hold and viewers begin to receive cues as though they are part of the natural order of things, colloquially speaking, 'they go without saying'. Producers begin to 'think with them', a kind of grammar ensues, procedures follow which then become part of the accepted pattern, a kind of folklore of production, which is culturally transmitted and culturally understood.

Reading at Three Levels

In making the connection with skill theory, and in view of the fact that reading visual images is primarily a perceptual task, we begin to appreciate that analysis by way of linguistics, while useful in some respects, is inappropriate for dealing with the complexity of the image as a form of communication. Its analogically rich strata and less highly conventionalised form puts the image at a distance from the verbal which is unbreachable. And although we might conclude that there is the beginnings of a grammar, it is still tentative and uncodified, bearing none of the rigour which we associate with the verbal. However, through its ability to represent things in analogical form, it can appear closer to the natural order of things. And furthermore, through the moving hand, as in drawing, it can leave a trail, a suggestion of freedom, of innovation, that the conventionalised letter cannot match. As a thing to be viewed, it may offer a choice of focus within one frame, such that the peripheral can become central and vice versa; this is the kind of accommodation that vision makes in everyday life.

In the verbal there is no change of focus, except at the level of thought. Through its propensity to initiate thought, the image carries the same potential.

However, as stimuli, as communicative devices, words and images have a common intention; that is, to organise the thoughts of the reader/viewer in particular ways. But whereas the word as letter is itself of little interest, except to those concerned with its typographical merits, the image, as form, can be extremely complex. This means that as a source of information, in information theory terms, the image has an additional dimension. Moreover, this dimension, which is one of spatial relationships, can lead directly to another, which is that of the aesthetic. Thus we can postulate three possible ways that the mind can be 'in-formed' by the image: through signs, that is through contextual relationships there before the eye; through symbolism, where the image is read as metaphor, and where relationships have to be imagined; and through aesthetics, where relationships are read from the image's form without regard for signification.

Each in its own way can be a separate source of information which demands to be read in a certain way. However this opens the prospect of fluctuating attention, similar to the figure/ground effect in psychology. This could be described as a kind of level switching; at one time the viewer's attention being engaged in a search for meaning at the level of syntagm, and then switched to that of symbolism, in those instances where symbols are on offer; or alternatively it could switch to the image as pure form, to its visual aesthetics. Information can be found at each of these levels, and the actual amount of information to be found depends upon two factors, the amount put there in the first place, and the viewer's ability to discern or infer relationships. The relationships may be subject to formal or informal (tacit) learning: firstly, the development of visual acuity such that the viewer becomes aware of the significance of spatial relations; and secondly, familiarity with the metaphorical significance of symbols; and thirdly, the sensitivity to the form as pure form, its aesthetic. With the competence obtained, the viewer can more skilfully attend to those facets which he or she finds most interesting, although a penalty may have to be paid, when, for example, the viewer is consumed with the aesthetics and fails to read the significance of any signs and/or symbols which are present, or vice versa.

The table below relates the level of reading to the kind of engagement:

reading level	relationships	meaning	image status
sign	syntagmatic	educed through juxtaposition	figure
symbol	paradigmatic	inferred through metaphor	icon
aesthetic	perceived within the form of the image	none	figure

At each level the viewer is engaged in the construction of relationships. The image itself is merely a stimulus, it is the viewer who makes the connections. Factors such as interest and learning obviously play a part, but as a relationship seeking activity it calls upon the exercise

of intelligence, which in the psychological literature has been defined as the 'eduction of correlates' (Knight,1956), which, in everyday language is none other than seeing or inferring relationships. The greater the complexity the greater the demands on intelligence. Thus when we speak about reading images, we mean that the viewer is engaged in seeking relationships at one or more of the three levels above, which, besides learning and motivation, is a manifestation of intelligence, a cognitive affair.

Summary

In this chapter we dealt with the notion of visual language, and while noticing that there are some similarities with the verbal, for example, the constraints that media and conventions impose, it is also a fact that there are marked dissimilarities. The verbal is digital and non-continuous, while the visual is analogue and continuous. The verbal has clearly defined units and rules regarding its allowable combinations. In contrast, the visual has no clearly defined units and universal grammar. Although it is common to hear the expression visual language, it is more like a 'language in the making', more open to invention.

Rather than staying in the shadow of the verbal, which is what is implied when linguistic concepts are used as benchmarks, we considered the visual as a system, a system of communication alongside, rather than below the verbal, which is itself a system. As icon, as symbol, the visual appeals to verbalisation, but as a non-discursive figure, it has a separate role to play in communication, more closely bound to the natural order of things, a kind of intermediary between nature and culture. In shifting our ground to that of the senses, to perception, a different kind of analysis becomes necessary; here such features as tacit knowledge and spatial ordering take on special significance, and context is of supreme importance.

We were led to consider the way in which findings from research into perceptual skills could be applied to the dynamics of viewing moving images. Although there are obvious differences between response demands, mental in viewing, and mental and physical in perceptual type skills, they are both concerned with time and space. Particular mention was made of selective attention, anticipation, and the role of cues, which serve not only as recognition aids, but as attention directors, and as guides for routing the viewer through sequences, from one frame, or from one episode to the next. Mention was also made of stereotypes, and the way in which, over time, they appear to be there as though by nature; the naturalisation of the cultural.

In addition to questioning the appropriateness of the term language, we also questioned the appropriateness of the term reading. In the context of the visual, what is meant by reading is the detection of relationships which lead to signification via syntagm or paradigm, that is, through sign or symbol. We also added a further dimension, that of aesthetics, which requires the viewer not only to perceive relationships in the form, but to relate them on a scale of values. It could be summarised as follows:

1. sign relationships; seeing relationships within the materiality of the image from which signification is educed, the relationship is syntagmatic,
2. symbolic relationships; inferring relationships on the basis of metaphor; relationships are unseen and require the exercise of imagination to make them manifest; the relationship is paradigmatic.
3. aesthetic relationships; relationships which are found in the form of the image, which lead to feelings measurable on scales of values; for example, pleasure to displeasure, or satisfaction to dissatisfaction.

Concluding Remarks

Visual communication has a surface level appeal which can be beguiling, but to understand fully the seriousness of its role as an agent of human communication, we have to look beyond the obviousness of its eye appeal. Initially one is drawn to the medium itself, fascinated with its ability to represent as though without a code, a state we reserve for nature. But, as in all forms of human communication that undergo mediation, the visual is an affair of three parts: the presenter/ sender ; the viewer/ receiver; and that which joins them, the medium, all of which are influenced by social and cultural antecedents. And all of this has ramifications which are both complex and problematic. In our journey down these pathways, we found ourselves engaged not only in the way that the world is visually perceived, but also in the way that it is re-formulated and re-presented. We were led into fields as diverse as psychology, semiology, aesthetics, and language. But in a general sense our task could be considered one of philosophy, the staking out of ideas, rather than the solution of problems. This was evident from the attention given to tacit knowledge, meaning, and aesthetics; and upon the existentialist fact of being in a world which is both unmediated and mediated, given directly to the senses, and indirectly through signs and symbols.

There were certain salient features that deserve special mention, the first and perhaps the most significant for visual communication is that of perception. Perception is always a presence; a direct engagement with things in the 'here and now'. But there is a catch when it is engaged with mediated images; although the engagement with the image is with a real presence, the image there before the eye, that to which it refers is always absent. Thus images as references, as signs and symbols, are in the paradoxical position of being concerned with presence and absence, a situation which calls upon the viewer to make the necessary mental connection between these conditions. In this sense, and in this sense only, the absent becomes present, perception is then encompassed in a wider embrace. This is the state of indirect perception, of mediation which leads to what we might call pseudo presence and pseudo reality, a Janus-like situation which, taken to extremes, can lead to perfect illusion.

In addition to the saliency of perception, which surfaced repeatedly throughout this book, special mention should be made of the importance of context. And here again we can see a connection with the natural order of things. Whenever vision is at work it sees things in contexts, within the frames of the eye: it sees things in juxtaposition, multi-linearly, which affects not only the way in which they are perceived, but also the way in which they are understood. Colours work like this, their values are affected by their relationship to other

colours in the same context. In a more prosaic way the advertising industry utilises the same potential when it frames its wares in contexts which carry prestige. Thus it is not only the ability to make things look like that which they represent, but also to show things in particular contexts, which gives the visual a special niche in communication.

Also worthy of special emphasis is the medium's openness to invention, to the 'doing factor' which is made manifest in most of contemporary art and experimental film. It is more like a 'language in the making'. Consequently the medium itself becomes central to the whole enterprise, unlike the verbal where the medium is more in the shadows. Although, over time, techniques and methods of production do become cliches and hence lose their originality.

And finally, it must be said that although the visual as a mode of communication has, generally speaking, received less emphasis than the verbal within the educational curriculum, present circumstances make this questionable. It would appear that owing to the rise of visual media in western society, particularly television, and computer-generated images, its profile should be raised, taking on board not only its visual appeal, but also the many factors that have informed this book.

BIBLIOGRAPHY

Andrew, D. *Concepts in Film Theory* (Oxford: Oxford University Press, 1984)

Arnheim, R. *Visual Thinking* (London: Faber & Faber, 1970), pp. 14-15, & p.235

Arnheim, R. *Art and Visual Perception* (Berkeley: University of California Press, 1974), p.101

Baggaley,J.& Duck,S. *Dynamics of Television* (Farnborough: Saxon House, 1976), p.90

Barthes, R. *Elements of Semiology* (New York: Hill & Wang, 1968)

Barthes, R. *Mythologies* (St. Albans: Paladin, 1973)

Barthes, R. *Image, Music, Text* (London: Fontana, 1977)

Barthes, R. *The Responsibility of Forms* (New York: Hill & Wang, 1985)

Bartlett, F.C. *Remembering* (Cambridge: Cambridge University Press, 1932)

Bartlett, F.C. *Thinking* (London: Allen & Unwin, 1964)

Bastick, T. *Intuition* (New York: Wiley, 1962), p.268

Bateson, G. *Steps to an Ecology of Mind* (St. Albans: Paladin ,1973), p.457

Bateson, G. *Mind and Nature* (London: Fontana, 1980), p.37

Baxendall, M . *Patterns of Intention* (New Haven: Yale University Press,1988), p.62

Benjamin, A. (ed) *The Lyotard Reader* (Oxford : Blackwell, 1989), pp.155-168

Bennington, G . *Lyotard: writing the event* (Manchester: Manchester University Press, 1988), pp.10-11

Berlyne, D.E. *Conflict, Arousal, and Curiosity* (New York: McGraw-Hill, 1960), p.229

Berlyne, D.E. *Studies in the New Experimental Aesthetics* (New York: Wiley, 1974)

Bruner, J.S. *Toward a Theory of Instruction* (Cambridge, Mass: Harvard University Press, 1966)

Buchler, J.(ed) *Philosophical Writings of Peirce* (New York: Dover, 1955), pp.98-119

Bryson, N. *Word and Image* (Cambridge: Cambridge University Press, 1981)

Bryson, N. *Vision and Painting* (London: Macmillan, 1985)

Bryson, N. *Looking at the Overlooked* (London: Reaktion Books, 1990)

Cassirer, E. *The Philosophy of Symbolic Forms, Vol.3* (New Haven: Yale University Press, 1965), p.201

Cassirer, E. *An Essay on Man* (New Haven: Yale University Press, 1979), pp.24-5 & p.144

Cherry, C. *On Human Communication* (New York: Wiley, 1961)

Damasio, A.R .'Brain and Language', *Scientific American*, 267:3 (1992), pp.89-95

Derrida, J. *Writing and Difference* (London: RKP, 1978), p.266

Eco, U. *A Theory of Semiotics* (London: Macmillan, 1977)

Edwards, B. *Drawing on the Artist Within* (New York: Simon & Schuster,1986), p.12

Ehrenzweig, A. *The Hidden Order of Art* (London: Weidenfeld & Nicolson, 1967)

Gibson, J.J. 'A Theory of Pictorial Perception', in Kepes, G.(ed.) *Sign, Image and Symbol* (London: Studio Vista, 1966), p.92

Gombrich,E.H. *Symbolic Images* (London: Phaidon, 1971), p.13

Gombrich, E.H. *The Sense of Order* (Oxford: Phaidon, 1984), p. 4 & p. 294

Goodman, N. *Languages of Art* (New York: Bobbs-Merrill, 1968)

Gregory, R.L. *Eye and Brain* (London: Weidenfeld & Nicolson, 1966) p.109

Gregory, R.L. *The Intelligent Eye* (London: Weidenfeld & Nicolson, 1970)

Gregory, R.L. 'Perception: where art and science meet' *Royal Society of Arts*, 5406, (1990), pp.399-405

Haussig, H.W. *A History of Byzantine Civilization* (London: Thames & Hudson, 1971)

Kandinsky, W. *Concerning the Spiritual in Art* (New York: Dover, 1977), p.50

Kandinsky, W. *Point and Line to Plane* (New York: Dover,1979), p.17

Kant, I. *Critique of Judgement* (New York: Hafner, 1951)

Kant, I. *Critique of Pure Reason (London: Macmillan, 1982)*

Knight, R. *Intelligence and Intelligence Testing* (London: Methuen, 1956), p.17

Langer, S.K. *Philosophy in a New Key* (Cambridge, Mass.: Harvard University Press, 1942)

Leach, E. *Culture and Communication* (Cambridge: Cambridge University Press, 1976)

Levinas, E. *The Theory of Intuition in Husserl's Phenomenology* (Evanston: North Western University Press, 1973)

MacQuarrie, J. *Existentialism* (Harmondsworth: Penguin, 1973), pp.10-11

McCarthy, A. & Warrington, E.K. 'Evidence for Modality-Specific Meaning Systems in The Brain' *Nature*, 334, (1988), pp. 428-430

MacKay, D.M. *Information, Mechanism and Meaning* (Cambridge, Mass.: M.I.T. Press, 1969)

Manovich, L. *The Language of New Media* (Cambridge, Mass.: M.I.T. Press, 2001)

Merleau-Ponty, M. *The Primacy of Perception* (Evanston: North Western University Press, 1964a)

Merleau-Ponty, M. *Sense and Non-Sense* (Evanston: North Western University Press, 1964b), pp. 54-58

Merleau-Ponty, M. *The Visible and the Invisible* (Evanston: North Western University Press, 1968), p.12

Metz, C. *Film Language: a semiotics of the cinema* (New York: Oxford University Press, 1978), p.26

Moles, A. *Information Theory and Esthetic Perception* (Chicago: University of Illinois Press, 1968), p.91

Morris, C. *Foundations of the Theory of Signs* (Chicago: Chicago University Press, 1938)

Penrose, R. *The Emperor's New Mind* (London: Vintage, 1991), pp. 548-49

Piaget, J. *Judgment and Reasoning in the Child* (London: Kegan Paul, 1928)

Polanyi, M. *The Tacit Dimension* (New York: Doubleday, 1966), p.29

Polanyi, M. *Personal Knowledge* (London: R.K.P., 1969)

Polanyi, M. & Prosch, H. *Meaning* (Chicago: Chicago University Press, 1975)

Popper, K.R. *Conjectures and Refutations* (London: R.K.P., 1963)

Sperry, R.W. 'Hemisphere Disconnection and Unity in Conscious Awareness' *American Psychologist*, 23, (1968), pp.723-33

Summers, D. 'Real Metaphor: towards a definition of the conceptual image' in Bryson, N., Holly, M.A. & Moxey, K. eds. *Visual Theory* (Cambridge: Polity Press, 1991), pp. 231-259

Thomas, M. & Penz, F.(eds.) *Architectures of Illusion* (Bristol: Intellect Books, 2003)

Werner, H. & Kaplan, B. *Symbol Formation* (New York: Wiley, 1964)

Zeki, S. *Inner Vision* (Oxford: Oxford University Press, 1999)

Zettl, H. *Sight, Sound, Motion: applied media aesthetics* (Belmont, Calif: Wadsworth, 1973), p.2

Zettl, H. 'Watching T.V. News: the use of digital video effects in news presentations' in *Proceedings of the Sixth International Conference on Experimental Research in televised instruction*, pp. 2-13, Montreal, Concordia University, 1986

INDEX